Christian Boltanski

Lynn Gumpert

Christian Boltanski

Flammarion

ACKNOWLEDGMENTS

To write about an œuvre that makes its point by its elusiveness is not an easy task. I would like to thank Christian Boltanski, who trusted in me and who helped with the layout of the book. Jennifer Flay, too, contributed many hours in assembling the illustrations; she has participated in this project from its very inception, and I owe her a great debt of gratitude. I am also greatly indebted to Deirdre Summerbell, who edited my manuscript in English with utmost patience and considerable persistence. Appreciation is due, as well, to Ghislaine Hussenot and Catherine Bastide, of the Galerie Ghislaine Hussenot, who were most helpful in providing documentation and answering questions. At Flammarion, I would like to thank Jean-François Barrielle, Bernard Marcadé, Pierre Christian Brochet, Suzanne Tise, Diana Groven, Anne Sefrioui, and Pascale Ogée. My thanks as well to Anne Rochette, who translated it for the French edition, Miriam Rosen and Lucy Oakley. Finally, I would like to express my profound appreciation to Dennis Cate, for both his unwavering support and his wholehearted encouragement.

L.G.

"Texts and Interviews" translated from the French by Francis Cowper
Typesetting by P. F. C., Dole
Photoengraving by Bussière, Paris
Printed and bound by Mame, Tours

Flammarion 26, rue Racine 75006 Paris

ISBN: 2-08013-559-7
Numéro d'édition: 0710
Dépôt légal: March 1994
Printed in France

CONTENTS

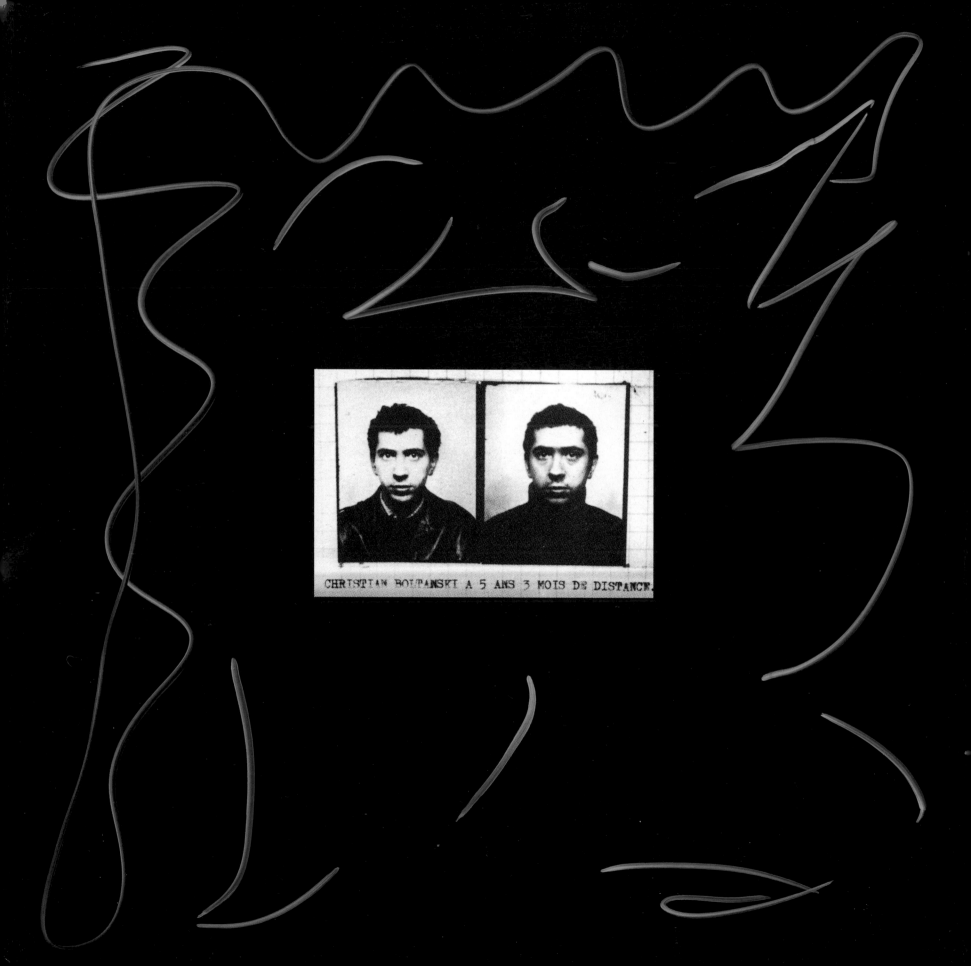

LA VIE IMPOSSIBLE

DE

CHRISTIAN BOLTANSKI

VENDREDI 3 MAI 1968 A 18 H - LE RANELAGH 5, RUE DES VIGNES PARIS-16ᵉ

11/1/70

Christian Boltanski
10 rue de Grenelle
Paris 7e

Monsieur,

Il faut que vous m'aidiez, vous avez sans doute entendu parler des ~~grand~~ difficultés que j'ai eu récemment et de la crise très grave que je traverse. Je veux d'abord que vous sachiez que ce que vous avez pu entendre contre moi est faux. J'ai toujours essayé de mener une vie droite (je pense, d'ailleur que vous connaissez mes travaux, vous savez sans doute que je m'y consacre entièrement, mais la situation a maintenant atteint un degré intolérable et je ne pense pas pouvoir le supporter bien longtemps, c'est pour cela que je vous demande, que je vous prie, de me répondre <u>le plus vite possible</u>. je m'excuse de vous déranger, mais, il faut absolument que je m'en sorte.

C. Boltanski

mon cher Boltanski,
que se passe-t-il ? je ne suis au courant de rien ... mais peu importe, dites-moi ce que je peux faire pour vous. si c'est dans le domaine des choses possibles, je le ferai de tout coeur. ne vous laissez pas abattre par l'adversité. amicalement : José Pierre

THE IMPOSSIBLE LIFE
OF CHRISTIAN BOLTANSKI

As a late twentieth-century artist, Christian Boltanski poses existential conundrums in a postmodern world. Born in Paris in 1944, this wry trickster, who can, by turns, be merry and morbid—and often both at the same time—has produced a substantial oeuvre out of such insubstantial materials as newspaper clippings, bare light bulbs, rusty biscuit tins, found snapshots, flickering shadows, and used clothing. Modest though their means are, these works are at once highly sophisticated and extremely accessible. Disconcertingly, they are also often impossible to distinguish as "art."

Consider, for example, the letter that Boltanski sent to a number of people in January 1970. Written in his childlike and nearly illegible hand, it read:

> You have to help me, you have no doubt heard of the difficulties
> I have been having recently and of the very serious crisis I now
> find myself in. I want you first to know that everything you might
> have heard against me is false. I have always tried to lead an hon-
> est life, I think, moreover, that you know my work; you certainly
> know that I dedicate myself to it entirely, but the situation now is
> at an almost intolerable point and I don't think I will be able to
> stand it much longer, which is why I ask you, why I implore you,
> to answer me *as quickly as possible*. I am sorry to bother you, but
> I have to find some way out of this situation.[1]

Imagine the predicament of those who received this brief, disturbing note out of the blue. Was it a hoax or deadly serious? Some of the recipients may at least have heard of Christian Boltanski, who was then just beginning to show his work in solo and group exhibitions. Some may even have received a mailing a few months earlier, either of a photocopied book claiming to reproduce photographs of his childhood belongings or, more mysteriously, of a folded piece of cloth con-

taining a lock of hair. But others would have been completely in the dark. Whatever the case, a few were apparently concerned enough to write encouraging letters back. "I had five responses," Boltanski remarked in a 1975 interview,

> which wasn't bad at all, five people who wanted to help me. But I made this piece because I really was very depressed. If I hadn't been an artist, I would have probably written only one letter and then maybe jumped out the window. But since I'm a painter, I wrote sixty of them, that is, the same one sixty times, and told myself, "What a good piece and what a fine reflection on the relationship between art and life!". . . When you want to kill yourself, you make a portrait of yourself in the process of committing suicide, but you don't actually do it.[2]

The letter was a multiple, an artwork, and only one among many that the artist sent through the mail between 1969 and 1974. As such, it allowed Boltanski to put some distance between himself and his emotional state—to become, in effect, the audience for other peoples' responses to it. By writing the letter and copying it over and over again by hand, he had found a way to separate himself from its highly charged contents. Perhaps more importantly, he had also found a way to engage his readers, whether they liked it or not, in his life and his art.[3]

Six months later Boltanski sent another letter. This time he made no mention of his emotional condition and focused instead on his métier. *Lettre manuscrite dans laquelle j'explique les directions contradictoires dans lesquelles mon travail s'engage* (Handwritten letter in which I explain the contradictory directions of my work), as the piece is now called, addressed what appeared to be conflicts in his work. While the directions he was pursuing "might seem, in their current state to have no connecting thread," he wrote, "I know they are related and that once the link is discovered, this will be evident."[4] Included with the letter were three examples: a photocopied sketch and several captioned photographs. Labeled "first example," the sketch depicted a work—made from cones of earth, nails, a light bulb, and a battery—which was very similar to an installation he had exhibited the year before at the Biennale de Paris. This crude drawing, if nothing else, announced Boltanski's predilection for creating works out of odd and unusual materials, an interest he would continue to pursue. Stripped from their original contexts, his second and third examples were probably more puzzling. One was a set of frontal and profile mug shots of a man, taken, according to the caption, "3 years, 4 months, and 27 days apart," and the other was a vertical, blurred clipping of a smiling little boy that was captioned, "The last photo of Paul Chardon."

Enigmatic though it may have seemed at the time to his correspondents—and, most likely to Boltanski himself—the reason he chose these photographs and

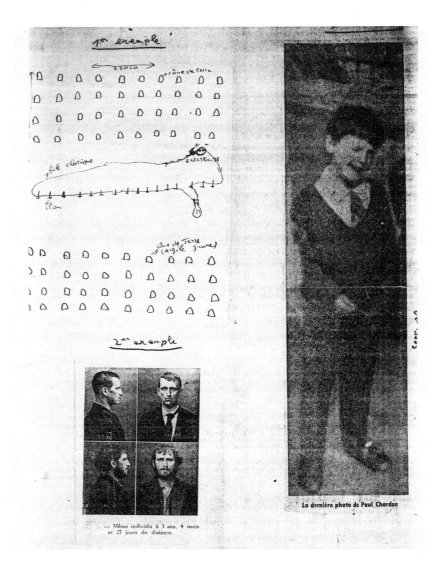

what their relationship was to the drawing would eventually become, as he said, evident. In the meantime, he was exploring options and techniques, searching for the means to express what would become an enduring conviction about the inherent absurdity of artistic expression in particular, and of life in general. To communicate this conviction, he would initially reprise (and, in some cases, develop), in visual terms, many of the devices favored by the dramatists of the Theater of the Absurd: meaningless repetitive activity (of which his cones of earth are a good example), illogic, mime, black humor, and circus clowning, to name a few. But a

5. *Lettre manuscrite dans laquelle j'explique les directions contradictoires dans lesquelles mon travail s'engage* (Handwritten letter in which I explain the contradictory directions of my work). Mail art, 16 June 1970.

conflicting need to distance himself from the often difficult subjects he undertook would force him to look further.

To this end, photographic documents and amateur snapshots, he realized, provided an abundance of prefabricated materials that he could powerfully manipulate. He was attracted to photographs, he has said, because they are "perceived as truthful, as a proof that the event they picture is real; they give the illusion of reality."[5] Part of that illusion proceeds from the uses to which they have been put, in particular, from their role as forensic and scientific documentation. In addition, a photograph is rarely encountered on its own; it is usually accompanied by a caption that "identifies" what it pictures. As the examples from the letter indicate, Boltanski recognized early on how strong is the fraternity between text and image. Indeed, the snapshot of the young boy was so emotionally wrenching precisely because its caption identified it as the "last" one of him to be taken. The implication that the boy was either missing or dead was especially appealing to Boltanski, who once observed that photography "seizes a moment in life and is its death."[6] While this is a notion that others have explored, none have recast it, as he has, into such a central component of their art. In much of his work, Boltanski mines photography's dark underside, finding and reprinting existing images that powerfully summon the medium's omnipresent specter of death. Moreover, his choice of a photograph of a young boy—Paul Chardon cannot be much older than seven or eight—also discloses his fixation (some might say obsession) not only with images of children but, as will become evident, with childhood itself. For Boltanski, however, our childhoods are not idealized passages into adulthood, but instead, the first parts of us to die.

While the subjects of childhood and death have formed the creative reservoir from which he has drawn to make his work, they are not his sole preoccupations. Much of his early work—as his "desperate" plea for help demonstrates—took as its subject his life. Boltanski's many reflections mirrored in his art could easily lead to accusations of narcissism. Rather, Boltanski parodies narcissism, inviting not admiration but ridicule. He has appeared innumerable times in his own artworks, often in comic or ironic guises. When playing the buffoon, he opens himself up to jeers and derision; unafraid of looking foolish, he has enabled us to laugh at ourselves.

Thus his life—or rather a mythologized version of it —has become part of his art. That neither one is entirely what it seems is revealed in a confession he makes that, over the years, he has often lied. "A large part of my activity has to do with the idea of biography," he has said, "but biography that is totally false, and that is presented as false, with all kinds of false evidence. You find this throughout my life: the nonexistence of the person in question. The more people speak of Christian Boltanski, the less he exists."[7] Fact and fiction are further con-

fused by his uncanny ability to repeat himself almost verbatim. In many interviews he has given over the last twenty years, he has repeated practically word-for-word the same examples or metaphors to illustrate stories that have become almost legendary. Spinning an engaging tale out of facts, half-truths, and falsehoods, he has also created an "official" biography for himself. This "biography" chronicles the exhibition history and artistic aspirations of "C. B." (the initials serving as a transparent alias) and uses illustrations which, like many of the artworks themselves, consist of small, out-of-focus or marred black-and-white photographs. By insisting that this formula appear in all major catalogues of his work, slightly revised and updated each time, Boltanski has contrived to confer upon it the status of fact.[8]

For Boltanski, the artist is someone who holds up a mirror so that others can recognize themselves. In so doing, of course, he also obscures himself. This simultaneously self-revealing and self-obscuring act figures among the paradoxes Boltanski dramatizes in his art. It suggests that the Christian Boltanski we have come to know is an artful construct, an out-and-out fiction that underscores the impossibility of ever really knowing anyone else, as well as the never-ending struggle to understand ourselves. It also suggests just how much a desire for meaning makes us susceptible to illusion. The willful contradictions evident in both his art and his life have led some art critics to charge him with ambivalence. In fact, Boltanski embraces ambivalence, acknowledging that nothing in life or art is ever black or white, that both are fraught with ironies and inconsistencies. This he does by performing a delicate balancing act between comedy and tragedy, truth and deception, sentimentality and profundity. That his art is so moving—making us laugh and cry at the same time—while freely admitting to its own manipulations and calculations is due, in part, to its seductive intelligence. That this profundity is merely a shadow cast by illusion is its central, inescapable truth.

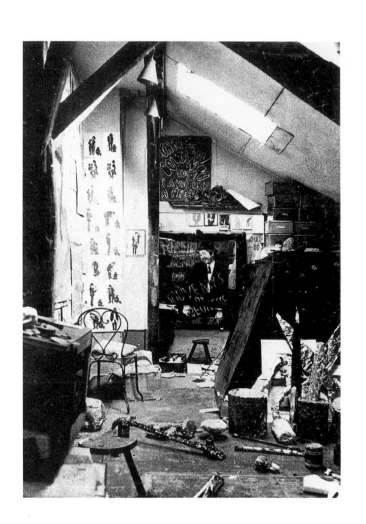

THE EARLY WORK

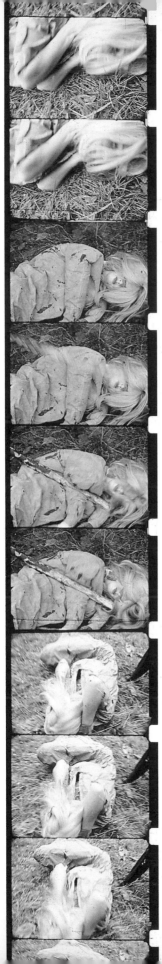

The work of Christian Boltanski, it has been observed, is emblematic of experimental art of the past few decades, a claim he himself is quick to affirm.[9] Like many other conceptually oriented artists of the period, he has made a practice of challenging fundamental assumptions about what constitutes an artwork. Like the others, he has also worked with media combinations that often defy categorization. In Boltanski's case, the list is especially impressive, including as it does painting, mail art, film, video, performance, photography, and installations, which he has combined in one way or another over the years. In keeping with a lot of avant-garde work of the time, many of Boltanski's early pieces—in particular, those dating from the late sixties and early seventies—were also shown outside of traditional art institutions.

Much of this early work was overtly expressionistic. This is especially true of a number of short color films he made in 1969, which were meant to be inserted without explanation into screenings of commercial films. Unschooled in the cinematic arts, Boltanski made the films at home or nearby with the help of his family and friends. Brutal, violent, yet obviously staged—they used masked actors and crude, life-size dolls fabricated by Boltanski—the films flashed by so quickly that, true to the artist's intention, they left viewers feeling uneasy, even vaguely terrorized. The eighteen seconds of *Tout ce dont je me souviens* (All I remember), for example, seemed to record a violent murder. "One has the impression," he wrote, "that a man kills a woman by hitting her with a stick, but it happens so quickly, it almost seems that one didn't see it."[10] In another film, descriptively titled *L'Homme qui tousse* (The man who coughs), a seated figure in a narrow, attic-like room incessantly coughed up a river of blood. Primitive and amateurish though they were, these brief movies were so successful at conveying their intense, if gruesome, scenes that they attracted attention at several international film festivals at the time.

The ungainly dolls Boltanski used as props in his films resemble the figures that populate his early paintings. These efforts—Boltanski dates his career from 1958, when he contends that he began to paint—occupied him for some ten years, but were routinely rejected when submitted to the annual "Salons de Jeune Peinture." Few of them survive. One that does, entitled *Entrée des Turcs à Van* (The entry of the Turks into Van), dates from the summer of 1961 and is a large painting (approximately three by six feet) of a fierce battle in a city. In the center of the work, an immense figure appears to float helplessly on its side with its arms extended in a gesture of supplication and surrender. Similarly cloaked in despair, two other figures enter from the lower right-hand side of the work, while another bicycles out of the scene at the top. All four are apparently the targets of a monstrous soldier who, armed and dangerous, dominates the upper left-hand corner of the panel. A Chagallesque lack of

p. 14:
6. Christian Boltanski's studio in 1974.

7. *Tout ce dont je me souviens* (All that I remember). Color film, 1969.

16

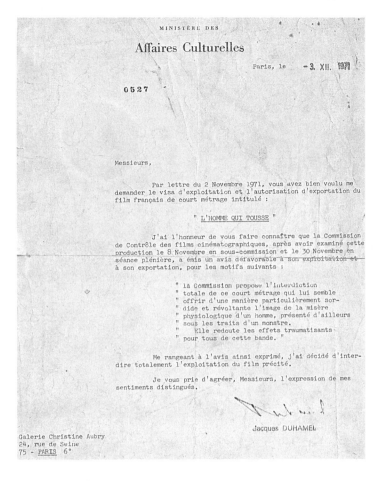

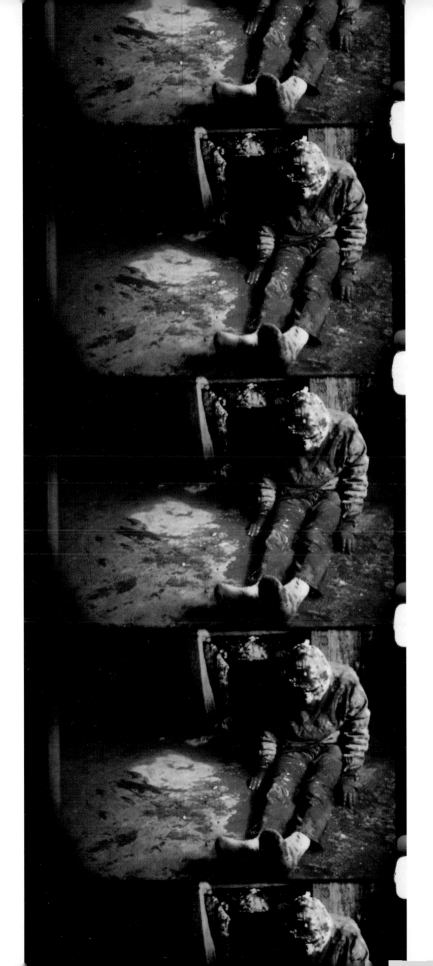

8. Rejection letter
concerning both the
distribution permit and the
exportation visa for the film
L'Homme qui tousse.

9. *L'Homme qui tousse*
(The man who coughs).
Color film, 1969.

modeling and perspective contributes to the sense of turmoil and pandemonium.

Artistically and otherwise, Boltanski was an autodidact. His only formal training had consisted of short stints at the Académie Julien and the Grande Chaumière in Paris. His general education was disrupted at age eleven, when he began to stay home from school and was instructed instead by his family, his older brother and mother in particular. About this period he has said:

> I remember the years just after the war, when anti-Semitism was still strong in France, "feeling . . . different from the others." I fell into such a state of withdrawal that at age eleven I not only had no friends and felt useless, but I quit school, too. One day, my brother congratulated me on one of my drawings and that was enough to convince me that I, too, was good for something; then I started painting without respite. . . . I chose religious or historical subjects (for instance, the Turkish massacre of the Armenians), with lots of figures in large formats on plywood. . . ."[11]

Panoramic scenes of mass confusion and disaster, such as the *Entrée des Turcs*, soon gave way to studies of more individuated forms of violence, such as eviscerated figures on surgical-like tables or in coffins and, finally, to the pursuit of similar themes in other forms.

Boltanski's first solo exhibition took place in Paris, in May 1968, at a commercial cinema called Le Ranelagh in the sixteenth arrondissement. In the lobby, he displayed several large, roomlike structures and, in the balcony above,

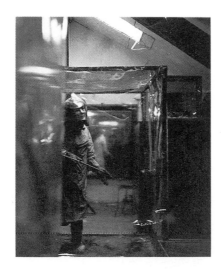 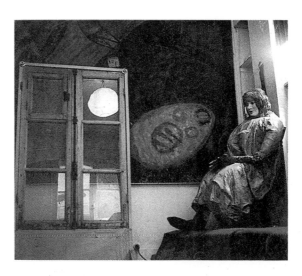

10. 11. Two views of Christian Boltanski's studio in 1967.

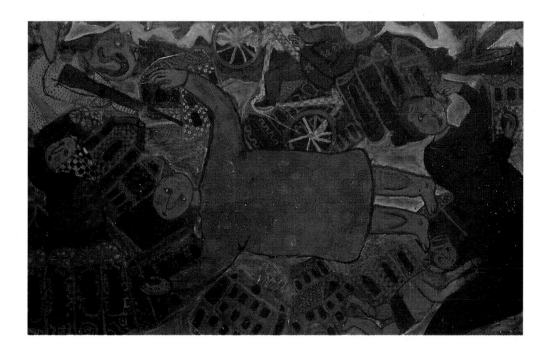

12. *L'Entrée des Turcs à Van*
(The entry of the Turks into
Van). 1961.

hung paintings from the previous year. One structure, which could be entered, seated six or seven, including a few of the lifesize dolls. His first film, *La Vie impossible de Christian Boltanski* (The impossible life of Christian Boltanski), which also provided the exhibition's title, was screened on its back wall. Like the others, this movie employed live actors in a surreal setting interacting with crude dolls, but it ran for a full twelve minutes.

The exhibition coincided with the *événements de mai*, the student demonstrations that gripped not only Paris but Berlin, Rome, and Turin as well. These disturbances, along with a series of subsequent strikes, were evidence of a desire—among the young, at least—for a system-wide cultural transformation. Many artists too felt a need for change that led them to explore, in critic Germano Celant's words, "anti-logical methods in an attempt to dismantle the rigid codifications of art." Believing in "the continuum between diverse elements . . . [artists] set off a chain reaction which chipped away at, and ultimately destroyed, the separate structures of the context of 'art,' making impossible any orderly return to the schematic, reductive methods previously extolled by the artistic establishment."[12] One result of this ferment was that many artists—Boltanski among them—quit painting and embarked on an extended inquiry into the meaning and purpose of art.

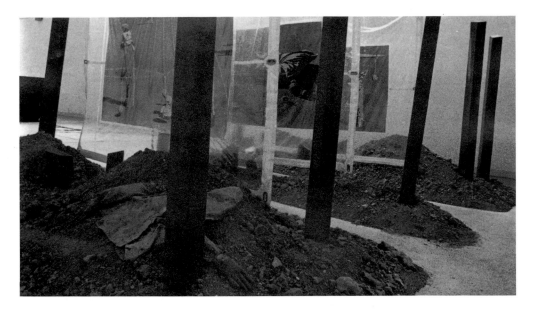

13. *La Concession à perpétuité* (Grant in perpetuity). Installation with Jean Le Gac and Gina Pane. Sixth Paris Biennale, 1969, at Musée d'Art Moderne de la Ville de Paris.

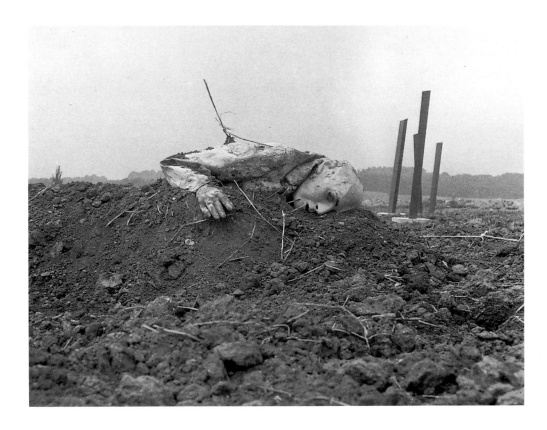

14. *La Concession à perpétuité* (Grant in perpetuity). On-site installation with Jean Le Gac and Gina Pane. Ecos, France, 10 September 1969.

On a practical level, the post '68 art scene in France was both liberating and frustrating. A moribund market and dearth of collectors in this pre-Beaubourg period contributed to an atmosphere in which nontraditional artists were able to escape the heavy and paralyzing mantle of France's rich artistic past. At the same time, it also resulted in, to quote critic Nancy Marmer, "an art of diminished means and reduced expectations." The materials of French experimental work of the late sixties and early seventies "tended to be meager, its present shadowed by its past, its method fraught with paradox."[13] These circumstances notwithstanding, certain artists seemed to delight in their marginalized role, questioning notions of context and value with ephemeral works made from non-art materials. It was within this milieu that Boltanski met a number of like-minded colleagues who later became friends, among them, Jean Le Gac, Paul-Armand Gette, Sarkis, Gina Pane, and Annette Messager.

Though he had met Le Gac in 1966, it was not until 1969 that the two began to work together. That same year, they invited Gina Pane to collaborate with them on a work. The result, entitled *La Concession à perpétuité* (Grant in perpetuity) combined performances and installations in the desolate landscape around Pane's country home with photographic documentation. For his contribution, Boltanski buried one of his dolls in a mound of earth, evoking the surreal violence of his films. Recreated for the Sixth Paris Biennale, *La Concession* won a prize. The documentation was also published in a book and circulated as a mail-art work.

In 1969, Boltanski and Le Gac also organized an exhibition at the American Center, whose director was particularly receptive to experimental activities in the visual and theater arts. In an attempt to radically expand the parameters of an art exhibition, they decided to invite some twenty artists to make pieces at the Center during the month of October. By exhibiting the artists working, rather than the completed results, they wanted to emphasize the importance of the process over the end product. For "Works in Progress," as the exhibition was called, Boltanski planted and then unearthed a thousand or so pink sticks in the Center's garden.[14]

This kind of repetitious activity was not new for Boltanski. Around the same time and over a period of approximately two months, he had made over three thousand balls out of dirt, some of which he used in installations. In 1971, he also set himself the task of carving over nine hundred cubes of sugar into abstract shapes without repeating any of the designs. The impossibility of creating a perfect sphere, which the first project was meant to illustrate, also suggested the absurdity inherent in both life and art. "I think," he said in 1971, "that all human activity is stupid. Artistic activity is also stupid, but you can see it more clearly. A man who tries to paint portraits of his brother over twenty-five years and who

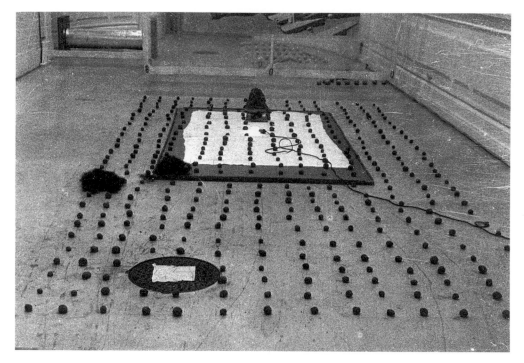

15. Installation view, Sixth Paris Biennale, "Jeunes artistes à Paris" (Young artists in Paris) at Palais Galliera, 1969.

16. *Les Sucres taillés* (Carved sugar cubes). 1971.

completely fails at it seems more idiotic than a man who practices medicine, although it's almost the same thing. But what seems marvelous to me is the striving—is the hoping to succeed in the full knowledge that you are not going to succeed, because you hope to succeed anyway. It's a kind of struggle to live, or a struggle to protest against the fact of dying; a protest against the fact of living."[15] By making artworks out of materials that clearly would not endure, Boltanski was also caricaturing artists who attempt to cheat death through their works. The absurdity of the tasks Boltanski set for himself and the fact that the results were almost guaranteed to self-destruct drove his point home.

The expressionistic tenor of his films and paintings and the obsessive nature of his balls of dirt and sugar cubes came together in a macabre way in another, more sinister series. In 1970, Boltanski began to fabricate hundreds of small knives and booby traps. The knives were fashioned from razor blades and needles and then attached to wooden handles, and the booby traps from needles sticking out of various small contraptions. Adding a poignant note, he wrapped the handles of the knives with strips of white cloth, which gave them the air of bandaged limbs or miniature, swaddled corpses.

Around this time, Boltanski also began to make artists' books, using a photocopy machine that Claude Givaudan, a sympathetic gallery owner, had made

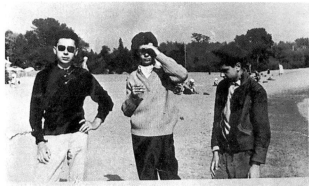

ils se sont fait photographier sur la plage. celui qui
est au centre a une casquette de marin, il met la main
devant ses yeux, celui qui se trouve à gauche de l'image
a un pullover foncé et la main sur la hanche; celui qui
est à droite, c'est le plus jeune, il doit avoir 13 ou
14 ans, porte un blouson. ils ont le regard fixé devant
eux à l'exception du plus jeune qui regarde vers la
droite; son visage qu'on ne voit que de profil semble
concentré vers quelque chose que nous ne discernons
pas.
christian boltanski et ses frères 5/9/59

17. *Christian Boltanski et ses frères, 5/9/59* (Christian Boltanski and his brothers, 5/9/59). Mail art, 9 October 1970.

18. *Fabrication et envoi de 60 petits sachets en drap blanc contenant des cheveux* (Fabrication and mailing of 60 small sachets of white sheet containing hair). Mail art, September-October 1969.

available to artists. This medium offered him an inexpensive and practical way to continue to explore his interest in storytelling. The book format, Boltanski also realized, represented an effective way to capture, in another form, the narrative impulse of his paintings and his films. Perhaps more importantly, it also initiated what would become an enduring fascination with another medium: photography.

His first book, *Recherche et présentation de tout ce qui reste de mon enfance, 1944-1950* (Research and presentation of everything that remains from my childhood, 1944-1950), was produced at Givaudan's gallery in May 1969 in an edition of 150 and sent out as mail art. It also was the first of many efforts to reconstruct his youth. Ostensibly autobiographical (like the film *La Vie impossible*), and held together with a plastic clip, the nine-page book included snapshots of family outings, Boltanski's 1951 class portrait, photographs of his childhood bed and a shirt he had worn, and a tattered page from a school essay. These amusing, yet moving photos and artifacts were reproduced as crude black-and-white images lacking in any tonal values. Described by Boltanski as a "search for a part of myself that had died away, an archeological inquiry into the deepest reaches of my memory,"[16] the book quickly led him to the discovery that very little evidence remained from his childhood. Indeed, though it was nowhere

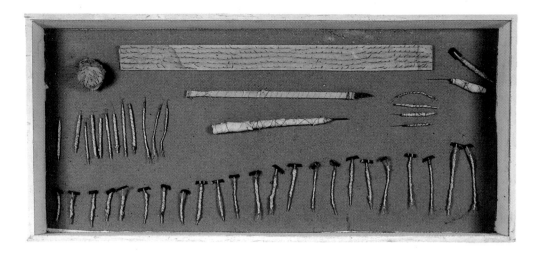

19. *Vitrine de référence*
(Reference vitrine). 1970.

mentioned, most of the objects pictured in *Recherche et présentation* were not even his own, but rather his nephew's, marking the first time he would use photography and misleading captions to illustrate that a picture can deceive. In addition, this book, along with other mail-art works, gave notice that a self-mythologizing project was under way, since it began to document the existence of a character conveniently called "Christian Boltanski." For example, readers learned from it that young Boltanski spent a day at the beach on 5 August 1945 and that he traveled by car to Le Lavandou in Var in 1948. They also learned that two-year old Christian played with blocks that the adult Boltanski found again in 1969.

This "autobiographical" effort was followed six months later by *Reconstitution d'un accident qui ne m'est pas encore arrivé et où j'ai trouvé la mort* (Reconstruction of an accident that hasn't happened yet and in which I met my death), a six-page book that claimed to document the future—in this case, Boltanski's own death in a bicycle accident. Among the documents it provided were Boltanski's emergency health card, an identity photo, a diagram reconstructing the scene of the accident on Avenue Jean-Jaurès, and a photograph of the police outline of the body on the street. If nothing else, this was a clear warning to readers that they should not always believe their eyes, and especially not where Christian Boltanski was concerned.

In November 1970, turning his attention away from providing documentation of either his future demise or his past childhood, Boltanski began to reconstruct

On ne remarquera jamais assez que la mort est une chose hon-
teuse. Finalement nous n'essayons jamais de lutter de front, les
médecins, les scientifiques ne font que pactiser avec elle, ils luttent
sur des points de détail, la retardent de quelques mois, de quelques
années, mais tout cela n'est rien. Ce qu'il faut, c'est s'attaquer au
fond du problème par un grand effort collectif où chacun travaillera
à sa survie propre et à celle des autres.

Voilà pourquoi, car il est nécessaire qu'un d'entre nous donne
l'exemple, j'ai décidé de m'atteler au projet qui me tient à cœur de-
puis longtemps : se conserver tout entier, garder une trace de tous
les instants de notre vie, de tous les objets qui nous ont côtoyés, de
tout ce que nous avons dit et de ce qui a été dit autour de nous, voilà
mon but. La tâche est immense et mes moyens sont faibles. Que
n'ai-je commencé plus tôt ? Presque tout ce qui avait trait à la pé-
riode que je me suis d'abord prescrit de sauver (6 septembre 1944 -
24 juillet 1950) a été perdu, jeté, par une négligence coupable. Ce
n'est qu'avec une peine infinie que j'ai pu retrouver les quelques élé-
ments que je présente ici. Prouver leur authenticité, les situer exacte-
ment, tout cela n'a été possible que par des questions incessantes et
une enquête minutieuse.

Mais que l'effort qui reste à accomplir est grand et combien se
passera-t-il d'années, occupé à chercher, à étudier, à classer, avant
que ma vie soit en sécurité, soigneusement rangée et étiquetée dans
un lieu sûr, à l'abri du vol, de l'incendie et de la guerre atomique,
d'où il soit possible de la sortir et la reconstituer à tout moment, et
que, étant alors assuré de ne pas mourir, je puisse, enfin, me re-
poser.

Christian Boltanski
Paris, mai 1969

20. Text by Christian Boltanski on the flyleaf of the original edition of the artist's book *Recherche et présentation de tout ce qui reste de mon enfance, 1944-1950* (Research and presentation of all that remains from my childhood, 1944-1950). May 1969.

experiences he had actually had—or claims to have had—in book form. *Reconstitutions des gestes effectués par Christian Boltanski entre 1948 et 1954* (Reconstructions of gestures made by Christian Boltanski between 1948 and 1954), published in an edition of five hundred, offered a series of comic photographs featuring an obviously adult Boltanski recreating everyday episodes from his childhood. "Reconstitution V," for example, showed him sliding down a bannister on 6 July 1951, as the caption read, and "Reconstitution VII" pictured him coming home from classes on the afternoon of 10 February 1953, school bag in hand.

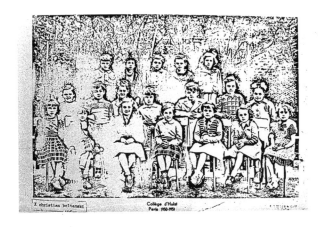

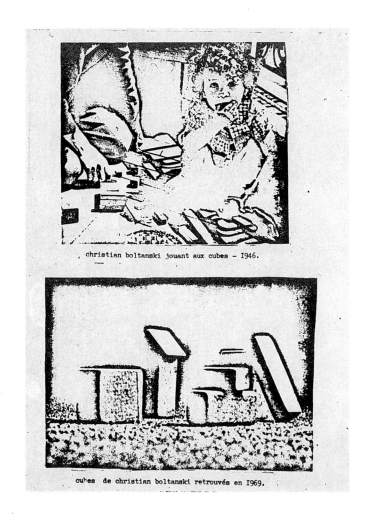

christian boltanski jouant aux cubes - 1946.

cubes de christian boltanski retrouvés en 1969.

page 69 du livre de lecture de christian boltanski - 1950.

21. 22. 23. Pages from the artist's book *Recherche et présentation. . .*

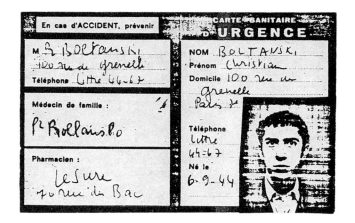

Dernière photo de Christian Boltanski

Traces de pneus consécutives au brusque coup de frein

24. 25. 26. Cover
detail and pages from
the artist's book
*Reconstitution d'un
accident qui ne m'est
pas encore arrivé et
où j'ai trouvé la mort*
(Reconstruction of an
accident that hasn't
happened to me yet
and in which I met
my death).
November 1969.

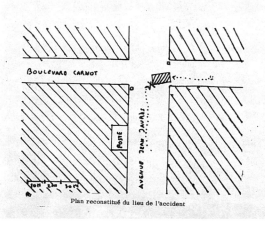

Plan reconstitué du lieu de l'accident

Relevé fait à la craie de la position du corps

His attempts to recoup as much as possible of his childhood included the recreation of past artifacts that had been lost or destroyed. In 1971, Boltanski began a series entitled *Essais de reconstitution d'objets ayant appartenu à Christian Boltanski entre 1948 et 1954* (Attempts to reconstruct objects that belonged to Christian Boltanski between 1948 and 1954). In a deliberately clumsy fashion, he reconstructed some of his lost toys, utensils, and clothing using Plasticine (an oil-based clay), often making multiple versions of each object, which he then displayed in crude tin drawers covered with wire mesh. Doomed from the start, these obsessive attempts "to get it right" blatantly stated that the reconstructions were neither the original items nor the memories he claimed they were.

At the same time that Boltanski was trying to reconstitute his childhood, he was also becoming more interested in how his work was displayed and presented. For a two-person show with Sarkis at the Musée d'Art Moderne de la Ville de Paris in September 1970, he decided to exhibit some of the knives and traps he had been making. He arranged them, row after row, in glass vitrines, like artifacts excavated from the ruins of a lost civilization. This orderly presentation in museum showcases not only displaced their potential function as tiny torture instruments, but also suggested natural science and archaeological museums, sites where Boltanski would later exhibit with Le Gac.

Display cases inspired another series of works generically titled *Vitrines de référence* (Reference vitrines), which Boltanski began in 1970 and produced sporadically through 1973. Several were first shown at the Grand Palais in 1972 in an exhibition entitled "Douze ans d'art contemporain en France" (Twelve years of contemporary art in France). Again borrowing several museum-type vitrines,

27. 28. Double-page spreads from the artist's book *Reconstitution de gestes effectués par Christian Boltanski entre 1948 et 1954* (Reconstruction of gestures made by Christian Boltanski between 1948 and 1954). November 1970.

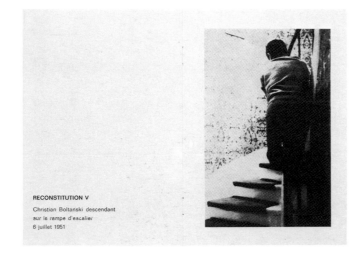

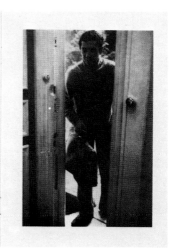

RECONSTITUTION V
Christian Boltanski descendant
sur la rampe d'escalier
6 juillet 1951

RECONSTITUTION VII
Christian Boltanski rentrant de classe
10 février 1953

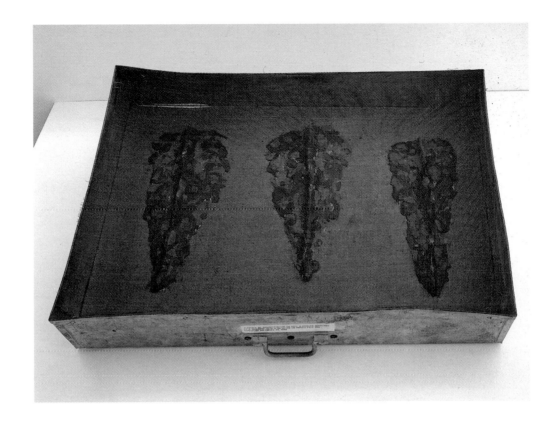

29. *Essais de reconstitution d'objets ayant appartenu à Christian Boltanski entre 1948 et 1954* (Attempts to reconstruct objects that belonged to Christian Boltanski between 1948 and 1954). 1970-1971.

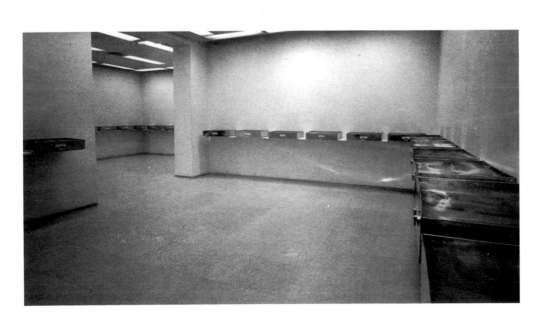

30. Installation view, "Reconstitution," Galerie Sonnabend, Paris, 1971.

he arranged in them a sampling of the work he had made since 1969—for example, small piles of the dirt balls, several of the knives and traps, pages from his books, and parts of mail-art pieces. Some of them were the only remaining evidence of pieces that no longer existed. Each item was identified with a small typed label that usually listed the date and title of the work. By carefully labeling and preserving his work, Boltanski not only became his own archivist; he preempted the role of a museum by appropriating its function.

But Boltanski was once again not entirely in earnest. His arrangements and labels had a decidedly homemade feel to them—the labels did not conform to a standard format and the placement of items was often amateurish and off-balance—which belied their institutional origin. This deliberately clumsy quality seemed to reveal a painful vulnerability. It was also signature Boltanski. Now as then, his seeming delight in the ad-hoc and the handmade has led him to reject methods and techniques that assure regularity and finish. The life of his works, like that of their maker, he suggests, is fragile and destined to decay.

The seemingly objective, museological vitrine was, without a doubt, a more removed and calculating approach to art-making than the full-fledged expressionism of his paintings and films. By holding his own work at a distance, in much the same way that he observed himself pleading for help by writing the same letter over and over again, Boltanski had found an effective way to insert a protective barrier between himself and the sometimes painful content of the earlier work. Moreover, by placing bits and pieces of his own work in the *Vitrines de référence*, he not only recuperated incidents and memories from his own life but began to recycle older pieces in order to create new ones, a technique he would use extensively in later works.

The more distanced methodology of the *Vitrines de référence* was also present in a book he published in May 1970. Entitled *Tout ce que je sais d'une femme qui est morte et que je n'ai pas connue* (Everything I know about a woman who is dead and whom I didn't know), it reproduced five snapshots given to the artist by an acquaintance.[17] Approaching the pictures in a quasi-scientific manner, Boltanski tried to determine all he could from them and then to report factually on what he had gleaned in straightforward captions. Or so it seemed. Here, again, Boltanski was exposing the flaws in photography's assurance that it is telling the truth and in the often misleading relationship of text to image. There was, after all, no guarantee that the woman had died or, for that matter, that the snapshots were all of the same woman.

Boltanski's interest in reading the snapshot—in the cultural mores and codes revealed in amateur photography—is not unique. As he himself has noted, developments in the social sciences in the sixties and seventies helped to foster

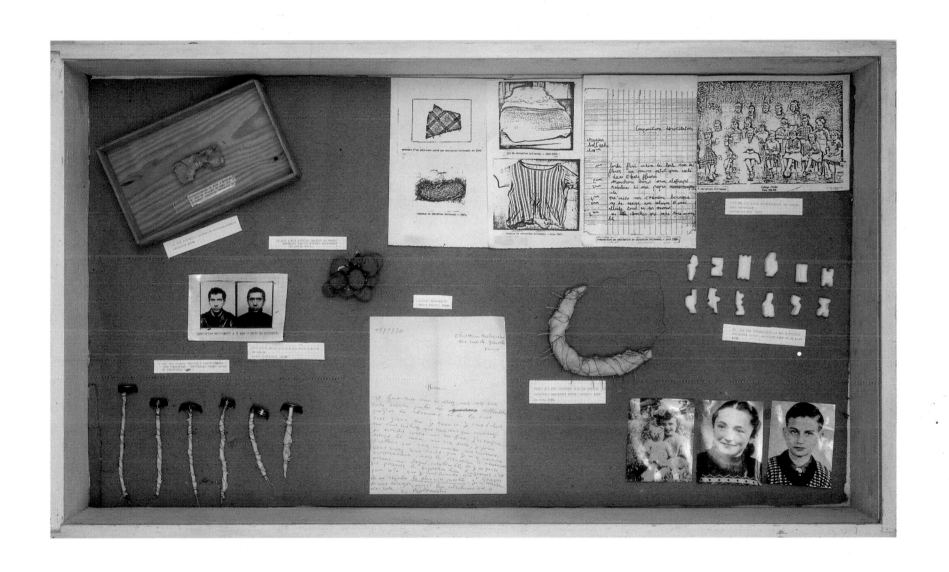

31. *Vitrine de référence* (Reference vitrine). 1970.

32. View of gallery at the Musée du Trocadéro (now Musée de l'Homme), 1935.

a growing awareness of the significance of the artifacts of everyday life and of social sciences:

> It was . . . the age of technological discoveries, of the Musée de l'Homme and of beauty, no longer just African art, but an entire series of everyday objects: Eskimo fishhooks, arrows from the Amazon Indians. . . . The Musée de l'Homme was of tremendous importance to me; it was there that I saw large metal and glass vitrines in which were placed small, fragile, and insignificant objects. A yellowed photograph showing a "savage" handling his little objects was often placed in the corner of the vitrine. Each vitrine presented a lost world: the savage in the photograph was most likely dead; the objects had become useless—anyway there's no one left who knows how to use them. The Musée de l'Homme seemed like a big morgue to me. Numerous artists discovered the human sciences (linguistics, sociology, and archaeology) there. . . .[18]

Boltanski was also able to learn firsthand about these developments from his brothers, one a sociologist, the other a linguist. Although he claims never to have read any of the literature related to their disciplines, he has acknowledged that he discussed issues of the day with them, and that it was they who first introduced him to the Musée de l'Homme in Paris. For example, Luc Boltanski's work with Pierre Bourdieu on *Un art moyen: Essai sur les usages sociaux de la photographie*, a book on the sociology of amateur photography, may have stimulated Christian's own early interest in this theme.[19]

IMAGE I

L'homme a la main posée sur l'épaule de la femme.
La journée est chaude. Le ciel est sans nuages.
Il y a à gauche un grand mur de pierre. La femme
est jeune, elle plie légèrement les yeux. Ils portent
tous deux des costumes de plage clairs. L'homme a
l'air sérieux et protecteur. La plage est de galets.

33. Double-page spread from the artist's book *Tout ce que je sais d'une femme qui est morte et que je n'ai pas connue* (Everything I know about a woman who is dead and whom I didn't know). May 1970.

One work in particular, *Album de photos de la famille D., 1939-1964* (Photo album of the family D., 1939-1964), from 1971, very clearly shows signs of a Bourdieu-like approach to its material. For it, Boltanski borrowed several boxes of family photos from a friend identified in the work as Michel D., but who was later revealed to have been gallery-owner Michel Durand. After having some 150 of them reshot by a commercial photographer, Boltanski attempted to put them in chronological order—à la *Tout ce que je sais*—in an effort to reconstruct the family's history. To do this, he assigned identities to the various people pictured—for example, he described the older man who appeared only at festive occasions as an uncle who did not live in the immediate vicinity. In a statement about the work, which was shown at Documenta 5 in 1972, Boltanski wrote, "I wanted—I, who knew nothing at all about these people—to try and reconstruct their life on the basis of these pictures which, having been taken at all the important moments, would remain after their death as the evidence of their existence."[20] But, despite all his efforts, Boltanski ultimately learned very little about

the family. That the chronology he devised for them proved wrong confirmed an earlier suspicion: "I realized that these images were only witnesses to a collective ritual. They didn't teach us anything about the Family D. . . . but only sent us back to our own past."[21]

Boltanski exhibited the slightly enlarged, horizontal black-and-white prints in deep, custom-made (though crudely realized) tin frames that were chronologically arranged in rows on the wall. Out-of-focus or awkwardly framed, as most family snapshots are, the individual images had a strange, almost muted pathos when they were displayed as a group. By now it has become almost a cliché to comment on photography's kinship with death. The observation forms one of the underlying premises of a seminal essay by Roland Barthes, *Camera Lucida: Reflections on Photography*, in which he discussed the process of being photographed. Remarking on the sense of inauthenticity it left him with, he wrote that it was as if he were "neither subject nor object but a subject who feels he is becoming an object: I then experience a micro-version of death (of parenthesis): I am truly becoming a specter."[22] Part of *Famille D.*'s effectiveness is due, no doubt, to the fact that for those who share similar cultural backgrounds, certain images trigger collective memories of family gatherings, for example, or holidays at the beach. But part is also due to photography's futile attempt to preserve life. As Barthes has noted, the "*Life/Death*" paradigm, in a photograph, "is reduced to a simple click, the one separating the initial pose from the final print."[23] A second, perhaps more distanced, death may well be evoked when we look at photographs of photographs.

34. Installation view, "Inventar," Hamburger Kunsthalle, Hamburg, Germany, 1991, with *Album de photos de la famille D., 1939-1964* (Photo album of the family D., 1939-1964). 1971 and *Vitrines de référence* (Reference vitrines). 1970-1971.

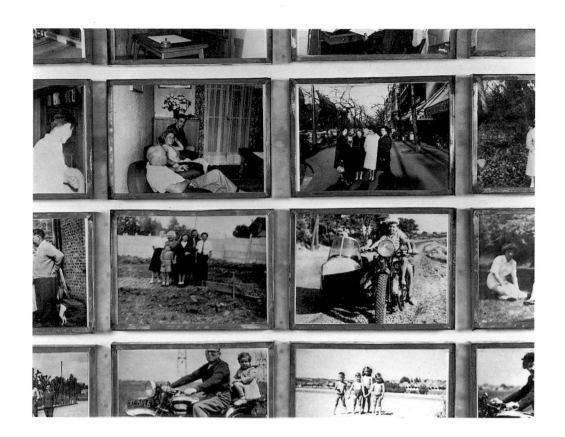

35. 36. *Album de photos de la famille D., 1939-1964.* 1971. Details.

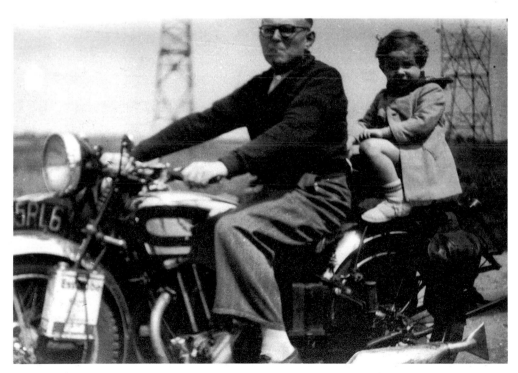

35

37. 38. Flyleaf and inside
page from the artist's book
Le Club Mickey (The Mickey
Mouse Club). 1990.

A family's snapshots, which usually record personal memories and events,
are viewed differently when exhibited on the walls of a museum. Not only is
that which is normally private made public, but it is exposed to aesthetic
scrutiny and judgment as well. Interestingly, the photographs comprising
Famille D. were not printed from the original negatives but were enlarged from
copy negatives. The loss of definition and precision that occurs with second-
generation prints—exemplified in Boltanski's rephotographed snapshots—
reminds us of the medium's capacity to generate endless copies of its results and
of another potential invasion of privacy.

Boltanski continued to appropriate amateur photographs in another piece,
Les 62 membres du Club Mickey en 1955 (The 62 members of the Mickey Mouse
Club in 1955). From 1972, it also consisted of black-and-white prints displayed
in tin frames. This time, though, the appropriated images were already second-
generation, having been taken from a children's magazine that Boltanski claimed
to have kept since he was a child. Rephotographed, the children's faces had a
crude, documentary air, the result of the broad-screened half-tone process.
About them, Boltanski wrote:

> I was eleven years old in 1955 and I resembled these sixty-two
> children, whose photos were pictured in that year's Mickey
> Mouse Club magazine. They had each sent in the picture that,
> in their opinion, represented them best: smiling and well-
> groomed or with their favorite toy or animal. They had the same
> desires and the same interests that I did. Today they must all be
> about my age, but I can't learn what has become of them. The
> picture that remains of them does not correspond anymore with
> reality, and all these children's faces have disappeared. . . .[24]

39. 40. *Les 62 membres du
Club Mickey en 1955* (The
62 members of the Mickey
Mouse Club in 1955). 1972.
Overall view and detail.

As it turned out, *Club Mickey* was the first of many works in which Boltanski used images of children other than himself or his family. His interest, however, was not so much in portraying childhood *per se* or in triggering collective memories, but rather in using photography's connection to death to dramatize that the children pictured in 1955 no longer existed. They, like little Paul Chardon, whose image was featured in Boltanski's 1970 mail-art letter, underscore the disturbing realization that the children we once were are also no more.

Boltanski addressed similar themes in a related work from the following year, *Portraits des élèves du C.E.S. des Lentillères en 1973* (Portraits of the students of the Lentillères College of Secondary Education in 1973). For this public project in the outskirts of Dijon, museum curator Serge Lemoine commissioned the young artist to make a work in the C.E.S. Lentillères. Boltanski then asked the students to give him their favorite pictures of themselves and, again, had the assortment of snapshots and school portraits he collected rephotographed. Arranged frame-to-frame along the corridor at the school's entrance, the portraits filled every inch of available space. The result recalled the ex-voto plaques that line the walls of sanctuaries or niches in a columbarium. *Horror vacui* and repetition, as Lemoine has noted, are key characteristics of Boltanski's artistic vocabulary.[25]

Given the close connection between his art and his life, it is possible to see the *Famille D., Club Mickey,* and *C.E.S. Lentillères* as Boltanski's attempts to appropriate a normal, bourgeois childhood for himself—another impossible undertaking. Whether this is true or not, that Boltanski resembled the smiling children in *Club Mickey*, as he had claimed, seems very unlikely. He was the youngest son of a highly intellectual, but eccentric, family. Deeply unhappy and "feeling different from the others," he quit school altogether at the age of fifteen. The family's difference apparently extended beyond his father's Jewish origins. According to Boltanski, his father, a well-known medical doctor, often refused to venture out alone, and his mother, a writer who published under the pseudonym of Annie Lauran, accompanied her youngest son everywhere he went until the artist was in his twenties. These circumstances, in combination with his own account of why he left school, would by themselves seem to suggest that his childhood was anything but normal.

Societal definitions of normality and the often deceptive nature of outward appearances were, in part, the inspiration for a work initially titled *Images d'une année de faits divers* (Images from a year of news items) that Boltanski made between 1972 and 1973. For this piece, he simply clipped 408 images of criminals and their victims from *Détective*, a weekly tabloid that focuses primarily on grisly tragedies (and which also provides the work with its alternate, more widely used title). Glued on gray paper and tacked simply, one atop another, to

41. *Portraits des élèves du CES des Lentillères* (Portraits of the students of the Lentillères College of Secondary Education).1973. Permanent installation at the Lentillères College of Secondary Education, Dijon.

the wall, the images, by their sheer number, have the effect of being overwhelming—their collective mass belying their inordinately modest means.

Like most tabloids, *Détective* illustrates its stories with family snapshots that are often the only existing photographic record of individuals whose victimization or criminal actions have thrust them into the public eye. What attracted Boltanski to these images was the fact that, once a photograph was separated from its caption, it was impossible to distinguish victim from criminal. Even

39

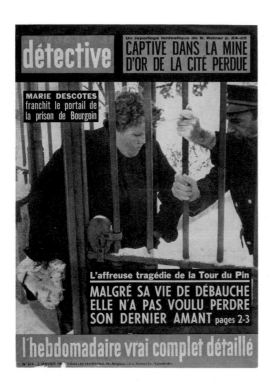

42. Cover of the weekly
Détective magazine (Paris).

images of children—of those we are most likely to assume have been caught up in some terrible tragedy—could very easily have been youthful shots of the boy next door who had, inexplicably it seems, gone wrong. Just as the photographs of *Famille D.* could have been taken by families such as our own, Boltanski seemed to imply, the murderers illustrated in *Détective* could well have been our relatives or, for that matter, ourselves.

Around the same time, Boltanski initiated a series of installations generically titled *Les Inventaires* (Inventories). Inspired, in part, by his father's story about a pair of shoes that had kept the shape of his grandfather's feet after his death, the installations were supposed to display all the possessions of someone who had recently died. The series had its genesis in Boltanski's third and last "*lettre manuscrite*," which was titled *Je me permets de vous écrire pour vous soumettre un projet qui me tient à coeur . . .* (I am writing to you in order to propose a project that is very close to my heart . . .) and dated 3 January 1973. He penned the letter by hand sixty-two times, he claims, and sent it to natural history and science museums, as well as to a few contemporary art curators who were familiar with his work. "I would like you to present," he wrote,

in one room of your museum all of the elements that surrounded

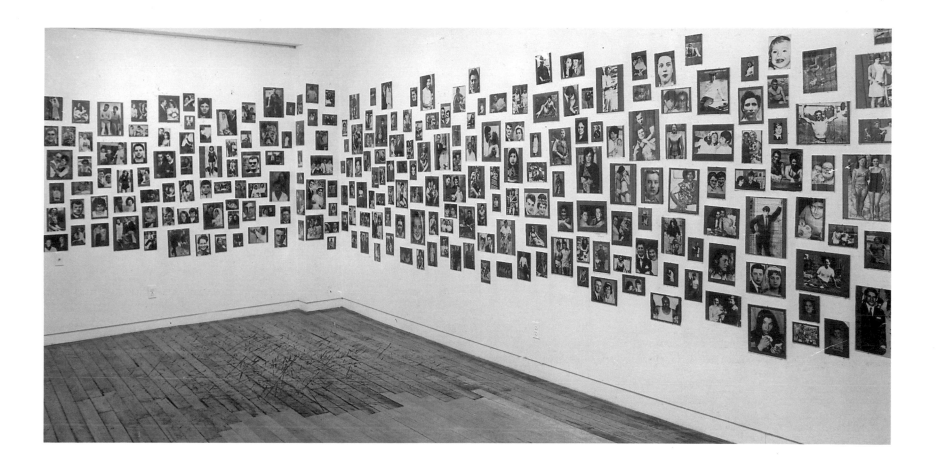

43. *Images d'une année de faits divers* (Images from a year of news items). 1973. Installation view, Sonnabend Gallery, New York, 1973.

a person during their life and which, after their death, remain the witnesses of their existence; these objects could include, for example, everything from the handkerchiefs they used to the wardrobe in their room. All of these elements should be presented in vitrines and carefully labeled.

Among the first to reply, the Staatliche Kunsthalle in Baden-Baden realized Boltanski's project as he had envisioned it, purchasing and exhibiting the effects of a woman who had recently passed away. Five other versions, which were mounted between June 1973 and December 1974, all deviated from the original plan. Peter Ibsen, the curator at the Museum of Modern Art in Oxford, for example, took pictures of the effects of a local resident—someone still very much alive but who had moved elsewhere—and sent them to Boltanski. He selected some four hundred images for exhibition. Organized into distinct

3 janvier 1923

Monsieur,

Je me permets de vous écrire, pour vous soumettre un projet qui me tient à cœur et que j'aimerais pouvoir réaliser.

Je voudrais que dans une salle de votre musée soient présentés les éléments qui ont entouré une personne durant sa vie et qui restent après sa mort le témoignage de son existence; cela pourrait aller par exemple des mouchoirs dont elle se servait jusqu'à l'armoire qui se trouvait dans sa chambre, tous les éléments devront être présenté sous vitrine et soigneusement étiquetés.

Je désirerais m'occuper personnellement du classement, de la présentation, ainsi que des recherches à effectuer. D'un point de vue pratique, je pense, que la plupart sinon la totalité de ces objets pourront être facilement rassemblés en faisant l'acquisition globale d'une vente après décès.

En espérant une prompte réponse de votre part, je vous prie de croire, monsieur, à mes sentiments respectueux.

C. Boltanski

VILLE DE GENÈVE

MUSÉE D'HISTOIRE DES SCIENCES
128, RUE DE LAUSANNE
VILLA BARTHOLONI

Monsieur Christian Bolianski
100 rue de Grenelle
Paris

Genève le 10 janvier 1973

Monsieur,

Votre lettre du 3 courant m'est bien parvenue et m'a étonné d'un coté parceque notre musée est entièrement consacré à l'histoire des sciences. Si nous pouvions reconstituer le cabinet de travail ou le laboratoire du 18ème ou 19ème siècle avec le mobilier authentique d'un savant connu, nous examinerions la question avec intérêt. Mais d'acheter n'importe quel mobilier après décès ne nous semble pas indiqué.

D'un autre coté les locaux de notre musée ne permettraient pas une présentation sous vitrines, telle que vous l'envisagez, vu, le manque de place.

Je vous signale que dans cet ordre d'idée le "Musée de l'Horlogerie" récemmenet créé et inauguré à Genève a reconstitué l'atelier d'un artisan-horloger tel qu'il était à son décès, avec mobilier, bibliothèque et gravures. Le résultat est parfaitement réussi.

Regrettant de donner une réponse négative à votre proposition, je vous prie d'agréer, Monsieur, mes salutations distinguées.

Cramer
Conservateur.

Dr P. F. J. A. JULIEN

WASSENAAR, ce 10 Janvier 1973
MARIHOF, SURONTPLEIN 1ª
TEL. 9961, GIRO 77310

M. C. Boltanski
à Paris.

Monsieur,

Votre lettre du 3 janvier , adressée au Conservateur du Nederlandsch Museum voor Anthropologie , dont je suis un des Dirigents, m'est parvenue ce jour.

Je regrette vous faire savoir que notre Musée n'est jusqu'ici qu'une fondation qui a pour but de créer un Musée, mais comme nos moyens sont insuffisants, il est peu probable que nous réussirons dans ce but dans un proche avenir.

Comme le Musée n'existe que sur papier, nous nous trouvons dans l'impossibilité de satisfaire à votre demande.

Veuillez agréer, Monsieur, avec nos regrets, l'assurance de nos sentiments les meilleurs.

Dr Paul Julien

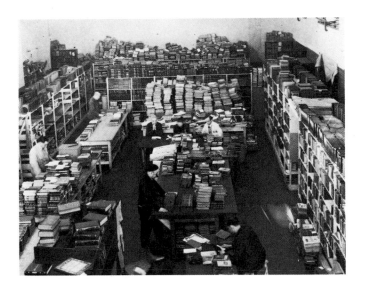

47. Prague, Central Jewish Museum. View of one of the many storage rooms for books confiscated by the Nazis, 1942-1945.

groups, these photographs were then pinned to the museum's walls. In Jerusalem, the Israel Museum mounted an exhibition of 850 belongings but, again, not of someone who had died, but rather of a student who was studying abroad for a year. And at both the Sonnabend Gallery in New York and the Centre National d'Art Contemporain in Paris, Boltanski "cheated," as he later admitted, by borrowing and exhibiting items belonging to personal acquaintances, and in Paris, by even adding a small refrigerator purchased at a flea market.[26]

While the *Inventaires* posed the question of what could be learned about individuals from their belongings, they also addressed the function of museums—in particular, their role in preserving not only paintings and sculptures, but in their galleries of antiquities, everyday domestic objects. "Where does art stop and life begin?" Boltanski asked, referring to another of his projects from this same period. The question was prompted by his work on a film about the donation of Brancusi's studio to the Musée National d'Art Moderne, and that led him to observe: "The studio inventory listed utilitarian objects and artworks without distinguishing between the two. . . . This artist's studio turned into a museum makes us realize that the act of preservation really doesn't preserve anything. . . . As soon as you attempt to protect something, you kill it."[27]

With the *Inventaires*, Boltanski returned to the more detached and by now familiar ethnological approach of the *Vitrines de référence* and *Tout ce que je sais*. When arranged in display cases, the domestic objects were layered with additional levels of meaning, highlighting again what can happen when the pri-

p. 42:

44. *Je me permets de vous écrire pour vous soumettre un projet qui me tient à cœur . . .* (I'm writing to you to propose a project that is very close to my heart . . .). Mail art, 3 January 1973.

45. 46. Two negative responses. January 1973.

48. Cover of the artist's book *Inventaire des objets appartenant à un habitant d'Oxford précédé d'un avant-propos et suivi de quelques réponses à ma proposition* (Inventory of objects that belonged to a resident of Oxford preceded by a preface and followed by some answers to my proposal). 1973.

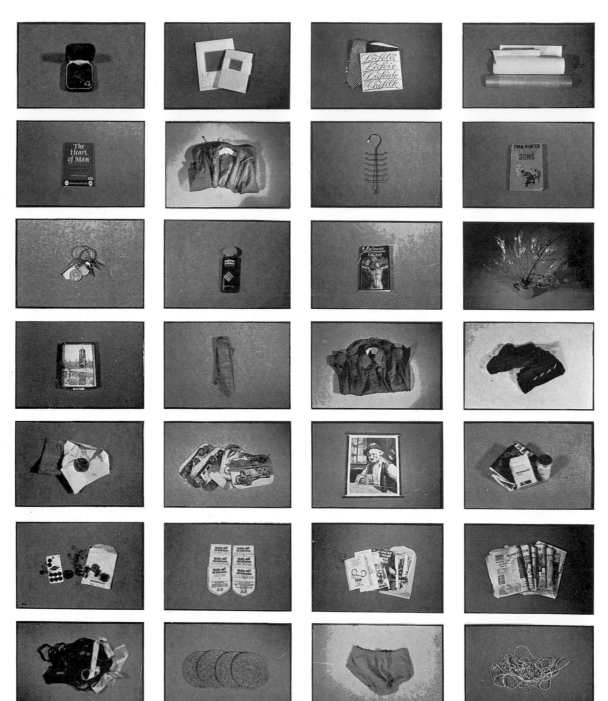

49. *Inventaire des objets ayant appartenu à un habitant d'Oxford* (Inventory of objects that belonged to a resident of Oxford). 1973. Detail.

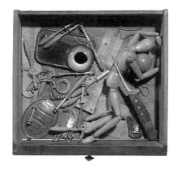

50. Daniel Spoerri, *Autoportrait, les tiroirs* (Self-portrait, the drawers). 1982.

51. Annette Messager, *Les Albums-collections* (The album collections). Artist's personal files. Installation view, "Ils collectionnent" (They collect), Musée des Arts Décoratifs, Paris, 1974.

52. *Inventaire des objets ayant appartenu à une femme de New York* (Inventory of objects that belonged to a woman of New York). 1973. Installation view, Sonnabend Gallery, New York, 1973.

vate is made public. As Serge Lemoine has pointed out, they also recalled similar work by other Conceptual artists of the seventies, such as the *tableaux pièges* (trap panels) of Daniel Spoerri and Arman's "*accumulations*."[28] Boltanski himself has cited the influence of "Ils collectionnent," an exhibition that took place at this time at the Musée des Arts Décoratifs (included in this show was the work of Annette Messager, whom Boltanski met in 1970 and with whom he has lived ever since).[29]

Participating in such influential events as Documenta 5 in 1972 also brought him into contact with the work of other, conceptually oriented artists. Joseph Beuys, especially, whom Boltanski met at the prestigious international exhibition, was to have a marked effect on the young artist. Boltanski's methodical self-mythologizing, embellished and enhanced by (pseudo)autobiographical anecdotes, mirrored Beuys's own tactics. Through his contact with the more sophisticated and worldly Sarkis, who worked at the time at the redoubtable Galerie Sonnabend in Paris, Boltanski also stayed abreast of developments in the international art world. Sarkis introduced him to dealer Ileana Sonnabend, who began showing his work in Paris, and afterward in New York. He also met curator Jean-Christophe Ammann, who soon included him in a group exhibition at the Kunstmuseum in Lucerne.

With the last of what was to be the initial series of *Inventaires*, *L'Inventaire des objets ayant appartenu à une femme de Bois-Colombes* (Inventory of objects

53. Double-page spread from the artist's book *List of exhibits belonging to a Woman of Baden-Baden followed by an explanatory note.* June 1973.

p. 47, top:
54. *Inventaire des objets ayant appartenu à une femme de Baden-Baden* (Inventory of objects that belonged to a woman of Baden-Baden). Installation view, Staatliche Kunsthalle, Baden-Baden, Germany, 1973.

that belonged to a woman from Bois-Colombes), which was shown at the Centre National d'Art Contemporain in Paris in October, 1974, Boltanski executed an ironic sidestep. Aware that much in his work up to that point had focused rather baldly on death, he decided to embark on a new series of works and a new identity—that of a clown. In reality, Boltanski was not straying that far from his old fold. His next show at the Westfälischer Kunstverein in Münster, called "Affiches - Accessoires - Décors" (Posters - Props - Sets), was loosely based on the museum devoted to Karl Valentin, a celebrated German comedian of the twenties and thirties. In it, he displayed all the posters, props, and accessories of a clown dubbed Christian Boltanski who, it was suggested, had died. When, as part of the show, Boltanski himself appeared in a performance accompanied by a ventriloquist's dummy called "Little Christian," the paradoxes once again started to fly. Boltanski's identity as a clown allowed him to poke fun at himself while also undermining highbrow art that takes itself too seriously. In addition, by resurrecting again, in "Little Christian," his childhood self, he reinforced the point that the quest to perpetuate youth usually fools only those who attempt it.

p. 47, bottom:
55. 56. *Inventaire des objets ayant appartenu à une femme de Bois-Colombes* (Inventory of objects that belonged to a woman of Bois-Colombes). 1974. Installation views, CNAC/Centre National d'Art Contemporain, Paris, 1974.

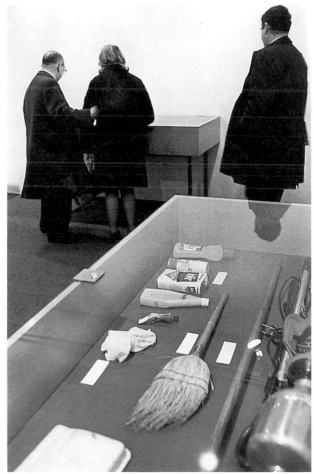

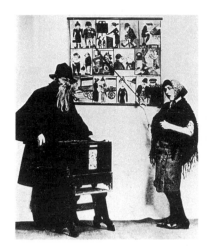

57. 58. The German
comedian Kurt Valentin.

Showcasing the clown's costumes and props were Boltanski's now familiar vitrines. He also exhibited the crudely made sets and props he had fabricated to serve as the backdrops for a new series, *Les Saynètes comiques* (Comic sketches). For it, Boltanski once again photographed himself reenacting events from his childhood. This time, though, he enlarged the cast of characters, playing all the parts himself. The hand-colored or, in another version, unaltered black-and-white photographs, were shown in a sequence, two or three segments to a frame, with captions that described the "tableaux." Against his unsophisticated, two-dimensional sets, Boltanski's costumes did little to disguise or transform him. Always pictured in the same serviceable but inelegant suit, he would merely add a paper flower to his hat when playing his mother or roll up his pants and pull his jacket over his head when he was acting the part of "Little Christian."

All the earmarks of Boltanski's early work thus resurfaced in the *Saynètes comiques*: the exaggerated poses did not recreate real episodes involving his own father and mother but parodied collective notions of parenthood, and the primitive sets obviously represented constructed rather than literal realities. In an interview, Boltanski remarked, "At the time of the *Saynètes comiques* . . . I was asking myself questions about the nature of representation and the double meaning of the verb 'to play.' . . . In a small book of 1974, *Quelques interprétations par Christian Boltanski* (Some interpretations by Christian Boltanski), I ask myself what differentiates the act of someone who drinks a glass of water from an actor's interpretation of someone drinking a glass of water."[30]

The photographic series *Morts pour rire* (Pretend deaths or Deaths for fun) followed the *Saynètes comiques*. With it, Boltanski explored the theme of sui-

59. *Affiches – Accessoires – Décors, documents photographiques* (Posters – props – sets, photographic documents). Installation view, Westfälischer Kunstverein, Münster, 1974.

60. *Affiches: Le Repas refusé* (Posters: The refused meal). 1974.

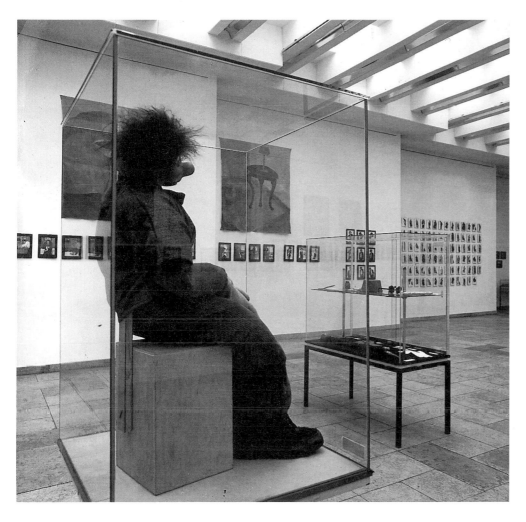

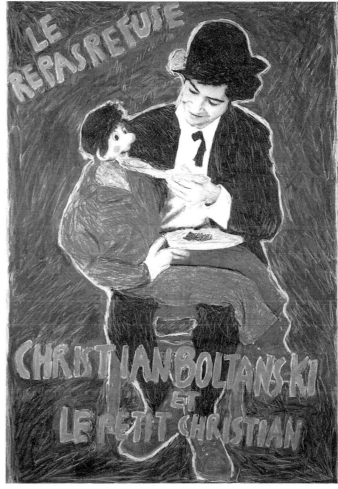

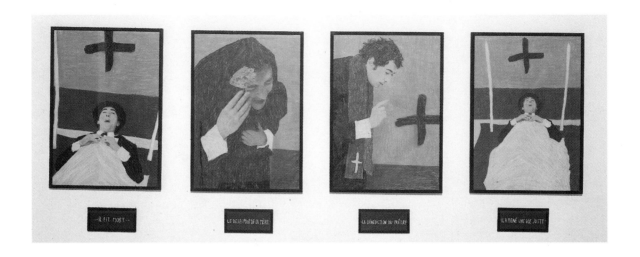

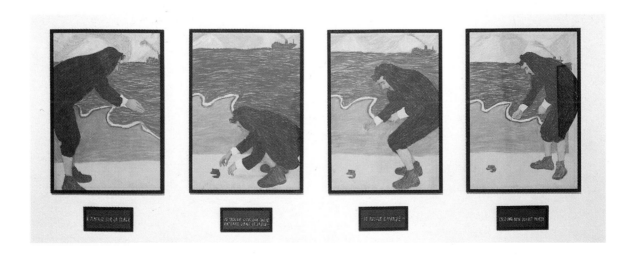

61. *Saynètes comiques: La Mort du grand-père*
(Comic sketches: Grandfather's death). 1974.
62. *Saynètes comiques: L'Horrible découverte*
(Comic sketches: The horrible discovery). 1974.

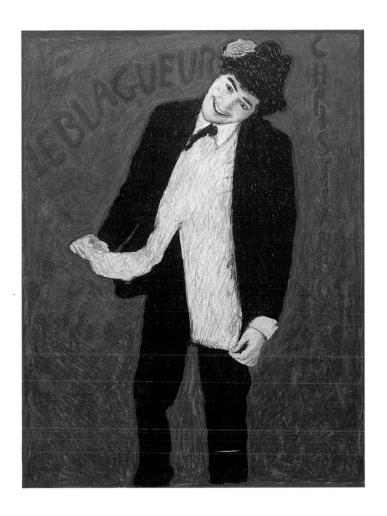

63. *Affiches: Le Blagueur* (Posters: The joker). 1974.

cide while maintaining his guise as clown. These ironic "before and after" shots juxtaposed two black-and-white photographs of an anguished Boltanski (in the left-hand frame) committing suicide and (in the right) gleefully demonstrating that the suicide attempt was a fake. For example, in the first frame of *La Noyade* (The drowning) from 1975, Boltanski, wearing his trusty all-purpose suit, is shown head-on, with a boulder tied by a rope around his neck, poised to dive. In the second, however, the camera pulls back to reveal him grinning sheepishly and pointing to the basin he is standing in as he effortlessly holds the apparently styrofoam boulder aloft. These pairings pointedly invoke the theatrical cliché of comedy/tragedy to reaffirm a basic truth: that the physical act of laughing is very close to that of crying. Here, the whimsical and playful side

of Boltanski's art coexists alongside its darker overtones. Once again, the more profound aspects of his work achieve power through their unsettling ability to make us wince and chuckle at the same time.

By the end of 1975, Boltanski felt that he had reached another watershed in his art and in his life. He responded by removing himself from his work and embarked on a series of photographic pieces that investigated the less emotional aspects of photography, taste, and cultural codes.

64. 65. 66. Cover and inside pages of the artist's book *Quelques interprétations par Christian Boltanski* (Some interpretations by Christian Boltanski). 1974.

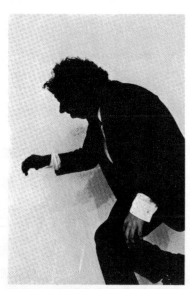

CHRISTIAN BOLTANSKI
INTERPRÉTANT LE ROLE D'UN VIEIL HOMME COURBÉ

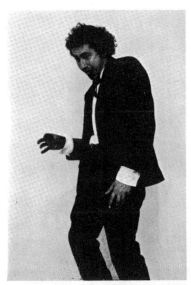

CHRISTIAN BOLTANSKI
INTERPRÉTANT LE ROLE D'UNE FEMME EFFRAYÉE

67. 68. 69. Cover and inside
pages from the artist's book
*Les Morts pour rire de
Christian Boltanski* (The
pretend deaths/deaths for
fun of Christian
Boltanski). 1974.

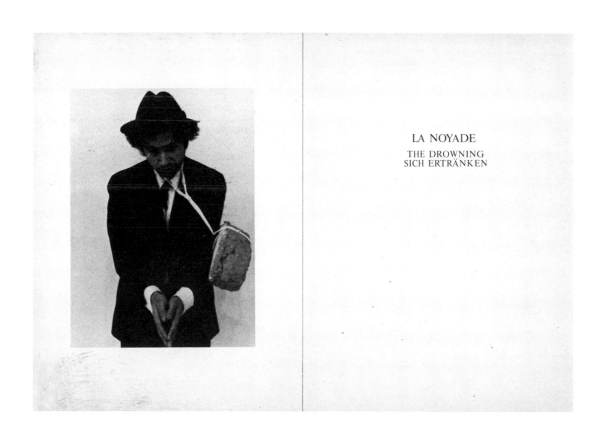

LA NOYADE

THE DROWNING
SICH ERTRÄNKEN

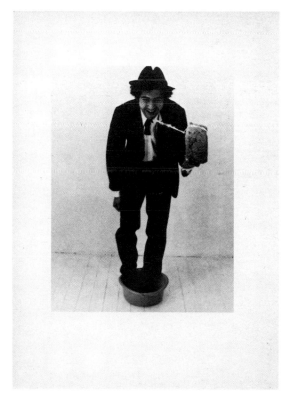

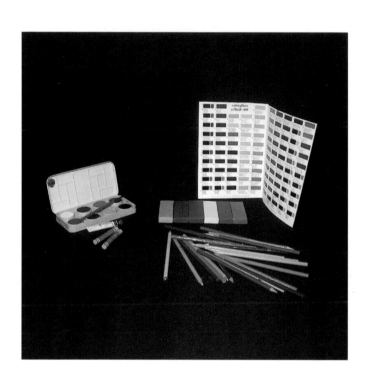

IMAGES MODÈLES
TO COMPOSITIONS

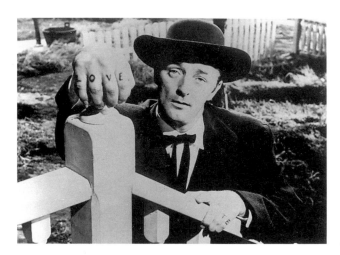

71. Robert Mitchum in
Charles Laughton's
Night of the Hunter, 1955.

Armed "with a suitcase full of little books, photographs, and fake relics," Boltanski had begun to feel, by the mid seventies, like Robert Mitchum's itinerant, evil evangelist in the film *The Night of the Hunter*, sermonizing on death wherever he went to install his exhibitions. "I didn't want," he said,

> to get stuck in a character of a liar. I wanted to destroy the myth, and to destroy it with irony and derision. So, one day, with the *Saynètes comiques*, I changed from being a preacher to a clown. It was the first step to really becoming an artist: I told people the same stories as before, but in a totally ridiculous way. I explained that what I had said before was false, even if in fact it was true. . . . [31]

But just as quickly as he assumed the role of Christian the clown, he abandoned it. Rejecting as well the persona of the distraught, high-strung artist he had convincingly created in the mail-art piece from 1970, Boltanski wrote another letter in 1975. In an excerpt from it, which was used as the text for an exhibition announcement, he declared:

> I am making photographs; I have perfected my technique, and I am trying to conform to the rules of this very difficult art. I am now tackling color photography, which lends itself especially well to those subjects I am fond of: all that expresses the beauty of simple things and the joy of living.[32]

As the color-photographer-who-takes-pretty-pictures, Boltanski effected another

p. 54:
70. *Composition photographique*
(Photographic composition).
1974.

CHRISTIAN BOLTANSKI

Photographies

29 Janvier 1976.
Galerie Sonnabend 12, Rue Mazarine . Paris

72. Invitation to "Images modèles" (Model images), Galerie Sonnabend, Paris, January 1976.

je fais de la photographies; j'ai perfectionné ma technique et j'essaie de me conformer aux rögles de cet art si difficile. J'aborde maintenant la photographie en couleurs qui se prête particulièrement bien aux sujets que j'affectionne: Tout ce qui exprime la beauté des choses simples et la joie de vivre.

costume change, but one that would prove especially fertile. Until then, his work with photography had been mainly limited to combining either found snapshots or his own black-and-white photographs with a range of other media. From 1975 to 1984, by contrast, he devoted himself exclusively to producing larger and larger color prints.

Boltanski switched to color for a number of reasons. Amateur (or amateurish) black-and-white prints had increasingly failed to satisfy him as his interest in making art that could be confused with "real life" deepened. In addition, as more and more conceptually oriented artists began to use black-and-white photographs to document their performances or to explore, as Boltanski himself had done, the complex relationship of text and image, he took, as he saw it, the only reasonable course of action open to him: he stopped using it altogether.

In typical Boltanskian manner, however, things were not quite that straightforward. At the same time he was announcing his shift to color photography, he was also maintaining that he was a painter, and a very conventional one to boot. That same year he stated:

> I'm an extremely traditional painter. Like all artists, I work to produce emotions in the viewer. I work to make the world laugh and cry. . . . I think that painters have always had more or less the same thing to say, the same desire to capture reality, but each time they express it with ways and means that are slightly different. . . . I ask a lot of questions about art and its purpose or

non-purpose, but, at the same time, in some vague and inexplicable way, I still believe in it.[33]

Boltanski's insistence on being called a painter was, for him, another way of underscoring the absurdity inherent in all artistic expression. His adoption of photography, a devalued medium within an art-historical hierarchy that situates painting and sculpture at its summit, injected a characteristic note of contradiction.

According to the exhibition announcement, Boltanski wrote the letter to an acquaintance, Guy Jungblut, from Berlin, where he had been invited in 1975 to participate in an artist's residency program, the Deutscher Akademischer Austausdienst (D.A.A.D.). There he made *Les Enfants de Berlin* (The children of Berlin), a series of color photographs of individual boys and girls. The results, however, were much more startling than the professional school portraits Boltanski was trying to simulate. Shooting the children, one after the other, with a blinding flash, it was as if, as he later observed, he was executing them.[34] And indeed, in the unforgiving light of the strobe flash, which captures even the smallest flaw, the children appeared startled and frozen, like deer caught in the headlights of an oncoming car. Just as Boltanski's various identities had been

74. Installation view, "Reconstitution," Musée de Grenoble, France 1991, with *Les Enfants de Berlin* (The children of Berlin). 1975 and *Lanterne magique* (Magic lantern). 1981.

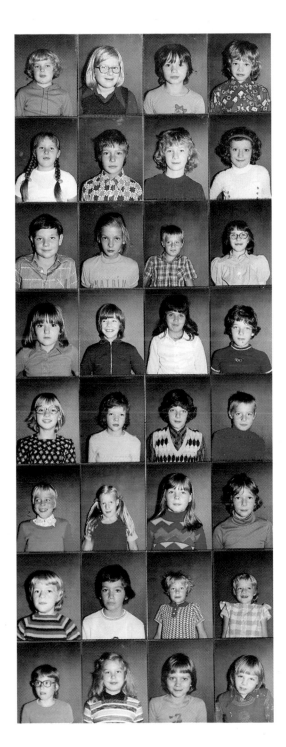

75. *Les Enfants
de Berlin*
(The children of
Berlin). 1975.

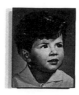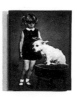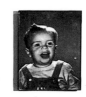

no guarantee of dramatic changes in the character of his work, so too was his shift to color photography no guarantee of pictures brimming over with "the joy of living." *Les Enfants de Berlin* seemed more of a logical continuation of the children's portraits that had featured so prominently in his early work and numbered among them the *C.E.S. Lentillères* and the *Club Mickey*. Once again, this time evidently against his will, Boltanski was invoking photography's darker underside.

76. *Les Jolis enfants* (The pretty children). 1975.

That said, *Les Enfants de Berlin* also represented a renewal of his interest in what photography revealed of societal values and initiated a series of investigations into notions of taste and cultural clichés, now known as *Les Images modèles* (Model images). Another work from 1975, *Les Jolis enfants* (The pretty children), similarly featured portraits of children. Resuming his practice of reshooting existing photographs, Boltanski selected and enlarged (to 16 × 12 in.) typically cute images of children done to death by commercial photographers. Seemingly taken from advertisements for soap powder or from a professional photographer's portfolio, these "pretty children" are softly lit, flattering portraits of youngsters who, either with a pet or favorite toy or in a close-up, are pictured against a colorful studio backdrop. Displayed one after another in a row, these works parody clichés of innocence and happiness, and their sense of timelessness contrasts sharply with the startled immediacy of their Berlin counterparts.

For another work from the series of *Images modèles*, *Le Voyage de noces à Venise* (The honeymoon in Venice), also from 1975, Boltanski collaborated with Annette Messager on a study of honeymoon clichés. Pretending to be on a nuptial tour of the romantic Italian city, Boltanski took ninety-six color pictures and Messager made twenty-one sketches in colored pencil of classic Venetian scenes. Rather than capturing an intensely personal experience, however, they demonstrated that "honeymooners" usually replicate preexisting images. The amateur photographer, as Boltanski illustrated, generates copies of culturally-specified models, many of which are derived from art historical precedents, such as sunlit landscapes or picnic outings seen in Impressionist paintings. In one snapshot from the fictionalized honeymoon, Boltanski captured Messager silhouetted against a "picture-perfect" view of the Venetian skyline.

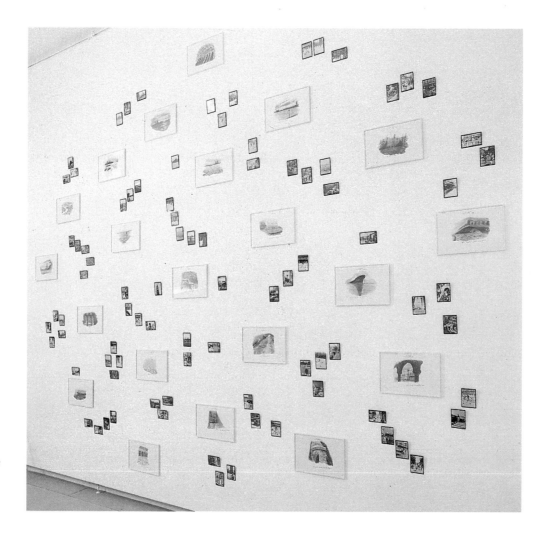

77. *Voyage de noces à Venice*
(Honeymoon in Venice).
1975. Collaborative work
with Annette Messager.

Boltanski resumed the role of commercial photographer in a closely related series from the same year, *Les Images stimulis* (Stimulating images). Readdressing issues crucial to his earlier works, but in formally different terms, Boltanski evenly lit and photographed isolated, everyday items—a plastic water pistol, cookies, a container of yoghurt, for example—centered against blue backdrop paper. To exhibit the pictures, he arranged them, as he had *Les Enfants de Berlin*, in rectangular or square groupings. Their ordinariness recalled the Oxford version of *Les Inventaires*. But where Oxford's black-and-white prints had been marked by a deliberately amateurish air, *Les Images stimulis* exuded professional polish. And although the presentation methods had changed,

Boltanski's aim of triggering collective experiences—in particular, memories of childhood through his use of youthful accoutrements—remained unaltered:

> I don't want viewers to discover; I want them to recognize. For me, a work is in part created by the people who look at it, who "read" it with the aid of their own experiences. I called one of my series *Stimulating Images* to suggest that what is being shown is only a stimulant: it permits each spectator to feel something different. In more general terms I would say that in life we always try to match what we see with what we know. If I show a photograph of the beach at Berck, one person will recognize it as the beach at Dinan, and another as the beach at Granville.[35]

In the first series of an extensive body of work that followed *Les Images modèles*, titled *Les Compositions*, Boltanski, true to his letter to Jungblut, chose subjects that successfully captured the "beauty of simple things." The *Compositions fleuries* (Flowery compositions), begun in 1976, suggested idealized images pitched by travel brochures and trite landscape paintings. Most favored vast expanses of flower beds in full bloom. In one, however, fishermen enjoying an afternoon on the lake are shown in the middle distance while foliage picturesquely frames the foreground. Here, the photographs functioned not to capture particular moments, but to freeze generic views of idyllic scenes—an aim, Boltanski felt, that was characteristic of the evolving aesthetics of color photography:

78. *Composition fleurie*
(Flowery composition).
1975.

> I believe that the aesthetic value that one attributes to the photography that has developed in the [mid seventies] is due to the following: the acceptance and general use of color, the development of specialized magazines that have created certain standards and rules which, consciously or unconsciously, a good number of amateur photographers adhere to. In the same way that photographic subjects are stereotypical, photographic beauty follows very precise rules.[36]

But all artists—photographers included—were united, as Boltanski had said, by their common "desire to capture reality." It is only the manner by which they choose to express themselves that varies. To emphasize this shared goal, he began to appropriate painterly techniques. The word "composition," after all, sparks not only recollections of the lycée with its daily essays but denotes as well the artistic arrangement of shapes and forms.

Compositions photographiques (Photographic compositions), from 1977, which measured one square meter (over ten square feet) each, approximated

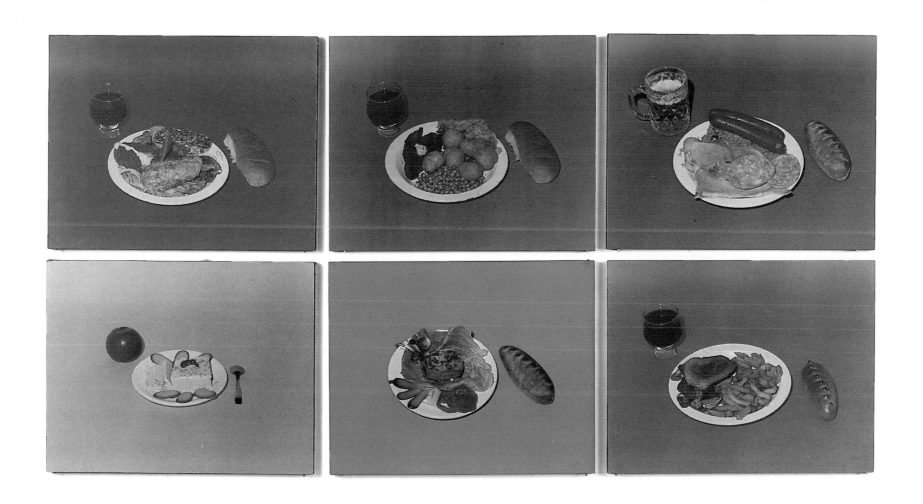

79. *Compositions décoratives*
(Decorative compositions). 1976.

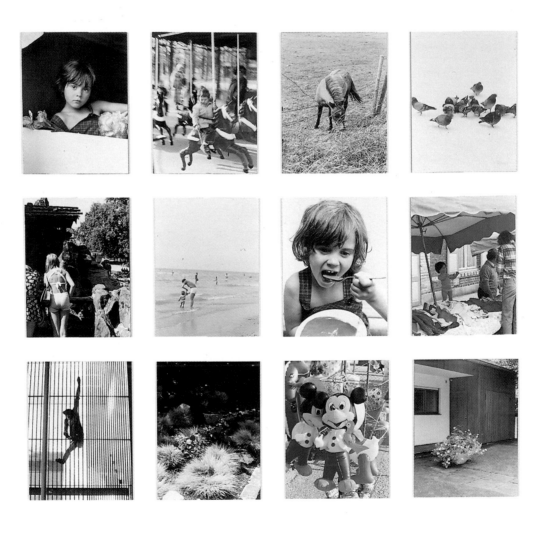

80. *Images modèles*
(Model images). 1975.

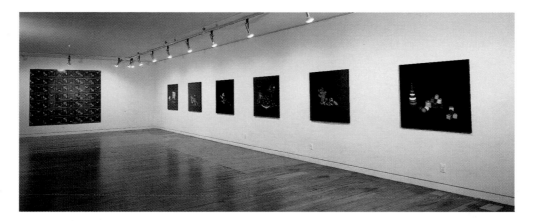

81. Installation view, Sonnabend Gallery, New York, 1979, with *Compositions photographiques* (Photographic compositions). 1977 and *Compositions murales* (Mural compositions). 1976.

the scale of moderately sized canvases and were substantially larger than the individual black-and-white photographs in his earlier work. For them, Boltanski devised a series of variations on the classic genre of the still life. In one example, several candles, a bottle of wine, a framed antique print, an open book, and fruit are artfully arranged to suggest a refined, upper-class interior setting, while another groups the implements of a Sunday painter—watercolors, a color chart for a brand of oil paints, and so on. Evenly lit, like *Les Images stimulis*, these still-life props appeared against a pitch-black background.

Later that same year, for the *Compositions murales* (Mural compositions), Boltanski was again arranging items—marbles, colored pencils, candies, and other objects that could function as abstract elements—but this time, against brightly colored backdrop paper. After making multiple prints of the same image, he lay them side by side to create horizontal or vertical decorative bands. This interest in repetitive patterns was not, at the time, unique. He was, he later admitted, briefly influenced by the "Pattern and Decoration" movement, which flourished in New York for a short time in the late seventies.

Indeed, painterly conventions involving light, such as chiaroscuro and modeling, also assumed increasingly important roles in Boltanski's compositional variations. He was to manipulate light in an especially dramatic manner in a subsequent series. For the *Compositions japonaises* (Japanese compositions), from 1978, he used tiny figures carrying paper parasols and brightly colored gravel paths leading to miniature pagodas to create illusions of a Japanese garden, or rather, a Western notion of a Japanese garden. The backgrounds were, again, pitch-black voids, which disoriented viewers by eliminating the horizon and thus denying naturalistic space. If some sense of scale could be inferred from the recognizable artifacts in the *Compositions photographiques*—for exam-

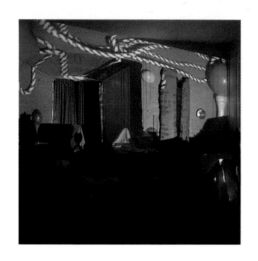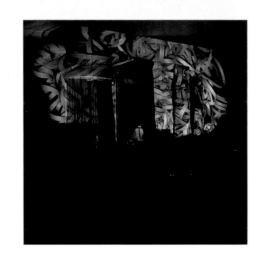

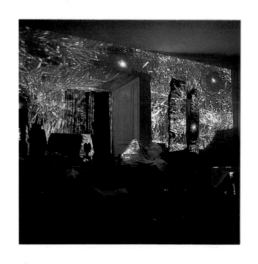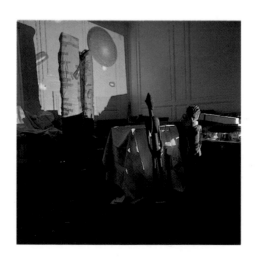

82. *Projections*. Installation view, *Le Coin du Miroir* (Mirror's Corner), Dijon, France, 1978.

66

ple, the wine bottle—any suggestion of perspective and relative proportion were eliminated altogether from the *Compositions japonaises*. Adding to the artifice were small abstract arrangements of geometrical shapes that appeared to hover in the black, impenetrable sky. "My Japanese gardens," he explained,

first referred to a sort of cultural ersatz that goes from fake Chinese furniture of the eighteenth century to the little gardens sold at the florists. . . . My *Compositions* . . . always contain allusions to existing images, a curious cultural mix where memories of classical paintings linger with other visual images and sources: films, photographs, advertisements.[37]

When he showed the *Compositions japonaises*, Boltanski took control of the exhibition space itself, creating an ambience of semidarkness. The photographs were lit only by small, black clamp-on lamps that suggested the small lights attached to the tops of picture frames. What the fantastic scenes recalled, as well, were "magic lanterns," like the one described by Marcel Proust in his *A la recherche du temps perdu (Remembrance of Things Past)*.

Having photographed groups of found or purchased items in the *Compositions photographiques* and *Compositions japonaises*, he simplified the format of a later series by shooting only a single object. The *Compositions héroïques* (Heroic compositions), from 1981, depicted enlarged images of toy Indians. One, for example, featured a small, plastic figurine armed with a tomahawk, again dramatically lit. Intentionally simulating the chiaroscuro employed in Baroque painting, Boltanski was emphasizing art's shared goal of capturing reality, but a reality that, as he had demonstrated in the *Images modèles*, was composed of cul-

83. *Composition murale* (Mural composition). 1977.

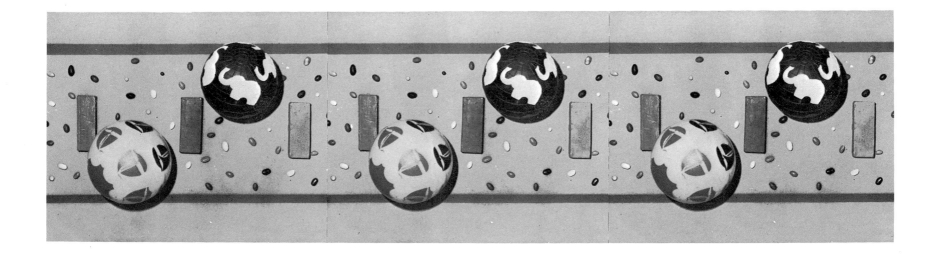

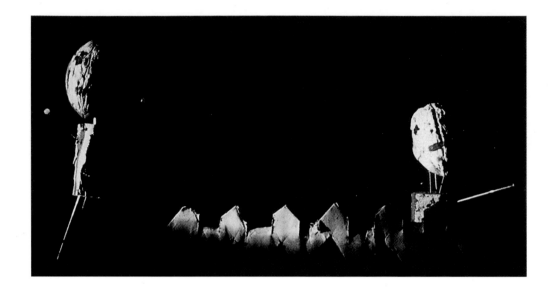

84. *Composition grotesque* (Grotesque composition). 1981.

85. Installation view, Musée National d'Art Moderne, Centre Georges Pompidou, Paris, 1984, with *Composition grotesque* (Grotesque composition). 1981, *Composition classique* (Classic composition). 1982 and *Composition enchantée* (Enchanted composition). 1982.

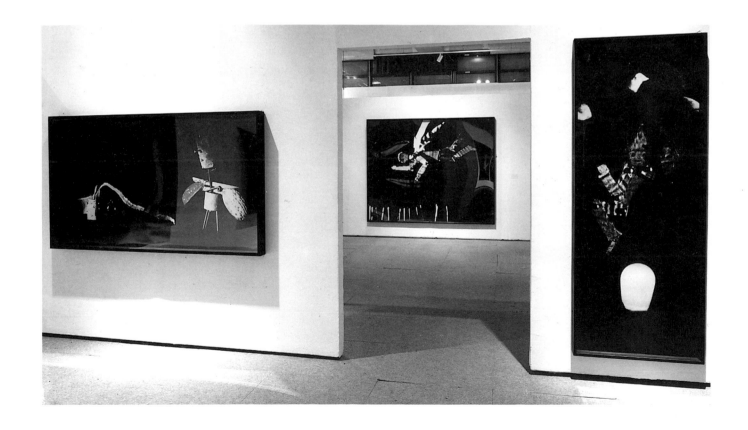

86. *Compositions japonaises* (Japanese compositions). 1978.

tural constructs: "The toys [used in the *Compositions*] interest me in that they are a cultural representation of reality. . . . I hope that my *Compositions* play the same role for the spectator that toys do for children: codified and collective images of reality."[38]

Rather than using existing toys in the *Compositions grotesques* (Grotesque compositions), also from 1981, Boltanski began to fabricate them himself. Cobbling together bits of found materials, including wire, corks, nails, and walnuts, he devised an odd assortment of characters who startlingly emerge out of totally black and indecipherable backgrounds. Puppetlike figures also appeared in another series from the same year. These were held together with round metal paper fasteners at the joints, and Boltanski maneuvered their arms and legs into different positions as he photographed them for his *Compositions théâtrales* (Theatrical compositions).

Boltanski continued to subtly alter or substitute different components in subsequent "compositions" into the mid eighties, experimenting with and refining the formal innovations that would have important repercussions in his later work. For example, those designated sequentially as *Musicales* (Musical), *Hiératiques* (Hieratic), and *Classiques* (Classical), were fashioned in Boltanski's intentionally crude, *faux-naïf* manner, with its overtones of Art Brut and folk art. All appeared in prints that were growing increasingly larger (over 6 feet tall, at times) as if to compete with the imposing scale of canvases then dominating the international art scene.

87. Installation view, ARC, Musée d'Art Moderne de la Ville de Paris, 1981, with *Compositions théâtrales* (Theatrical compositions). 1981.

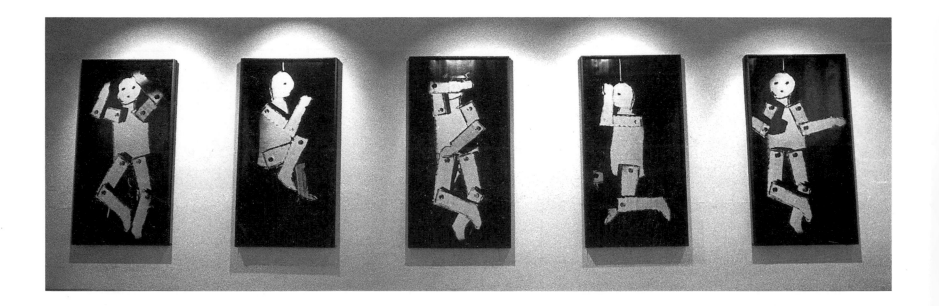

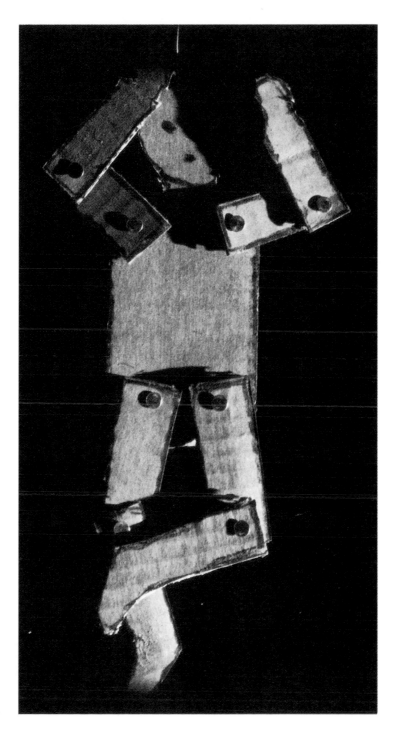

88. *Composition théâtrale*
(Theatrical composition). 1981.

By creating his small, handmade protagonists, Boltanski had added yet another identity to the ever-lengthening list: that of puppeteer. Like the artist, the puppeteer pulls strings to manipulate emotions; he also, according to Boltanski, is a magician who animates the inanimate and thus effects "alchemical" transformations. But rather than exhibiting these strange, at times sinister figurines (some of them strongly suggested voodoo fetishes), Boltanski magically transmuted them into forms that appeared greatly enlarged and two-dimensional. For Boltanski, the wooden frame and protective glass functioned not unlike his earlier vitrines, as a distancing factor that diminished their more expressionist elements.

Boltanski enhanced the sense of drama and magic in the *Compositions* by employing a theatrical-like lighting of the objects he photographed and, eventually, of the rooms in which he exhibited them. To shoot the later *Compositions*, Boltanski would plunge a room into total darkness and then focus a sole spotlight on one of his figures. By using the cinematic devices of close-up and projection, he achieved results that were terrifyingly large and frighteningly convincing. Again, in the absence of any background references to serve as a gauge, viewers were given virtually no clues to the original object's true size.

With the puppets and toys pictured in the *Compositions*, Boltanski resurrected his familiar theme of childhood memories. The banal, everyday objects that he photographed in the earlier *Images stimulis* and *Images modèles* were

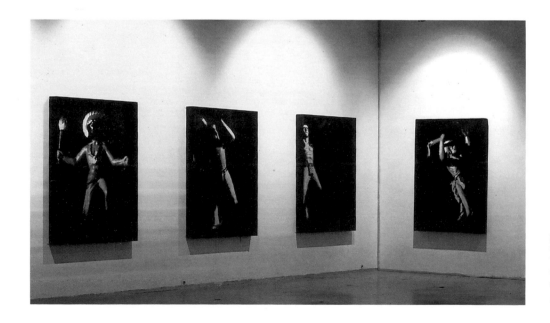

89. Installation view, ARC, Musée d'Art Moderne de la Ville de Paris, 1981, with *Compositions héroïques* (Heroic compositions). 1981.

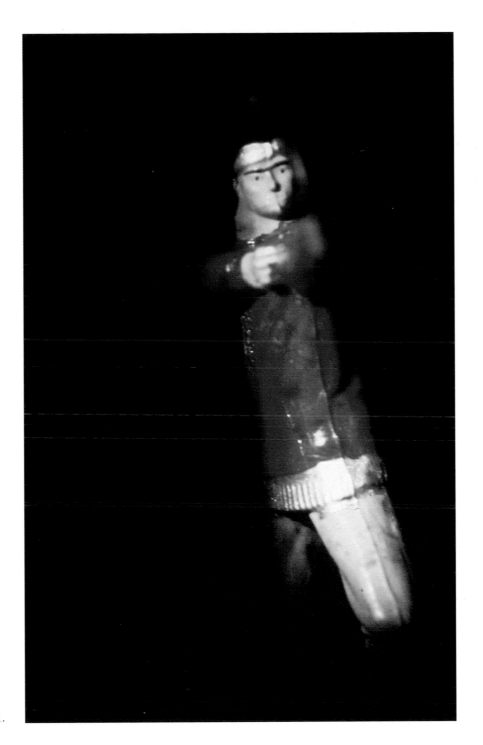

90. *Composition héroïque*
(Heroic composition). 1981.

ultimately replaced by odd, disturbing creatures he fashioned himself. By vastly enlarging them, he transformed them into frightening apparitions that children fear lurk in darkened bedrooms, shadows that can look like nighttime monsters come alive. With their metamorphosis from miniature to monumental, Boltanski again demonstrated that photography is not a measure of the real, but can manipulate, distort, and deceive.

Moreover, Boltanski learned another crucial lesson about the importance of context. The *Images modèles* and *Compositions photographiques*, as he admitted in 1984, were not perceived in the same way when installed in an avant-garde art gallery and in the window of a commercial photographer. What is deemed beautiful by audiences of outdoor art fairs is judged trite and uninteresting by art-world denizens.[39] Taste, in other words, is variable and culturally determined. Although both series met with apathy when initially shown in various exhibitions in France and in New York, they now appear remarkably prescient in their investigation of "quality" and "kitsch." Their attempt to achieve an apotheosis of clichéd beauty is not that different from similar endeavors some five to ten years later, such as Jeff Koons's sculptures, inspired by collaged greeting cards (also greatly enlarged in scale), Richard Prince's appropriated images from cigarette commercials, or Mike Kelly's stuffed animals, to name just a few.

Manipulating lighting and context, Boltanski also significantly upped the scale of his work. The thin line between illusion and reality, artifice and truth, would play an increasingly important role in his art as it became even more overtly dramatic in the next major body of work, *Leçons de ténèbres* (Lessons of darkness).

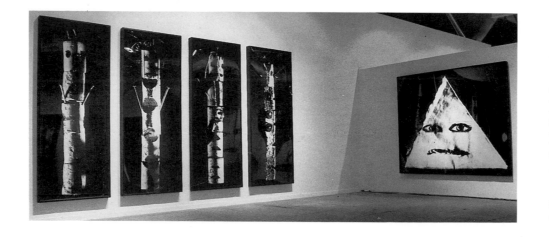

91. Installation view, Musée National d'Art Moderne, Centre Georges Pompidou, Paris, 1984, with *Compositions hiératiques* (Hieratic compositions). 1983 and *Composition mythologique* (Mythological composition). 1982.

92.
*Composition
architecturale*
(Architectural
composition).
1982.

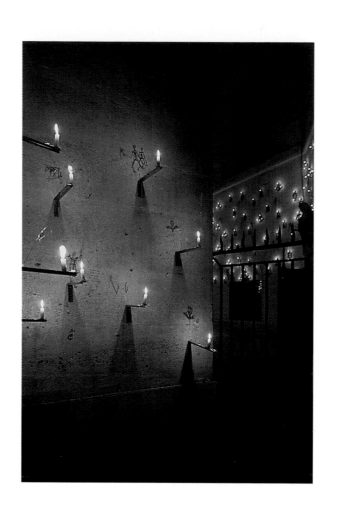

LESSONS OF DARKNESS

94. "Lesson of Shadow Games," from *Introduction à la haute école de la peinture* (Introduction to the noble school of painting) by Samuel van Hoogstraten. 1652.

In 1984, Boltanski presented fifteen years of his work in a retrospective at the Musée National d'Art Moderne, Centre Georges Pompidou, in the Beaubourg district of Paris. Working with curator Bernard Blistène, he designed an installation comprised of two distinct parts. The first occupied a narrow central corridor and contained works that illustrated his life as an artist. It focused on Boltanski's signature theme of reconstitution—his attempts to reconstruct memories of childhood and family life—and included key works such as *Club Mickey* and *Famille D.* Displayed here as well were some *Vitrines de référence*, themselves mini-museums presenting a selection of pieces from 1969 to 1971. In the second section—a series of rooms opening off the central corridor—his color photographs from the *Images modèles* to the *Compositions hiératiques* held center stage. With this bifurcated exhibition plan, Boltanski was exploiting, with his usual irony, a self-aware, internal split ("painter" and "biographer/curator" rolled into one). Here, the detached, ethnographical approach of the earlier work collided with the increasing drama of the *Compositions*.

The show, which also traveled to the Staatliche Kunsthalle in Baden-Baden and the Kunsthaus in Zurich, confronted Boltanski with the fact that he had strayed far from his early intention of constructing an ironic oeuvre from fragile materials, that he had produced instead a series of imposingly large, framed works. This realization provided the impetus for his next series, *Ombres* (Shadows), which signaled Boltanski's rejection of the physically substantial *Compositions* and his conscious desire to recapture the qualities of ephemerality and humility that had characterized his early work.

p. 76:
93. *Les Bougies* (Candles). 1986. Installation view, Chapelle de la Salpêtrière, Festival d'automne, Paris, 1986.

95. Henri Rivière, *La Tentation de saint Antoine* (The temptation of St. Anthony), 1887.

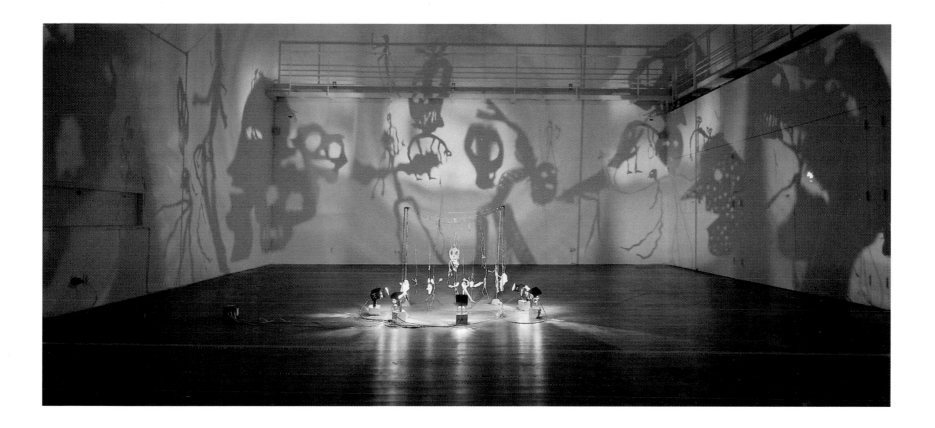

96. *Ombres* (Shadows).
1984. Installation view,
Institute of Contemporary
Art, Nagoya, Japan, 1990.

To do this did not mean, however, relinquishing his tiny, puppetlike figures. Instead, he continued to fabricate them from pieces of cork, paper, cardboard, copper, and tin. But rather than photographing them and then enlarging the results to monumental proportions, as he had in the later versions of the *Compositions*, Boltanski used the figures instead to create haunting installations of flickering shadows.

Boltanski first showed *Ombres* in 1984 at the Galerie 't Venster in Rotterdam. There he suspended the figures from a makeshift metal frame whose supporting legs ended in mounds of clay. Three slide projectors, camouflaged with pieces of crumpled aluminum foil, were trained on the figures, thus catapulting their shadows onto the surrounding walls. Revealing the work's jerry-rigged nature, the electrical cords from the projectors created a disordered web on the floor. A small fan in one corner of the gallery gently set the marionette-like cast of characters into motion. Kept at a distance, spectators viewed the shadows

from the doorway of the gallery and, in later variations, through small windows in specially constructed rooms.

The room-size installation transformed the Galerie 't Venster into a magical theater. The scale and definition of the quivering shadows varied, depending on how far their source figures were from the projectors. Those closest to the light cast darker, sharper forms; those farther away, fainter, blurrier shapes. At first, unsuspecting viewers were enchanted with the spectacle of moving images that covered the walls, unconcerned with the jumble of equipment on the floor. Gradually, however, the shadows' more sinister qualities came into focus. The figures themselves, literally suspended in air, underwent an iconographic metamorphosis as viewers realized that what they were looking at was an army of hanged men, interleaved with menacing skeletons and supernatural beings. Among the group and constructed out of wire, the hunched figure of the grim reaper, scythe in hand, reinforced the bleaker aspects of this macabre dance of death.

Rich in nuance, shadows have traditionally stimulated a range of associations. For the Paris Biennale of 1985, Boltanski constructed within the vast space of the Nouvelles Halles de la Villette a small, dark room, whose cavelike atmosphere recalled Plato's parable in the *Republic*, where concepts of illusion and reality are demonstrated with shadows. In other installations, his shadows have functioned more primordially, suggesting the presence of multiple souls or ghostly ancestors. They also have links with the tradition of the intricate shadow theaters of Indonesia, as well as the artist-produced spectacles they inspired in fin de siècle Parisian cabarets.[40]

Often lurking among the shadows in Boltanski's puppet spectacles were winged figures. Like their cardboard forebears in the earlier *Compositions classiques*, these figures carried both magical and religious overtones, a combination that provided the inspiration for an important body of work begun around 1984 while Boltanski was working on the *Ombres*. In *Les Monuments* (Monuments), as the series was called, Boltanski again capitalized on photography's close ties to memory and death by commenting on the irony that photographs, which are meant to preserve what they record, also perish, that they are made only of paper. An important stimulus for the work was a school portrait, which was taken when he was seven years old and which was used as the cover for his first book, *Recherche et présentation*. In it, Boltanski and his seventeen solemn classmates were organized by an anonymous photographer with a row of girls seated in front, their legs demurely crossed. Identifying himself in the photograph with an "X" in ink, he later observed:

> Of all these children, among whom I found myself, one of whom
> was probably the girl I loved, I don't remember any of their

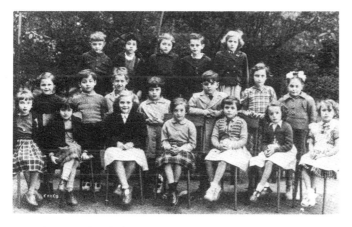

97. Photograph of Christian
Boltanski's class at the Hulst
Middle School. Paris, 1951.

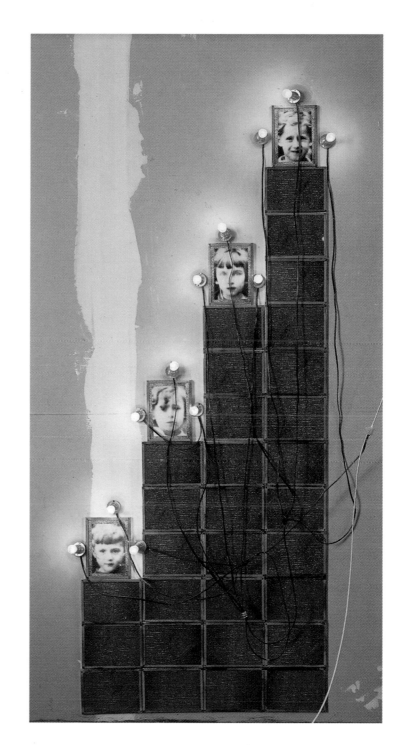

98. *Monument*. 1986.
" Monuments, " Galerie
Crousel-Hussenot, Paris,
1986.

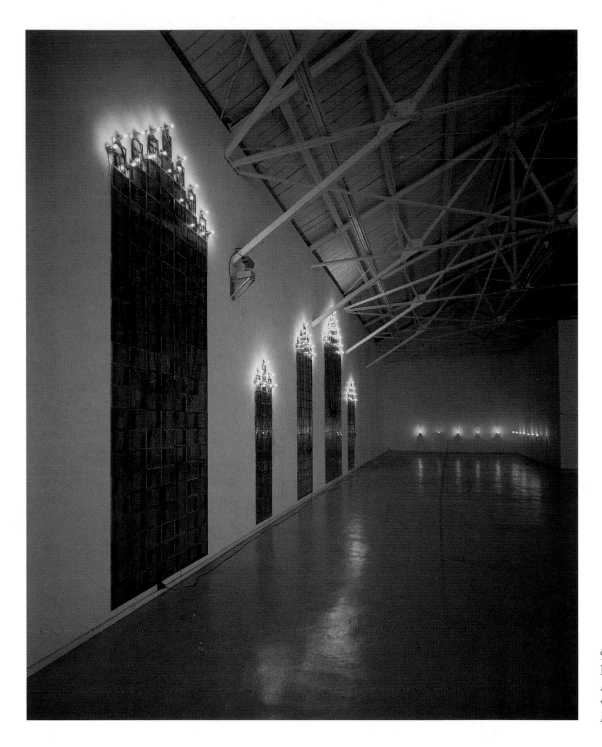

99. Installation view,
Institute of Contemporary
Art, Nagoya, Japan, 1990,
with *Monuments*. 1985 and
Bougies (Candles). 1986.

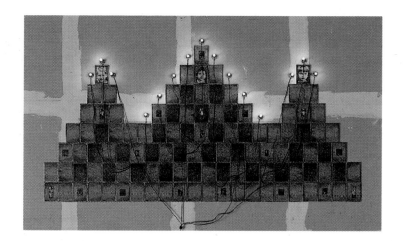

100. *Monuments*. 1985. "Monuments," Galerie Crousel-Hussenot, Paris, 1986.

names, I don't remember anything more than the faces on the photograph. It could be said that they disappeared from my memory, that this period of time was dead. Because now these children must be adults, about whom I know nothing. This is why I felt the need to pay homage to these "dead," who, in this image, all look more or less the same, like cadavers.[41]

Deceptively modest, this new series pointedly invoked both funerary sculptures and public memorials. However, Boltanski's *Monuments* were not constructed out of stone or marble but rather out of small, tin-framed photographs arranged in geometrical, often symmetrical, configurations. Surrounded by small, incandescent light bulbs, these black-and-white portraits of children, were combined with monochromatic color prints—usually gray, red, gold, or blue—made by simply photographing "papiers de Noël," shiny or metallic Christmas wrapping paper. The traditional idea of a monument—of solemn, respectful remembrance—was further undermined by the tangled web of black wires leading to the small bulbs, which disrupted the ordered arrangements of photographs.

Usually installed in semi-darkness—the only illumination was provided by the works themselves—the *Monuments* resembled Byzantine icons, the electric lights standing in for devotional candles, and the photographs of metallic wrapping paper for their hammered surfaces of gold, copper, and tin. For Boltanski, they also commemorated a fundamental precept of Catholicism: the principle that anyone can be saved, anyone can become a saint. And, in particular, the

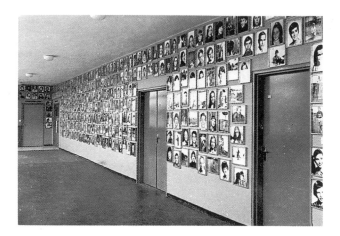

101. *Portraits des élèves du C.E.S. des Lentillères* (Portraits of students from the Lentillères College of Secondary Education). 1973. Permanent installation at the Lentillères College of Secondary Education, Dijon, France.

anonymous portraits of children suggested as well the festival of "Toussaint" (All Saints' Day), which celebrates unrecognized saints who do not have their own feast days.

In 1985, Boltanski was invited to create an installation for the Consortium, a contemporary art exhibition space in Dijon. Returning to this city, where he had made *Portraits des élèves du C.E.S. des Lentillères* a decade before, he used the same photographs that he had employed for the earlier public commission. "Ten years later," he remarked, "all these children's faces really seemed to me to be like corpses. The pictures are dead forever, since they are now adults."[42] Subtitled *Les Enfants de Dijon* (The children of Dijon), the new piece was a variation on the *Monuments*, but now the framed rectangles of Christmas paper were reduced to thin, colored photographic strips that bordered the children's rephotographed and cropped images. In this incarnation, some of the portraits were dispersed along one wall, where they were individually lit by bulbs whose black wires gathered disjointedly in odd clumps before reaching the electrical outlets on the floor. On another wall, the others were arranged in three symmetrical compositions: two stepped pyramids of lights each surrounding six photographs on either side of a more elaborate configuration in the center.

The ability of the camera lens to zoom in underlies, in part, the effectiveness of the *Monuments*. In Dijon, Boltanski manipulated this cinematic technique to great advantage: using the close-up not only to magnify but to exclude, he forced viewers to confront each subject, which heightened the sense of palpable immediacy. It was the everyday, ordinary innocence of the children's faces

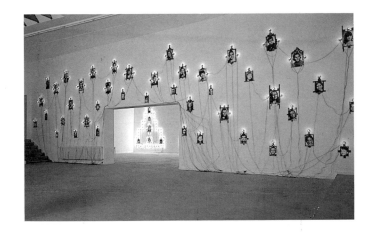

102. 103. *Monument: Les Enfants de Dijon* (Monument: The children of Dijon). Installation view and detail, Le Consortium, Dijon, France, 1985.

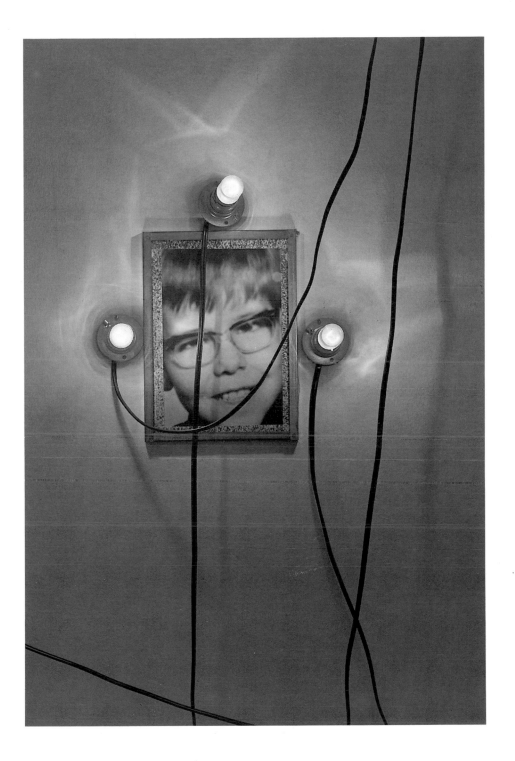

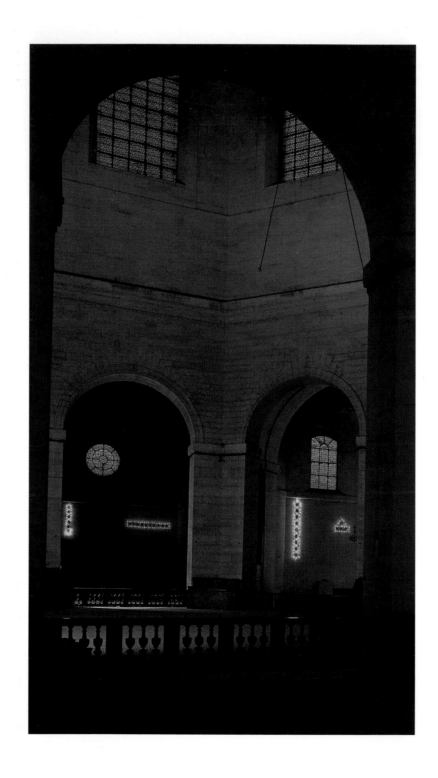

outlined with strips of the photographed wrapping paper or further encased in shoddy tin frames (with their overtones of containment and possible death) that contributed to the work's haunting pathos. "Perhaps Boltanski has simply discovered something latent in ordinary photographs," Adam Gopnik remarked,

that can make them, in special circumstances, elegiac. Part of his discovery involves a fact about photography: we can look at people's faces in photographs with an intensity and intimacy that in life we normally only reserve for extreme emotional states — for a first look at someone we may sleep with, or a last look at someone we love.[43]

Moreover, the fact that the *Enfants de Dijon*'s images were, like those of *Famille D.*, rephotographed photographs also contributed to their poignancy. By the time they would be incorporated into other versions of the *Monuments*, these black-and-white portraits would be third- or fourth-generation prints. Consequently blurred and out-of-focus, they seemed to be invested with the authority of documents, an illusion countered by the soft yellow glow of the

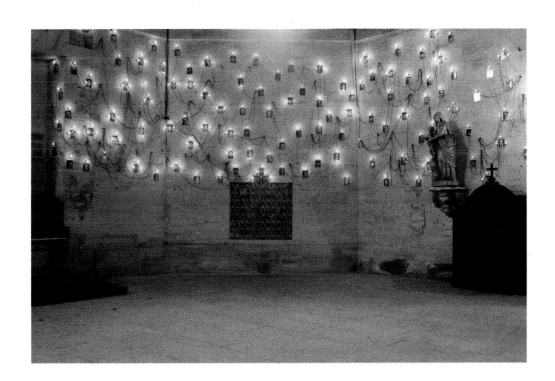

104. 105. Installation views, Chapelle de la Salpêtrière, Festival d'automne, Paris, 1986.

bulbs surrounding and illuminating them. Boltanski had thus expanded his notion of objectification to include the very business of fabrication. By resurrecting images he had used in earlier pieces and deploying them in new configurations, he was simultaneously emphasizing both photography's inherent reproducibility and its potentially dehumanizing property. In addition to cannibalizing preexisting works, Boltanski was making good on his intention to return to an earlier stylistic hallmark of his own work, since the new pieces too were composed of humble materials—paper, tin, and light bulbs. An important difference was that he now deployed them with a heightened sense of drama.

In 1986 Boltanski participated in two exhibitions that were to have an enormous impact on how he conceived of and installed future shows. That summer he was invited by Suzanne Pagé to create an installation for the Venice Biennale. In addition to the French Pavilion, the Association Française d'Action Artistique had procured the Palazzo delle Prigione, a former prison, as the location for a supplemental show of French artists. Here, in this dramatic and historical site, Boltanski installed a variation of *Enfants de Dijon*. The results were highly theatrical and very moving. Eliminating all sources of

106. 107. *Monuments: Les Enfants de Dijon* (Monuments: The children of Dijon) and *Monument*. Installation view, Palazzo delle Prigione, 42nd Venice Biennale, 1986, and detail.

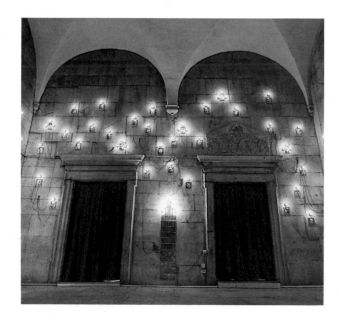

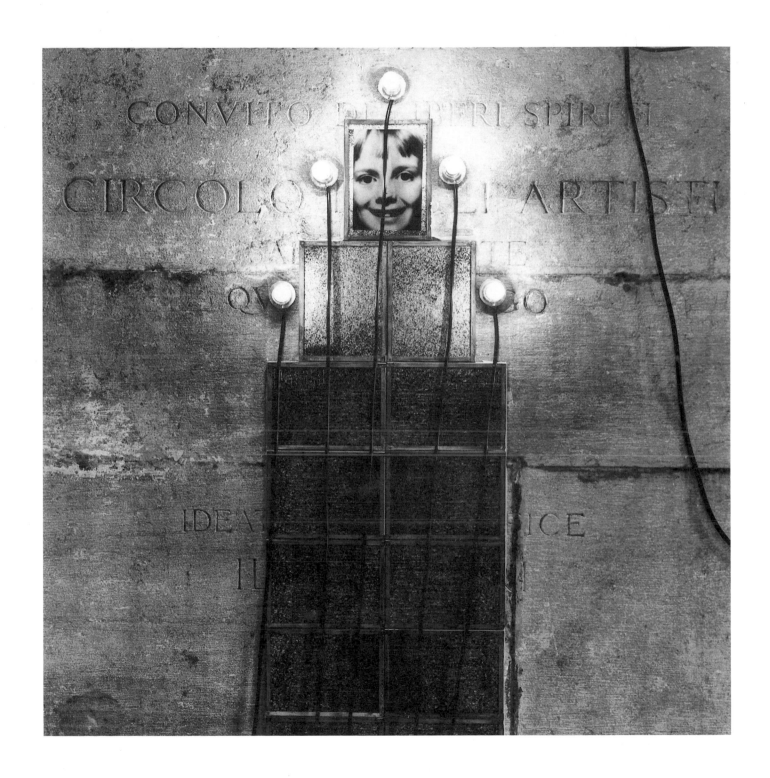

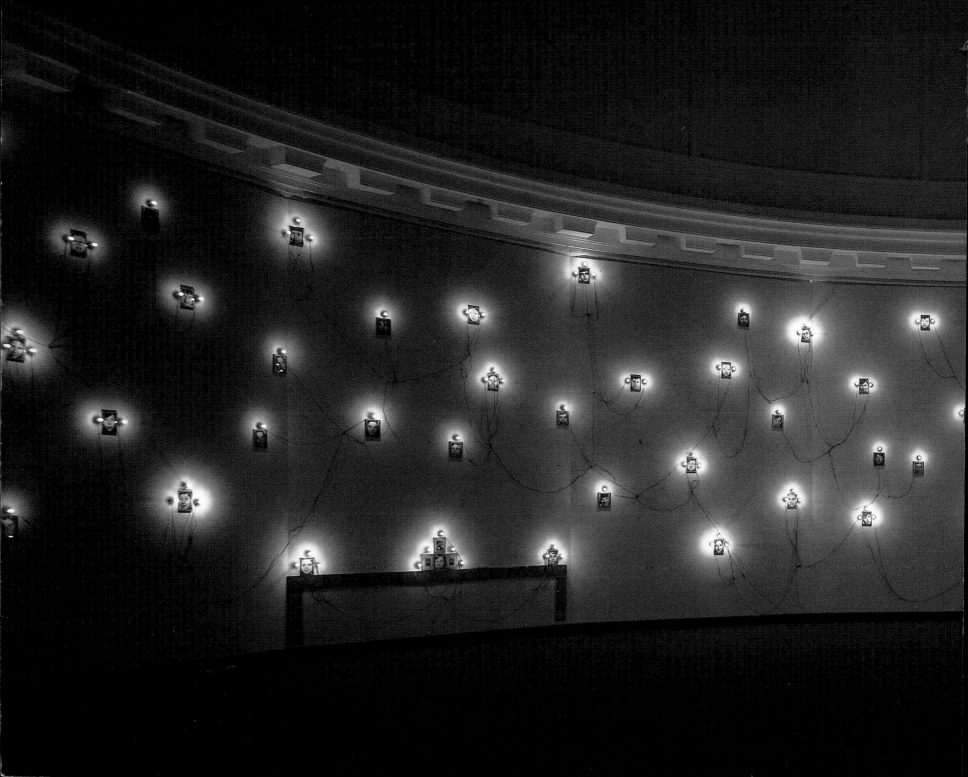

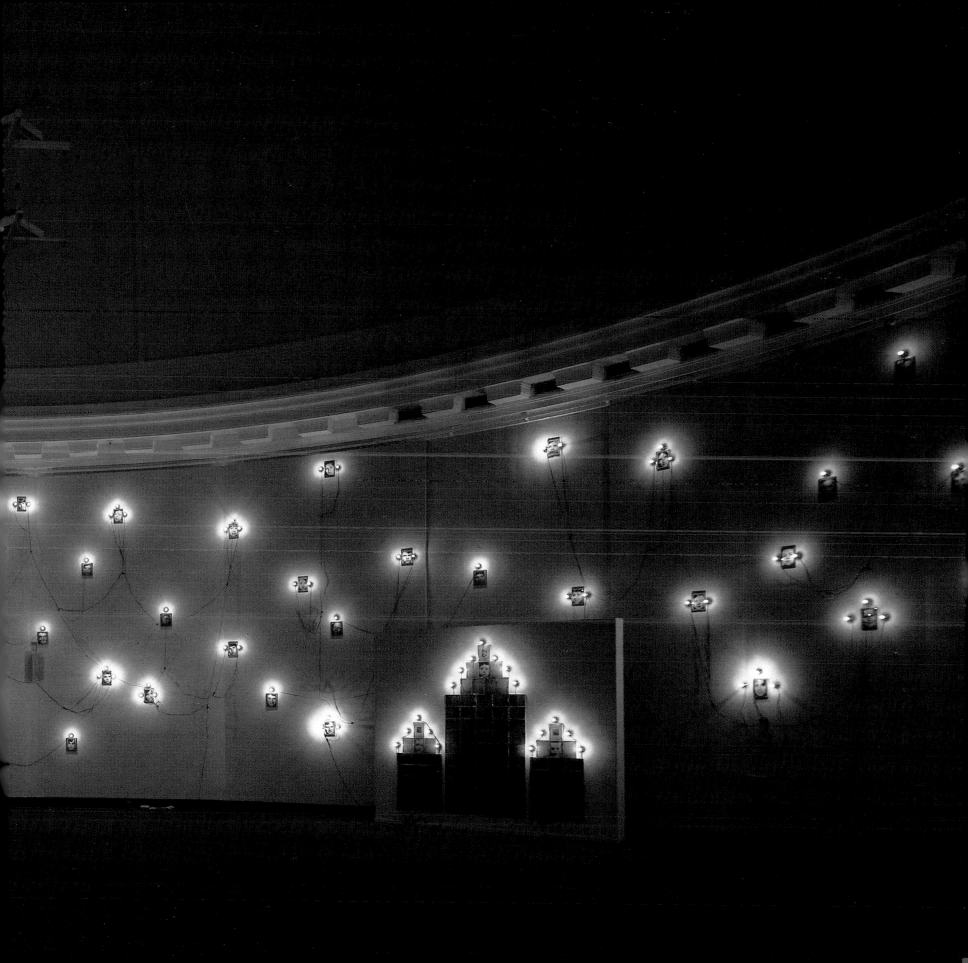

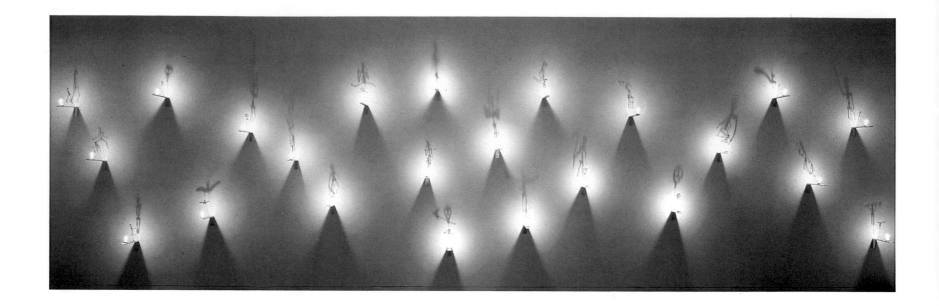

p. 90-91:
108. Installation view, "Inventar," Hamburger Kunsthalle, Hamburg, Germany, April 1991, with *Monuments: Les Enfants de Dijon* (Monuments: The children of Dijon) and *Monuments*.

natural light, he orchestrated for the first time how the audience literally "saw" the exhibition. Having left the golden light and intense summer heat of Venice, viewers entered the cooler medieval building only to be confronted with the dreamlike spectacle of an enormous *Monument* combined with variations of the *Ombres*.

In the semidarkness of the main room, they were overwhelmed by the mass of faces of the children of Dijon in their incandescent halos. In an antechamber, Boltanski released angels when two small puppetlike figures, constructed out of cardboard and feathers and attached to slide projectors mounted atop one another on a shelf suspended from the ceiling, slowly began to revolve. The angels' greatly magnified shadows thus circled the walls, their contours changing and adapting to the various surfaces they crossed.

That fall, Boltanski participated in the annual Festival d'Automne in Paris, this time installing *Les Enfants de Dijon* in La Salpêtrière, a chapel located next to, and affiliated with the hospital of the same name. Again experimenting with how viewers perceive his work, Boltanski installed several *Monuments* high up on the walls. As he was unable to control the light, his sole circulating angel was only visible at dusk, seeming to appear miraculously as the day grew darker. Boltanski was convinced that unsuspecting visitors were not aware that the

109. 110. *Les Bougies* (Candles). 1986. Installation view and detail, Kunstmuseum, Bern, Switzerland, 1987.

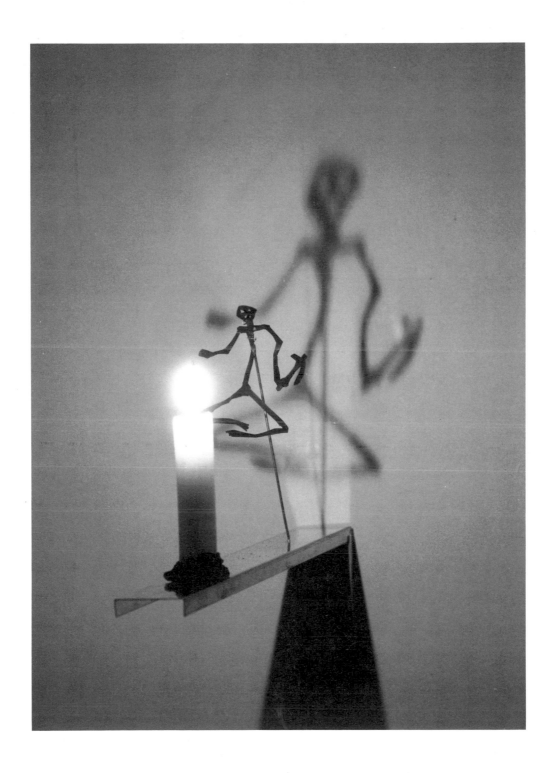

chapel was being used as the site of an art exhibition and so mistook the works for church decorations. If this is true, then Boltanski's desire that his art be mistaken for life was, once again, realized.

The religious and sacral aspects of these works, especially *Bougies* (Candles), another variation of the *Ombres* begun around this time, were emphasized in a church setting. Installed in La Salpêtrière as well, *Bougies* used miniature figures fashioned out of sheets of copper or tin and attached to narrow shelves that projected out from the wall just far enough to hold candles. With the candlelight in front of them, the figures cast their shadows onto the walls behind. As the flames flickered, the phantasms danced, appearing to rise magically out of the inverted triangles of darkness created by the shelves. On the guest list for this dance, once again, was death, in the form of the grim reaper, accompanied by a gallery of sinister skulls and ominous winged creatures.

As a result of these two installations, which combined various versions of *Ombres*, *Monuments*, and *Bougies*, Boltanski coined a new collective title incorporating all of them: *Leçons de ténèbres*. *Leçons* suggested memories of school days, *ténèbres*, the evil and the sinister, night and death, the absence of light and life. This title also highlighted the works' allusions to religious conventions,

111. Installation view, Chapelle de la Salpêtrière, Festival d'automne, Paris, 1986.

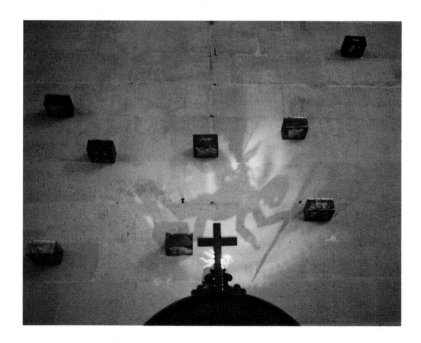

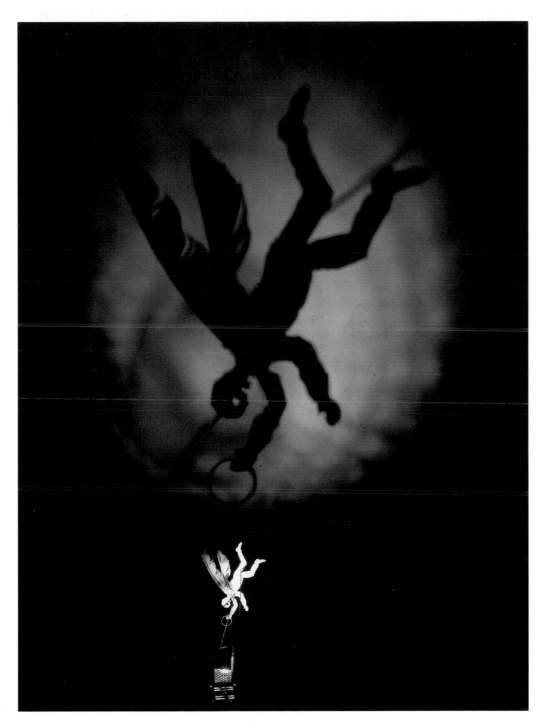

112. *L'Ange d'alliance*
(The angel of accord). 1986.

referring especially to the Lamentations of Jeremiah set to music and traditionally performed during the week preceding Easter. The *Bougies*, in particular, are steeped in religious symbolism; in Catholicism, the candle serves as a symbol for Christ, for his divine nature (the flame), supported by his body (the wax), and for the human soul. Their fluttering flames, along with the scent of melting wax, also conjure up early morning services of Holy Week, the most somber period of the liturgical calendar, and which terminate with a ritualistic extinguishment of all candles.[44]

Over the years, Boltanski has likened making art to the often slow, laborious process of psychoanalysis. Insights into his motivations and aspirations have been gradually disclosed both in his art and in the many interviews he has given over the years. In *Récit-Souvenir* (Story-recollection), a 1971 piece that was published in a magazine, Boltanski narrated a seemingly autobiographical but, in reality, partially fabricated story about his grandparents. During the course of the story, he disclosed that his grandfather, David Boltanski, had been from a poor but very religious family of singers in Odessa. With this tantalizing, if brief, moment of "candor," he had let drop the hint that his family's origins were Jewish, but it was not until 1984 that he would openly discuss what he termed his Jewish "culture/non-culture," to which he ascribes his marked predilection for contradiction:

> A strange relation to the divine, the feeling of being simultaneously part of the "chosen" and the least of men, has driven me to affirm then contradict myself, to cry and laugh at myself, to say that I paint without painting . . . In Jewish culture, I'm drawn to the fact that one says one thing and its opposite at the same time, or the way of answering a question with another question and constantly mocking what one does. . . . I imagine that my ambiguous relationship with painting and my use of photography are linked to this Jewish consciousness, if I so much as have one. I do photography, considered a less noble art than painting, as if I were afraid to confront this very sacred art. Anyway, this is all very fuzzy in my own mind; I have no Jewish culture. I am like the Indians who, in westerns, serve as guides to the soldiers: they forgot everything, but when they drank, Indian dances came back to them.[45]

So, in addition to their Catholic overtones, the works now grouped under *Leçons de ténèbres* can also be read as alluding to Judaism, with the candles and the lights signifying Hanukkah menorahs, the candelabra used in the Jewish "festival of light," or the tradition of *Jahrzeit*, in which the dead are remem-

récit-souvenir

Mon grand-père, David Boltanski, était chanteur à Odessa et, une fois, son père le gifla parce qu'il avait parlé avec des jeunes gens russes. Il était d'une famille pauvre et très religieuse. C'est en chantant des airs d'opéras italiens qu'il rencontra ma grand-mère qui, elle, était la fille d'un riche marchand. Puis, un jour, mon grand-père tomba malade et comprit qu'il ne pourrait plus jamais chanter. Il décida alors de partir pour la France, rendant le voyage, il fut étonné de la politesse des employés de chemin de fer et débarqua à Paris un dimanche. Il chercha tout de suite du travail et entra dans le premier atelier qu'il vit ouvert à la sortie de la gare. On lui demanda des certificats, il montra ses mains. C'est ainsi qu'il fut engagé comme ouvrier carrossier. Ma grand-mère était amoureuse et elle avait beaucoup pleuré quand mon grand-père était parti. Elle s'enfuit finalement de chez elle en emportant un énorme samovar et en laissant une lettre à son père. A Vienne, elle envoya un télégramme à mon grand-père qui vint l'attendre à la gare. Il était habillé en ouvrier et avait le visage fatigué et vieilli. Elle eut du mal à le reconnaître. Puis, il l'amena dans sa chambre, au sixième d'un immeuble de la rue des Volontaires et la laissa au milieu des valises non défaites pour aller travailler. Restée seule dans la chambre, ma grand-mère pleura et pensa un moment à repartir pour Odessa. Mais elle n'osa pas, à cause de la lettre qu'elle avait laissée et de toutes les espérances de bonheur qui y étaient écrites.

113. *Récit-Souvenir* (Story-recollection). April 1971.

bered with special memorial candles. But perhaps the most powerful resonance of all is their evocation of the millions of Jews who died in the concentration camps during the Holocaust.

Boltanski, it would seem, was only able to come to grips with the genocide of European Jewry and his own Jewish heritage in the mid eighties. This heritage had been confounded by his father's conversion to Catholicism early in life (an action that did not, however, spare his father from the threat of deportation later on). As Boltanski revealed during an interview in 1988, "There were all sorts of things about my own childhood that I suppressed in my work because they were too special. For example, in my first works I never mention that I was from a Jewish family, I described it as a normal French family."[46] Around the same time, Boltanski recounted the story of how his father had been

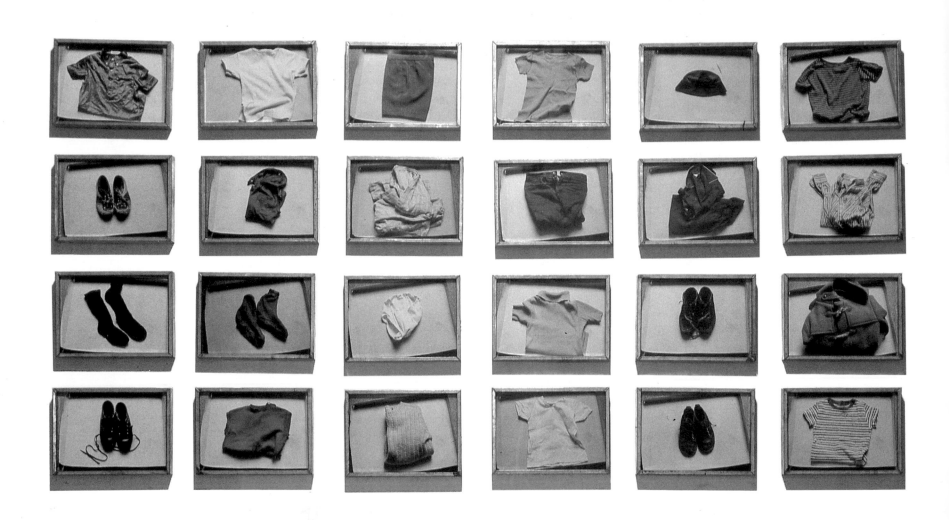

114. *Les Habits de François C*
(The clothes of François C). 1972.

hidden under the floorboards of the family home for the duration of the German occupation of Paris.[47]

Although Boltanski did not experience the war firsthand—he was born several weeks after the official liberation of Paris, at a time when sporadic gunshots could still be heard—his childhood was marked by it. Not only had many of his parents' Jewish friends disappeared during the war, but the topic of France's cooperation and collaboration with the Nazis had not been avoided at home by his family, as it generally was in French society. Looking back later at his early work, Boltanski saw in it an attempt not only to deal with the mass murders of the Jews, but with the agonizing question of how such an atrocity, at odds with basic notions of humanity, could have occurred. The subject of the Turkish massacres depicted in his early paintings especially, he realized, had provided him with one way to approach this weighty and difficult subject.

Another was evinced in a work from 1972, *Les Habits de François C* (The clothes of François C), in which viewers were confronted with black-and-white, tin-framed photographs of children's clothing. Shot from above, each item isolated in a crude cardboard box, these images of crumpled, well-worn clothes were oddly moving. As with the actual or photographed objects of the *Inventaires*, questions naturally arose as to the identity and whereabouts of the missing owners. What happened to them?—and to those deported to the camps?—Boltanski seemed to be asking. At the same time, he was also instigating a disjunction of his own by transforming, through photography and museological classification, their personal belongings into documents and museum artifacts.

Famille D., too, takes on additional meaning. The years covered by the snapshots span from 1939 to 1964, encompassing the war, the occupation of Paris, as well as the decades following the liberation. His reconstruction of a "typical" family could be read as a case study of French attitudes toward the period, one that underscored the fact that for most people living in France at the time, life, at least on the surface, continued on as usual. Thus implicit in these snapshots of family gatherings and holidays was not only collective memories, but also the collective amnesia of French society as a whole. From this perspective, the mass memorial suggested by the anonymous faces of *Les Enfants de Dijon* and the *Monuments* evokes memories of the incomprehensible numbers who died in the concentration camps—the transformation of the children into black-and-white photographs being analogous to one of the more horrifying aspects of the Holocaust: the objectification of a people in the dehumanization of the Jews.

But Boltanski did not approach the subject of the Holocaust head-on until

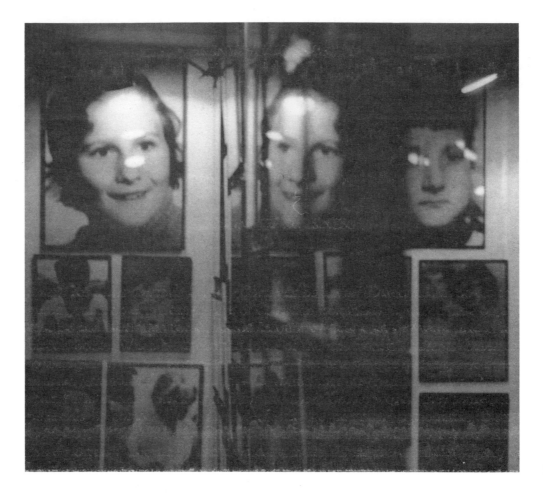

115. *Archives.* 1987. Detail.

1987, and when he did, it was in the context of a German exhibition. For his contribution to Documenta 8, held that summer, Boltanski chose to install his work in a cramped architect's office in the Fridericianum, a neoclassical structure that had been partially restored after it suffered extensive damage during Allied bombing and which has housed the periodic, international exhibition since 1955. In the small room, he constructed three cell-like partitions out of wire screen on which he hung over 350 black-and-white photographs. Of varying sizes, the prints were crudely sandwiched between two sheets of glass and held together with black tape. Ominously perched on top of the wire enclosures were a number of black clamp-on desk lamps that, once again, provided the piece's sole illumination.

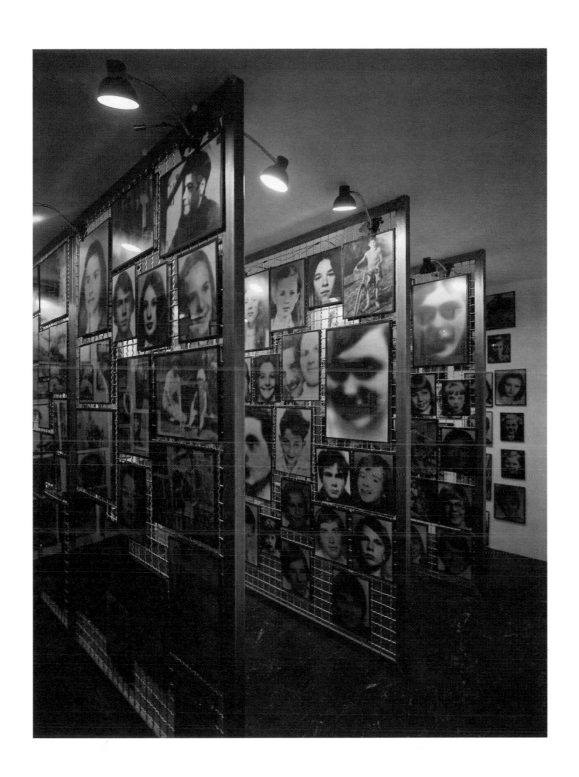

116. *Archives*. 1987.
Installation view,
Documenta 8, Kassel,
Germany, 1987.

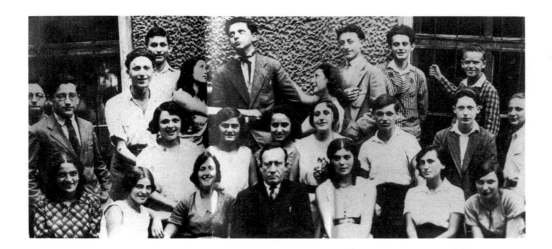

117. Photograph of graduating class, Chajes high school, Vienna, 1931.

The narrow cells, wire fencing, and extremely crowded conditions recalled the barracks of Auschwitz and other camps, as well as the *horror vacui* of his earlier installation at the C.E.S. Lentillères. The many faces, some life-size, unrelentingly stared out at viewers in the claustrophobic room. Some, apparently posing for a professional photographer, were frozen in artificial smiles. Others were enlarged to such an extent that they looked like ravaged skulls. Still others had adopted mugshot-like poses suggesting automated photo-booth portraits required for official French identity cards.

As its title, *Les Archives* (The archives) implies, the work functioned as the summation and documentation of Boltanski's work to that date, since its photographs had all appeared in other pieces, including *Famille D.*, which had been shown at the 1972 Documenta fifteen years earlier. The notion of an archive also suggested the meticulous records kept of concentration camp inmates by the Germans, as well as the lists of Jewish names gathered by the French police.

But despite all the powerful and haunting allusions to the Holocaust, Boltanski has steadfastly avoided using actual photographs or images from the death camps. Indeed, his only depictions of specifically Jewish children occurred in two subsequent series, *Le Lycée Chases* (Chases high school) and *La Fête de Pourim* (The Purim holiday). The stimulus for the former was a photograph of the graduating class of a private Jewish high school that Boltanski found in a book on Vienna's Jews. The class portrait, along with its caption, "All we know about them is that they were students at the Chases High School in Vienna in 1931," served as the preface to an exhibition catalogue for the

118. *Boîtes à biscuits datées contenant des petits objets de la vie de Christian Boltanski* (Dated biscuit boxes containing small objects from the life of Christian Boltanski). Installation view of "Local I" exhibition, Galerie Daniel Templon, Paris, 1970.

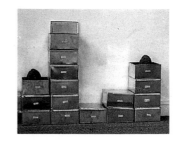

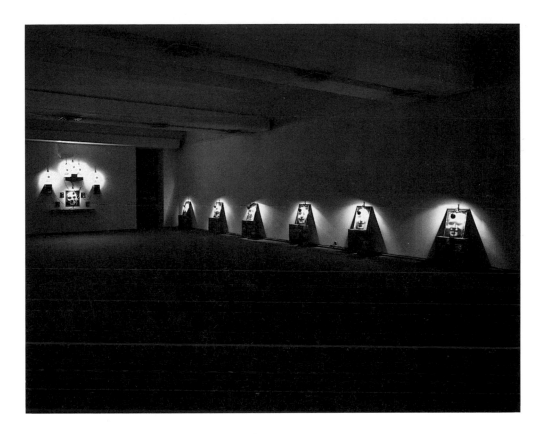

119. Installation view of "Le Lycée Chases," Kunstverein für die Rheinländer und Westfalen, Düsseldorf, 1987.

Kunstverein in Düsseldorf in 1987. For the pages that followed, Boltanski rephotographed each of the students in this casual group portrait of adolescents and their stern teacher. Enlarging the faces until they had lost any trace of individuality, Boltanski transformed them into skeletal vestiges—their eyes reduced to empty black sockets, any hint of a smile metamorphosed into the grimace of death.

For the exhibition itself, he assembled and framed in tin eighteen of these large, blurry black-and-white close-ups. Each was perched on top of two stacks of rusty biscuit tins. Clipped to the portraits were the extendable desk lamps Boltanski had used in *Archives*. Here, rather than illuminating the images below, the interrogation-room-like lamps acted to obscure them, creating circles of reflected light on the glass protecting the photographs. The metal frames recalled those of *Famille D.* and *Les Habits de François C*, and the tins were very similar to ones he had used in a work from 1970, *Boîtes à biscuits datées con-*

tenant des petits objets de la vie de Christian Boltanski (Dated biscuit boxes containing small objects from the life of Christian Boltanski), in which little objects that he had fabricated for a specific amount of time each day were placed into biscuit boxes. When he unearthed some of the tins from his parents' basement to use again in the Salpêtrière installation —the first time he had employed them in arrangements with photographs—he found that they had rusted, which made them seem ancient. Stacked high for the *Lycée Chases* works, they looked like pedestals of corroded coffins underneath the portraits surmounting them.[48] Composed of only trace amounts of silver gelatin on specially prepared paper, these portraits eloquently and ironically made visual the ultimate fragility of both photographic representation and human identity.

From 1987 to 1990, Boltanski made numerous variations based on the Chases graduating class and on a 1939 group portrait of Jewish children posing in costume for Purim, the holiday that celebrates the narrow escape of Persian Jews from mass execution.[49] Some, titled *Reliquaires* (Reliquaries), were three-dimensional sculptures, the ubiquitous rusty biscuit tins again serving as supports for the macabre photographs. *Autels* (Altars) grouped photographs and tin biscuit boxes on the wall in symmetrical arrangements, à la *Monuments*, but with clamp-on lamps replacing the incandescent light bulbs. In others called simply *Odessa*,

120. Double-page spread from the artist's book *Le Lycée Chases: Classe terminale du Lycée Chases en 1931: Castelgasse, Vienne* (Chases high school: Senior class of the Chases high school in 1931: Castelgasse, Vienna). 1987.

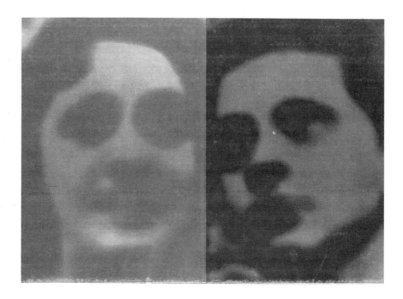

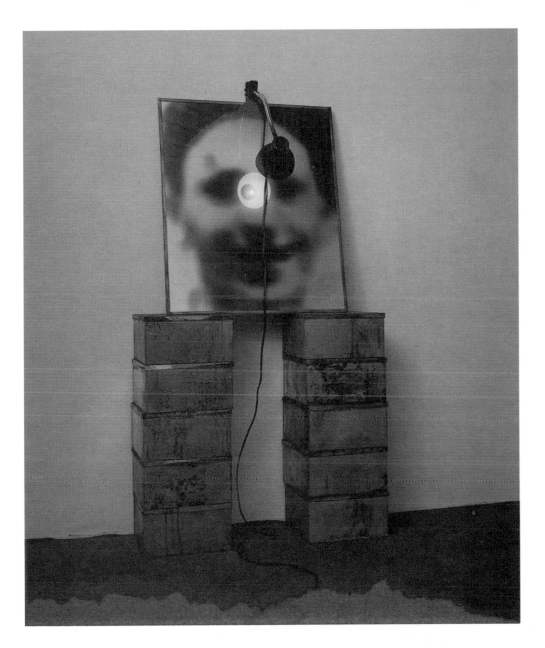

121. *Le Lycée Chases*
(Chases high school), detail. 1988.

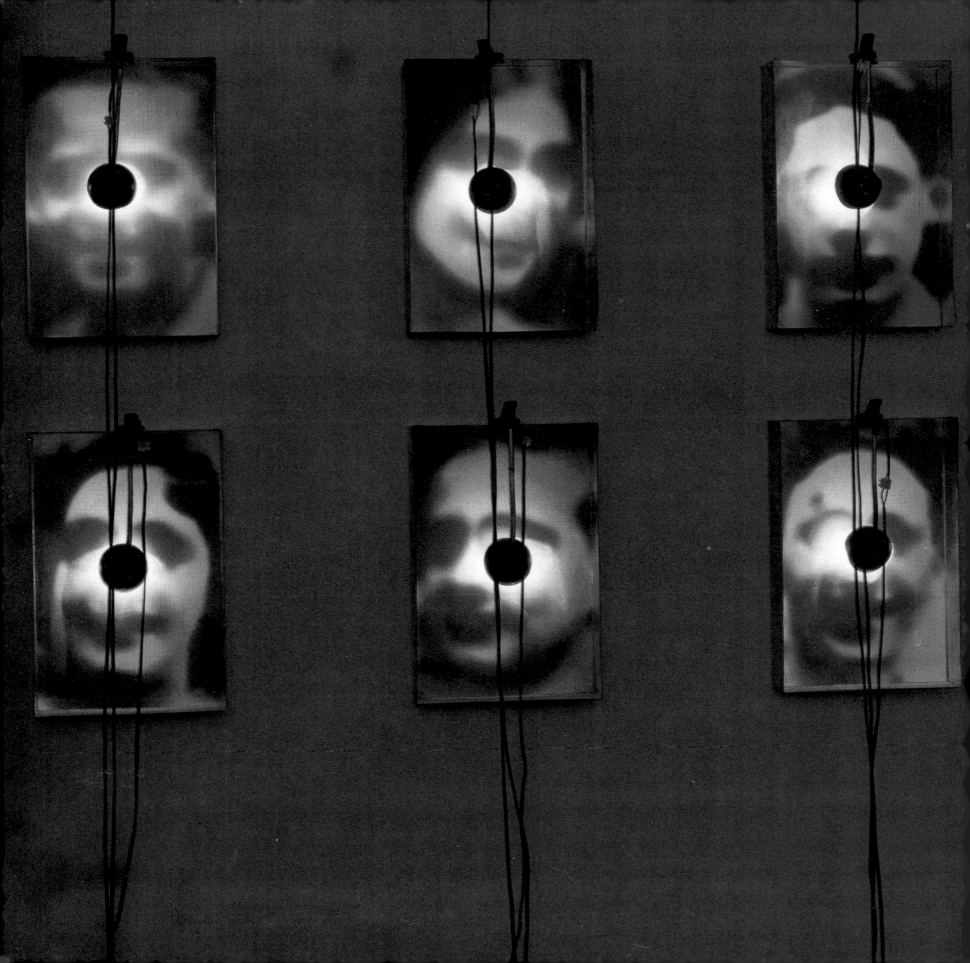

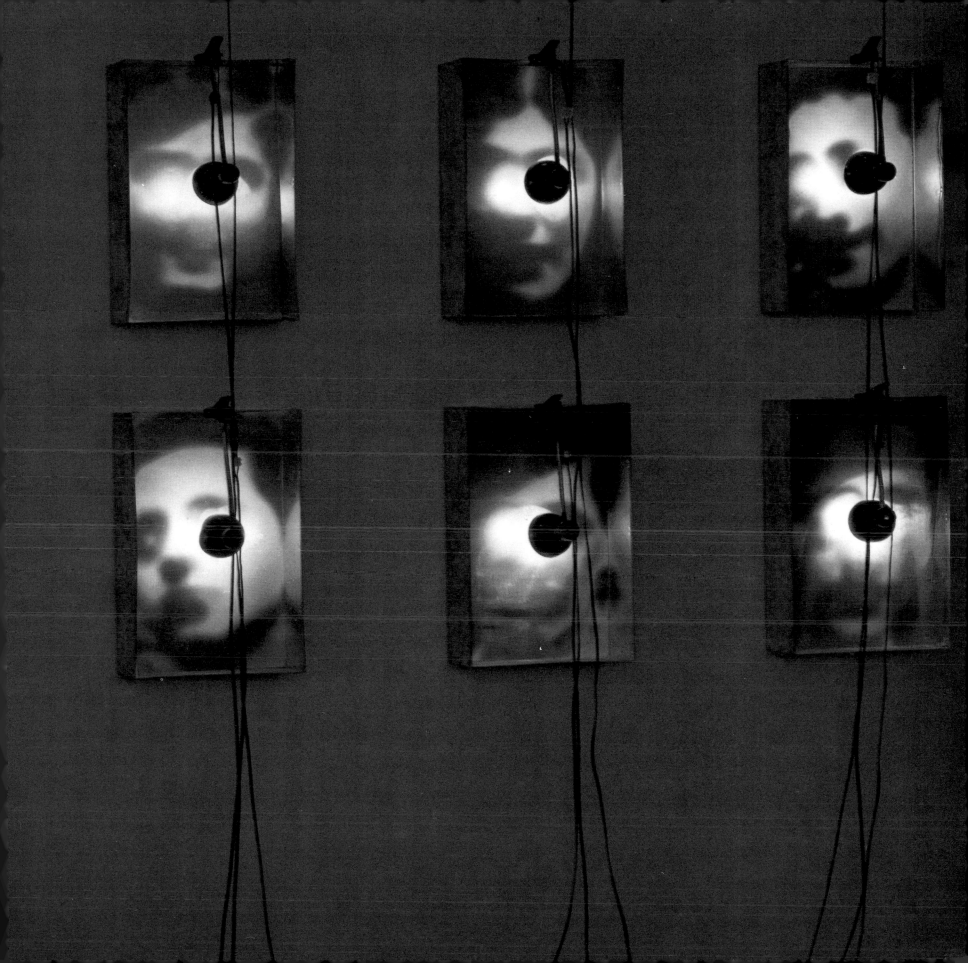

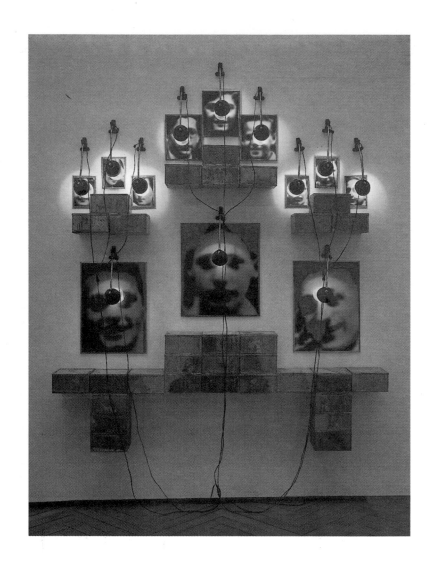

pp. 106-107:
122. *Le Lycée Chases*
(Chases high school), detail.
1988. Installation view,
"Lessons of Darkness,"
Museum of Contemporary
Art, Chicago, 1988.

123. *Autel Chases* (Altar to the Chases high school). 1987.

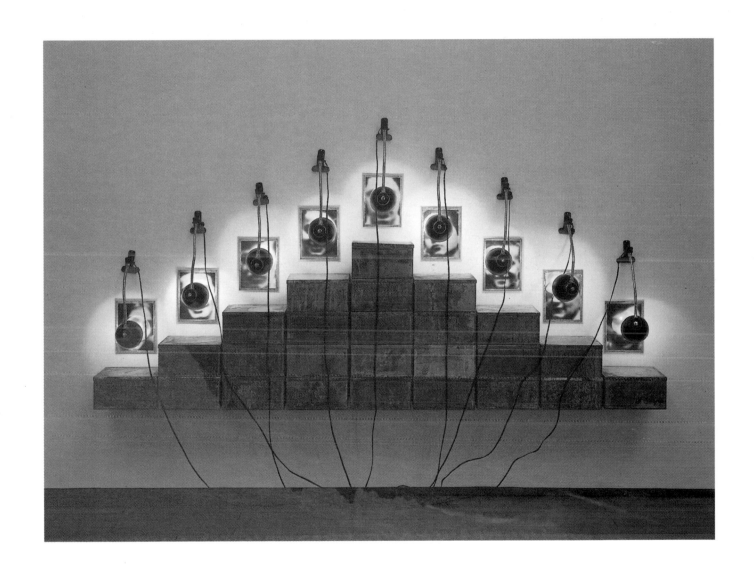

124. *Autel Chases* (Altar to the Chases high school). 1988.

125. Photograph of Purim
celebration at a Jewish school in
France, 1939.

close-ups of the children were encircled with lights. In still others, enlarged and
blurry photographs were placed in tin drawers like those used in the Plasticine
Reconstitutions. Hung vertically on the wall, the drawers were covered with wire
mesh and the desk lamps pushed up claustrophobically against them to create
even ghostlier impressions of the already substantially emaciated images.

 In 1988, Boltanski introduced a new formal element into *Canada*, another
series of works about the Holocaust that took its title from the euphemistic
name the Nazis gave the warehouses where interned Jews left their personal
belongings. The first version, a monumental installation at the Ydessa Hende-
les Art Foundation in Toronto, used over six thousand second-hand garments.
As Boltanski has explained, clothes, like photographs, can connote death.
"What they have in common is that they are simultaneously presence and
absence. They are both an object and a souvenir [or memory] of a subject,
exactly as a cadaver is both an object and souvenir of a subject."[50] Hung by nails
and covering every inch of a specially constructed room, the brightly colored
clothes were illuminated only by the now-familiar black clamp-on lamps.

 In another variation for an exhibition titled "Réserves: La Fête de Pourim"

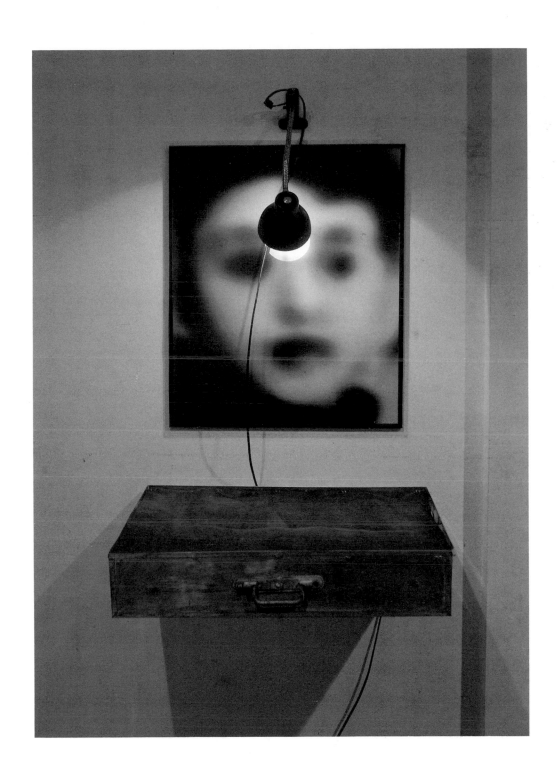

126. *Réserves: La Fête de
Pourim* (Reserves: The
Purim holiday). 1989.

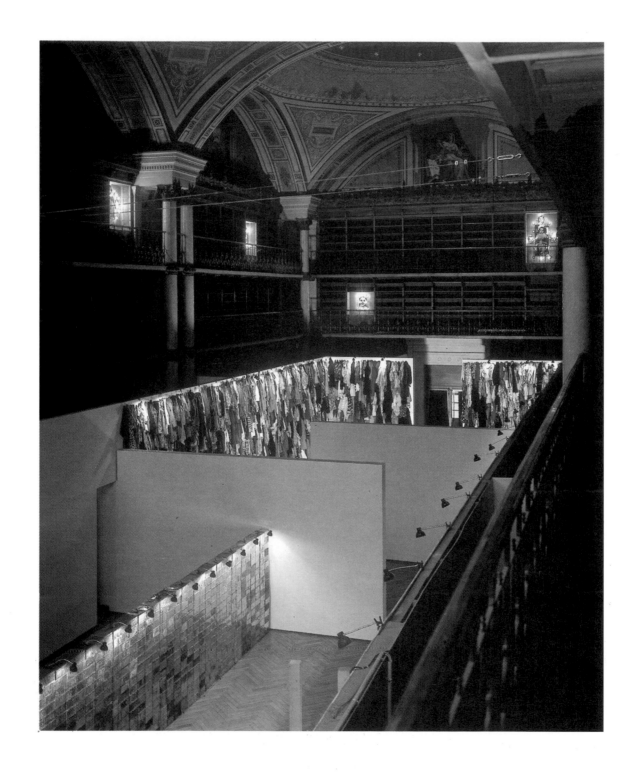

127. Installation view, "Reconstitution," Musée de Grenoble, France, 1991.

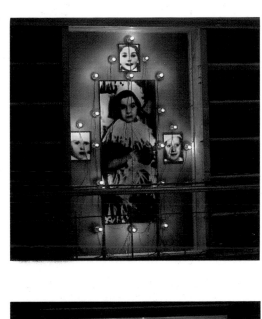
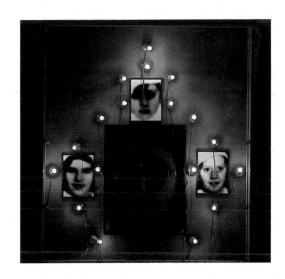
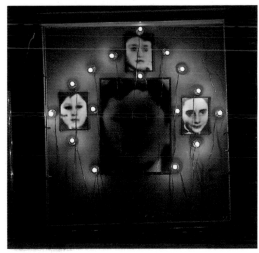
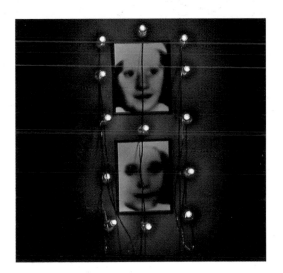

128. *Monument (Odessa)*. Details,
"Reconstitution," Musée de Grenoble, France, 1991.

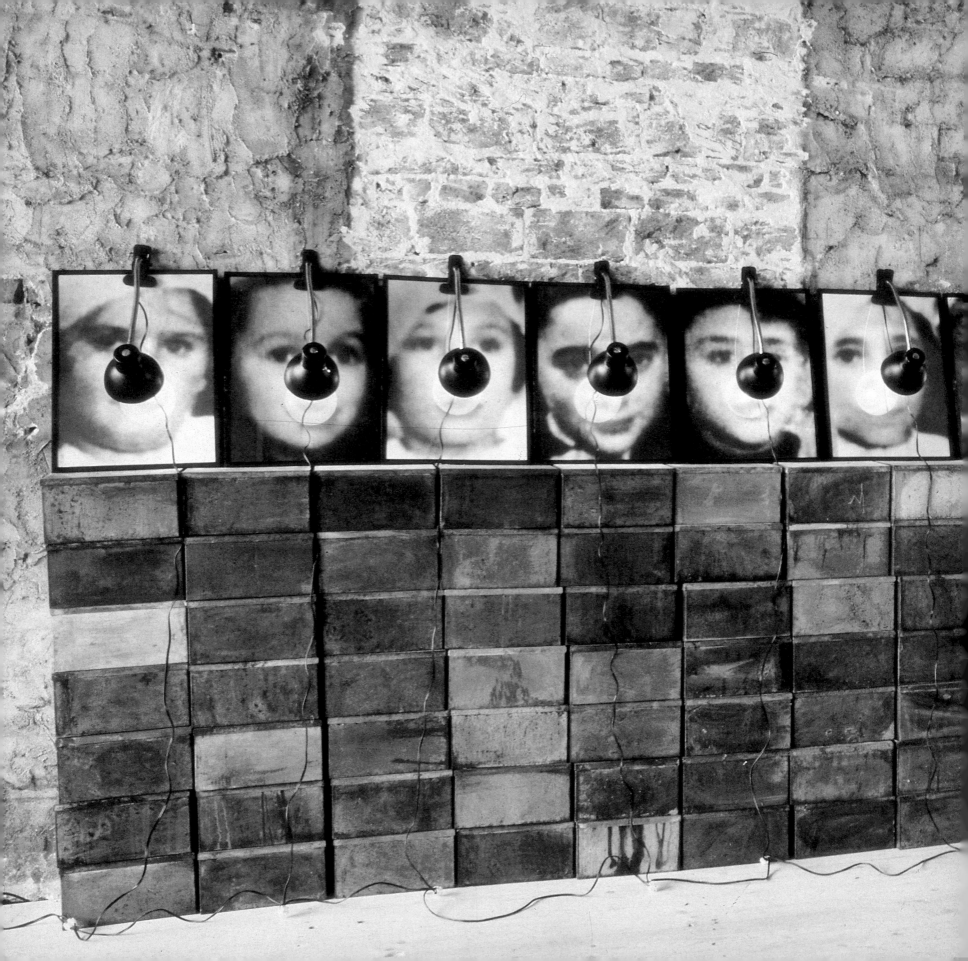

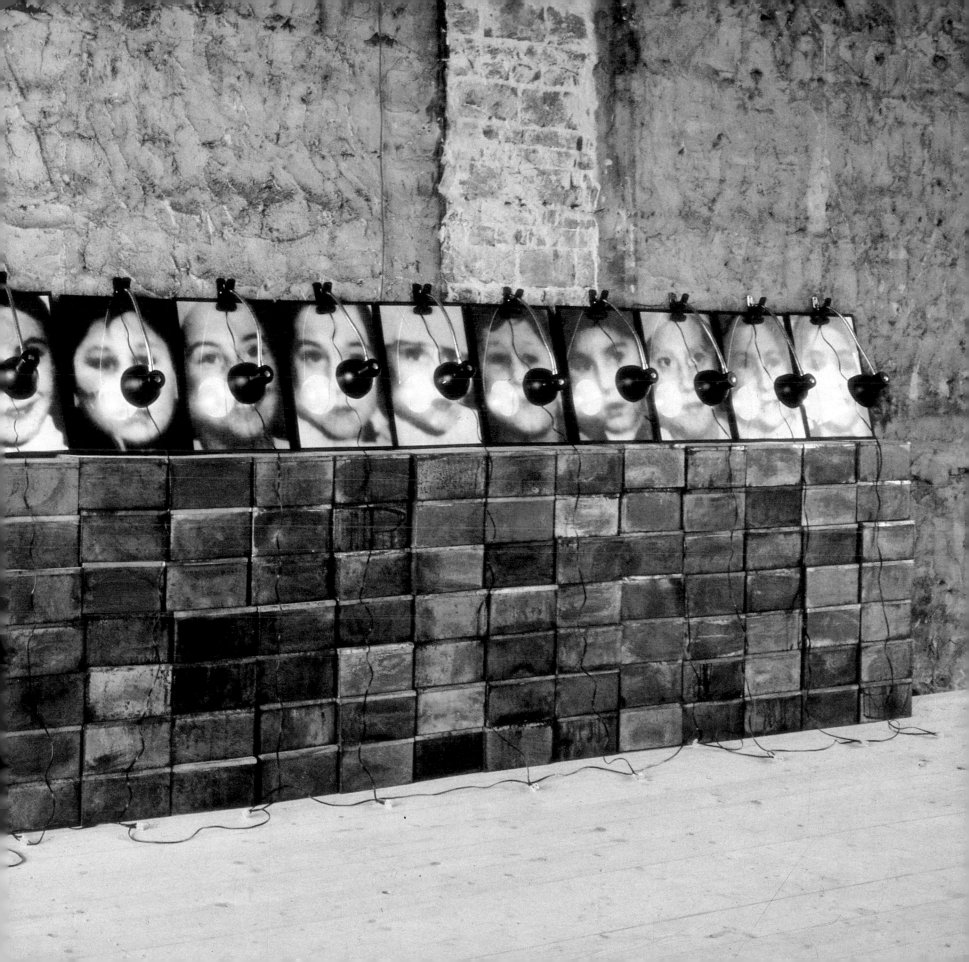

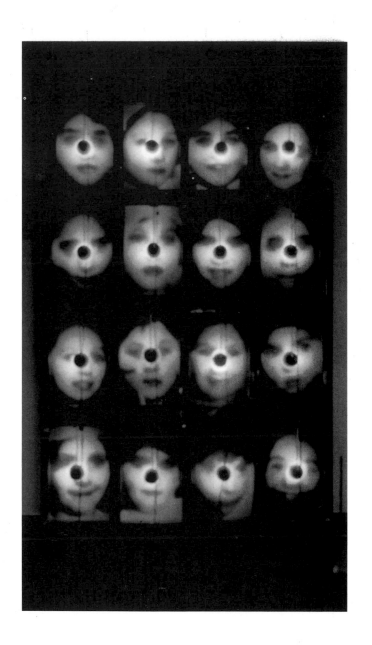

pp. 114-115 :
129. *Monument: la Fête
de Pourim* (Monument: The
Purim holiday). Installation
view, Galerie Bébert,
Rotterdam, The
Netherlands, 1988.

130. *Reliquaire* (Reliquary). 1989-1990.

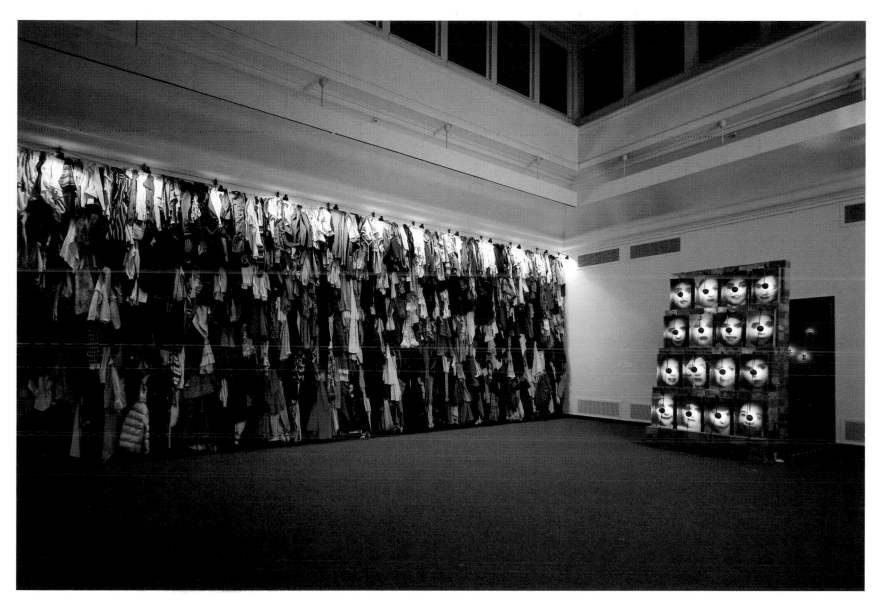

131. Installation view, "Inventar,"
Hamburger Kunsthalle, Hamburg, Germany, 1991, with
Réserve: Canada, 1988, and *Reliquaire* (Reliquary), 1989-1990.

(Reserves: The Purim holiday), at Basel's Museum für Gegenwartskunst, Boltanski placed over a thousand pounds of used clothing on the floor and lit them, again, with desk lamps placed high up where the walls met the ceiling. The regular pattern of the lamps' electrical cords created a measured rhythm of black lines that chillingly contrasted with the haphazardness of the strewn garments. To see the exhibition, visitors had to walk on the soft clothes, and with each step, they increasingly felt as if they were walking on human bodies. In Boltanski's schema, spectators, like artists, are implicated by their actions. Treading on the clothes emptied of their owners emphasized absence, which was symbolically connected with murder and death.

Even with these works, however, Boltanski obstinately refrained from citing the Holocaust directly. Although he used pre-war photographs of Jewish adolescents, there was no way of knowing whether or not they had survived the war.[51] And despite the assumption made by many that the children pictured in the *Monuments* and *Les Enfants de Dijon* were concentration camp casualties, they were "neither heroes nor victims," as Boltanski has pointed out, but "'dirty kids' that one sees every day."[52] Moreover, to distance his clothes pieces from the camps, he always prominently arranges several items, such as a tee-shirt with the logo from the 1989 Batman movie, in order to emphasize that they are contemporary artifacts.

It was a grisly, sensationalized death that Boltanski exploited in another series, *El Caso*, which was first shown at the Centro de Arte Reina Sofia in Madrid in May 1988. Named after a Spanish tabloid that reproduces family snapshots of murder victims next to forensic-style photographs of their mutilated corpses, this work bore witness to Boltanski's obsession with the objectification of life in death. Rephotographed close-ups of the victims, again illuminated by the harsh glare of desk lamps pushed unforgivingly up against their glass-covered faces, seemingly hovered above tin biscuit boxes containing the newspaper photos of their corpses. In another room, folded linen sheets were stacked on crude wooden shelves that extended from floor to ceiling, suggesting shrouds used to wrap the dead. (The Reina Sofia was formerly a hospital.) In an artist's project for the catalogue, Boltanski illustrated the murder sites on semitransparent, vellumlike paper. Bizarrely desolate as a rule, these scenes conveyed a sense of stifled and menacing silence.

The newsprint "cadavers" hidden in the tin biscuit boxes of the Reina Sofia installation were reconstituted as the crux of another piece also titled *El Caso*. Commissioned by the Swiss art journal *Parkett* as a limited-edition multiple, the work featured seventeen rephotographed images of corpses from *El Caso* in a pocket-size booklet. Measuring only 2 x 2 ½ inches, these gruesome images were held together by tiny metal ring binders. As with many of Boltanski's later

132. *Canada*. 1988. Installation view, Ydessa Hendeles Art Foundation, Toronto, 1988.

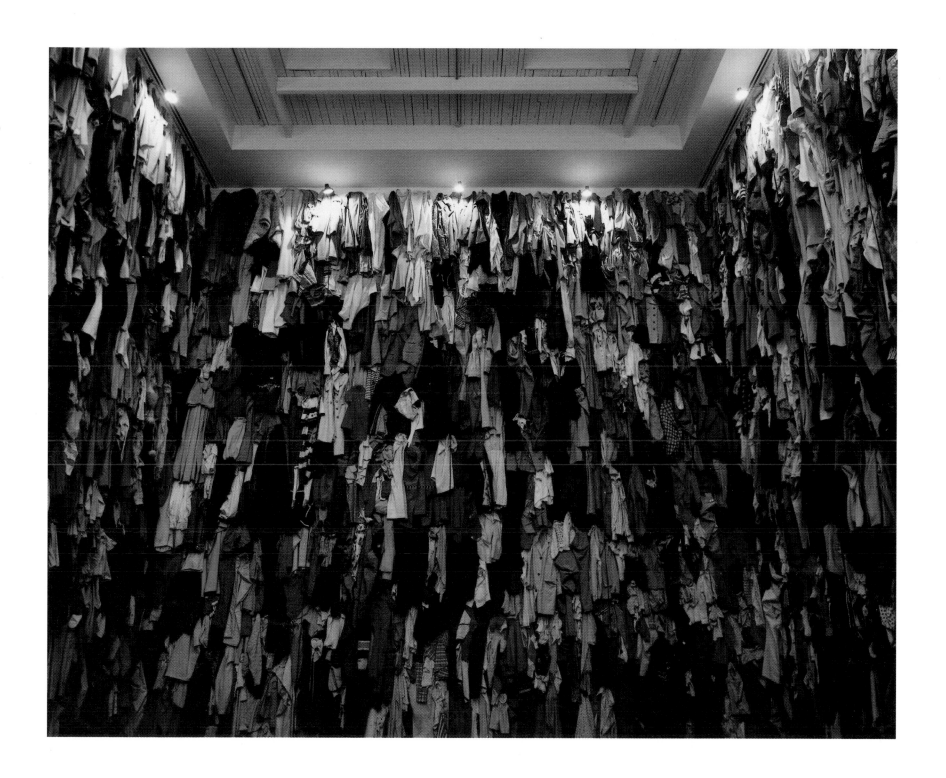

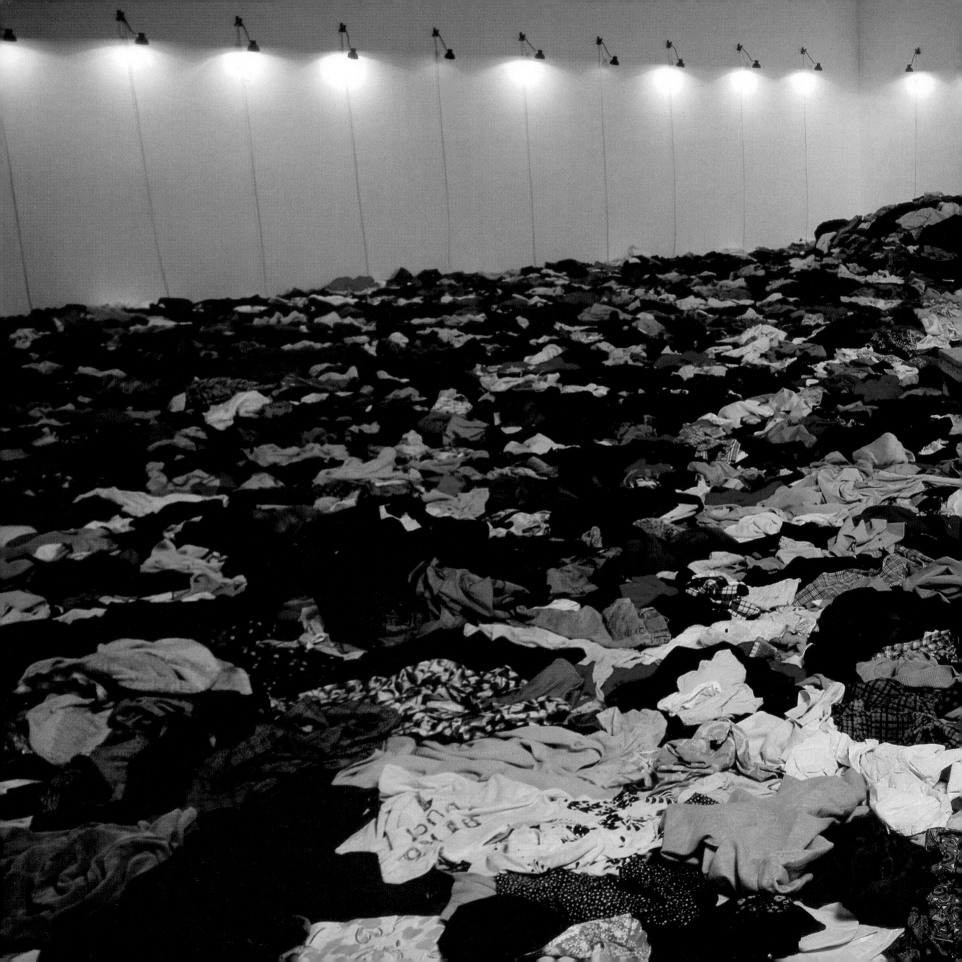

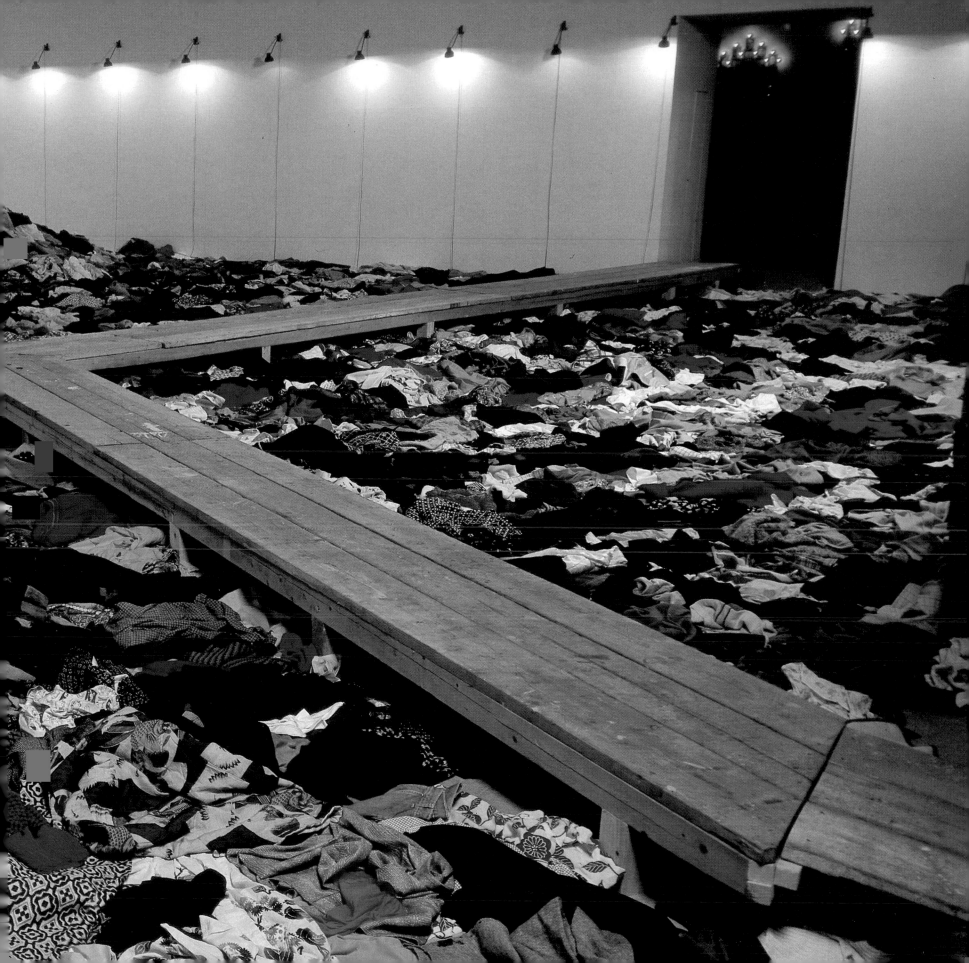

134. Cover of the Spanish weekly *El Caso*, May 1990.

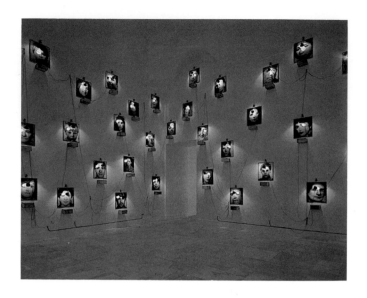

135. 136. *El Caso*. 1988. Installation views, Centro de Arte Reina Sofia, Madrid, Spain, 1988.

pp. 120-121:
133. *Réserve: Lac des morts* (Reserve: Lake of the dead). 1990. Installation view, Institute of Contemporary Arts, Nagoya, Japan, 1990.

pieces, the *El Caso* multiple was difficult and disturbing; like the act of walking on the used clothing, viewing its images implicated the audience. If Boltanski has been a vendor of corpses, as he has claimed, then by extension, the viewer has, by the mere act of looking, been their consumer.

The *El Caso* project eerily recalled Boltanski's early films, in particular, *Tout ce dont je me souviens*, which showed a man mercilessly beating a motionless woman with a stick. The two decades that separate these works, however, illustrate a significant shift in his approach to art-making. Simply put, *Tout ce dont je me souviens* was a simulation acted out by people, while *El Caso* remained firmly grounded in reality—what we saw were images of the dead bodies of real people. Reprinting the violent and brutal deaths pictured on the pages of the Spanish tabloid was the closest Boltanski would come to suggesting the horrific documentation of concentration camp victims featured, for example, in the film *Nuit et brouillard (Night and Fog)*. They demonstrated, as well, the extremes to which Boltanski's obsession with death would take him.

Newspaper clippings of victims had also formed the crux of his 1973 work

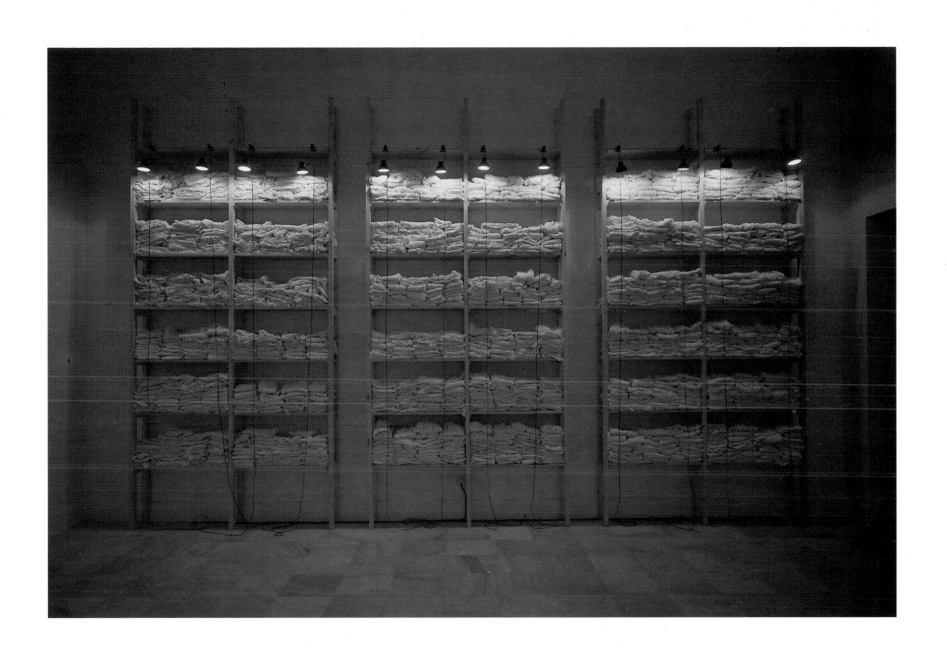

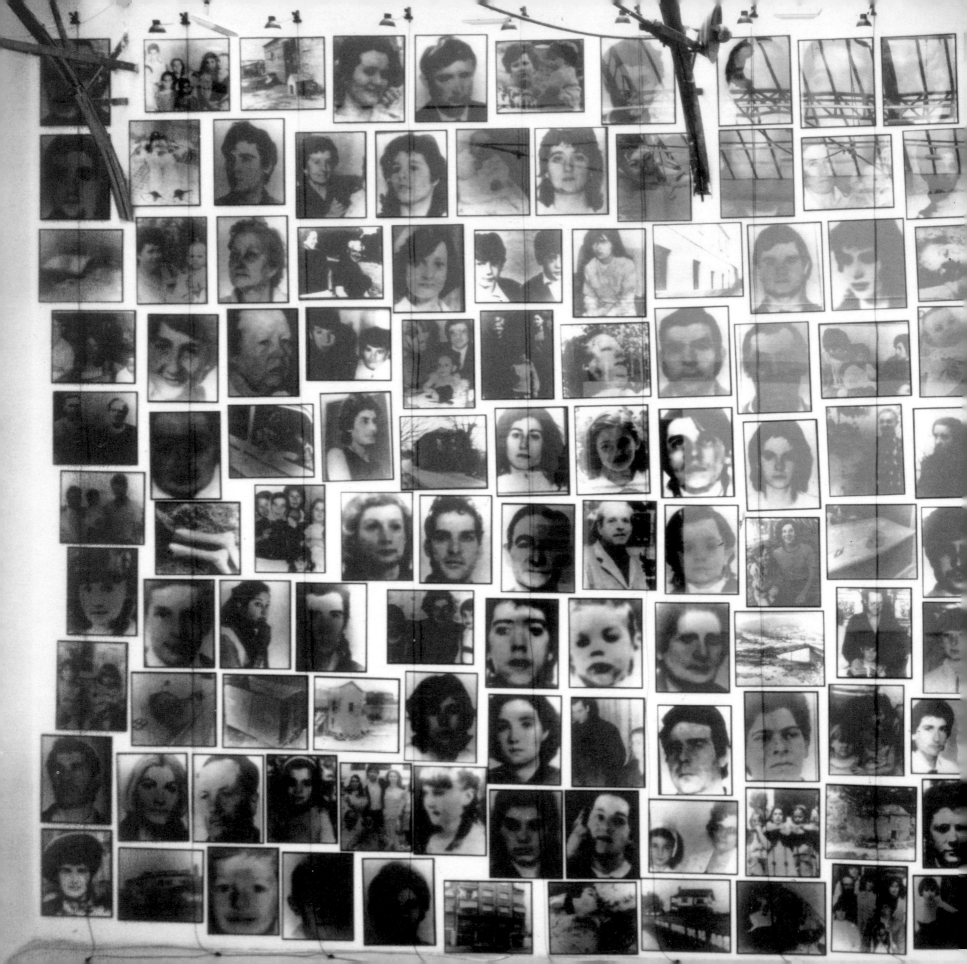

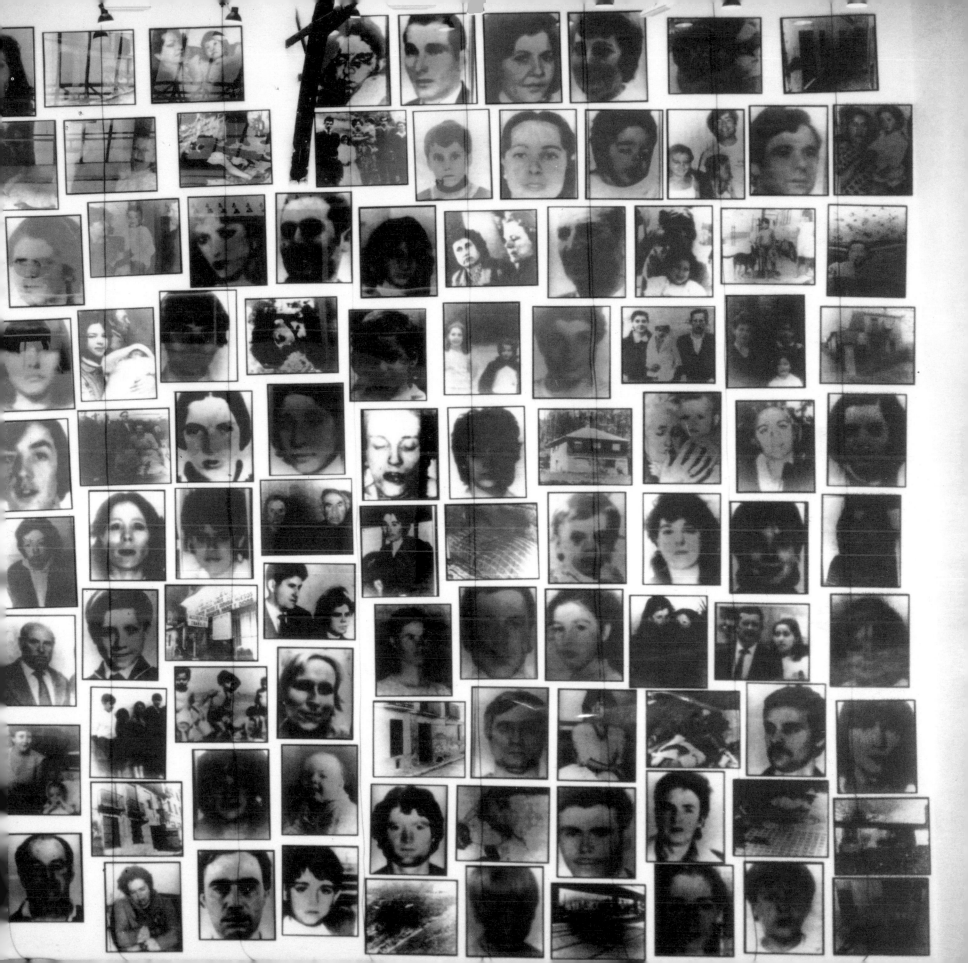

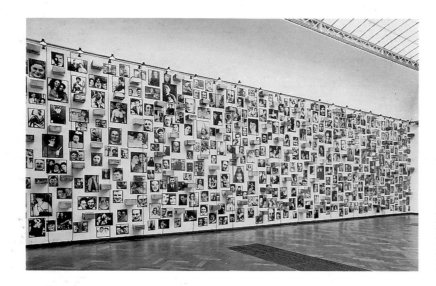

138. *Les Archives: Détective* (Archives: Détective). 1987. Installation view, "From the Europe of Old," Stedelijk Museum, Amsterdam, Holland, 1987.

pp. 124-125:
137. *Archives de l'année 1987 du journal El Caso* (Archives from 1987 from the newspaper *El Caso*). 1989. Installation view, "Archives," Galerie Ghislaine Hussenot, Paris, 1989.

Détective. In 1987, after finding all the issues of *Détective* from 1972 at a local flea market, Boltanski embarked on another series using images from the French tabloid. In one version, first shown at the Stedelijk Museum in Amsterdam and now in the collection of the Ydessa Hendeles Art Foundation, Boltanski interspersed various-sized enlargements of the rephotographed images with biscuit boxes along an enormous wall, and top-lit them again with black clamp-on lamps. The piece was titled *Les Archives: Détective* (The archives: *Détective*), and its biscuit boxes ostensibly contained the articles retailing the innocent deaths or murderous crimes of the pictured individuals.

In another version, included in the American and Canadian tour of the 1988 retrospective exhibition "Lessons of Darkness," Boltanski used the newspaper images themselves, as he had in his 1973 version of the piece. These he taped to the front of cardboard cartons scribbled with random dates from 1972, which were then stacked on crudely constructed wooden shelves. This archive—whose title recalled Boltanski's 1987 Documenta piece—was marked by closure more than disclosure. Its cardboard boxes, it was intimated, housed documents concerning the individuals whose images were taped to the outside. In reality, they contained unrelated newspaper stories, which demonstrated, as the 1973 version had, that once separated from their identifying captions, it became impossible to distinguish the murderers from the murdered.[53]

For an exhibition at the Musée d'Art Moderne de la Ville de Paris in 1989, which explored the relationship of contemporary art to the historicizing function

139. Photographs clipped from the weekly *Détective*, 1972, by Christian Boltanski.

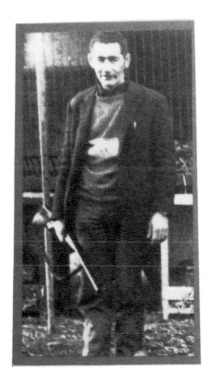

140. Italian cemetery.
Photograph by
Gilles Ehrmann
reproduced in *Traverses*
(Paris), September 1975.

of the museum, Boltanski created another version of his archives. To see *Réserve du musée des enfants* (Storage area of the children's museum), as it was titled, viewers had to descend a staircase previously off-limits to the public. On the wall of an antechamber below, fifty-five large, blurry black-and-white photographs of children were formed into a monumental rectangle, surmounted by clamp-on lamps whose cords fell over and partially obscured the young faces. Here again, cropping played a crucial role. Zeroing in so tight that, at times, a cheek or two fell by the wayside, Boltanski successfully created the impression that the over-life-size faces were in a state of decomposition. In the next room, a shock of color greeted viewers. From floor to ceiling, standard metal shelving housed carelessly folded piles of children's clothing lit, as in the antechamber, by arched, institutional lamps.

The work's location in the museum's reserves, an area used to store works of art not on exhibition, contributed to its melancholy ambience. Susan Stewart has noted that it is to out-of-the-way places like attics and cellars that ordinary mementos are removed to make way for "real life":

> Other rooms of a house are tied to function (kitchen, bath) and presentation (parlor, hall) in such a way that they exist within the temporality of everyday life, but the attic and the cellar are tied to the temporality of the past, and they scramble the past into a simultaneous order which memory is invited to rearrange: heaven and hell, tool and ornament, ancestor and heir, decay and preservation. The souvenir is destined to be forgotten; its tragedy lies in the death of memory, the tragedy of all autobiography and the simultaneous erasure of the autograph.[54]

Although Stewart refers to personal souvenirs, her comments about the attic and cellar also apply to museums, themselves oversized repositories of immortalized memories in the form of works of art. Pieces relegated to storage are, in fact, often forgotten, in spite of the museum's specific charge to commemorate. Museum archives are, in a funny way, particularly poignant places, documenting and chronicling the history of the histories they are charged to preserve.

In 1990 Boltanski embarked on a series titled *Les Suisses morts* (The dead Swiss), for which he clipped illustrated obituaries from a Swiss newspaper. Provided by family members, the photographs printed with the notices were usually smiling snapshots of the recently deceased or more serious, studio portraits commemorating significant events—a wedding, graduation, and so forth. Again, Boltanski reshot the already grainy images, enlarging them to slightly over life size, but, this time, taking care not to distort them as he had his Lycée Chases students. Rather, Boltanski wanted to emphasize their normality. "Before, I did pieces with dead Jews but 'dead' and 'Jew' go too well together. There is noth-

141. *Réserve: Détective*.
1988. Installation view,
"Inventar," Hamburger
Kunsthalle, Hamburg,
Germany, 1991.

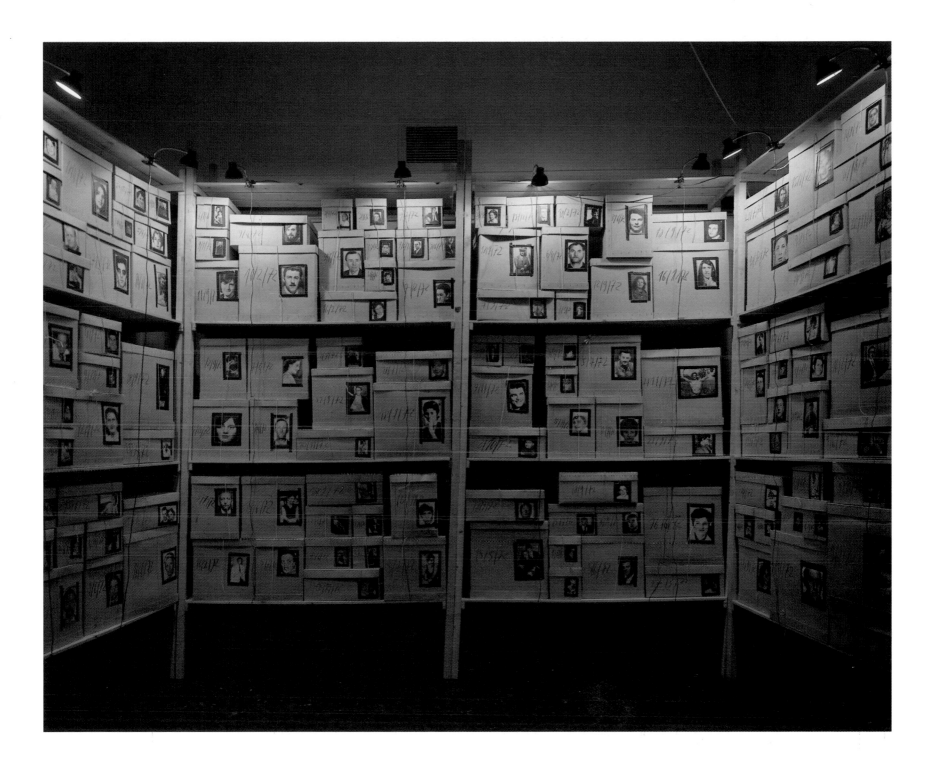

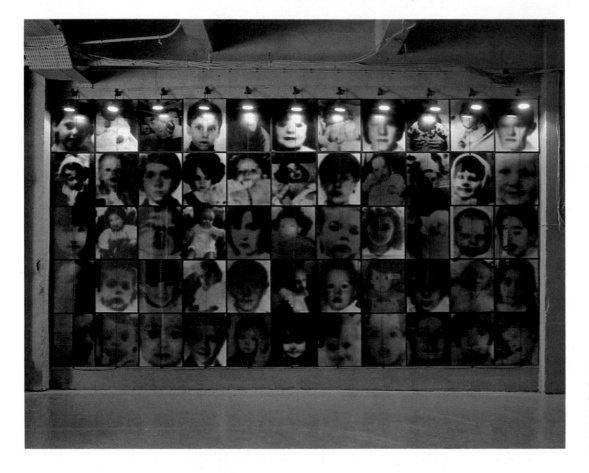

142. 143. *Réserve du musée
des enfants* (Storage area
of the children's museum).
1989. Installation view,
Musée d'Art Moderne
de la Ville de Paris, 1989.

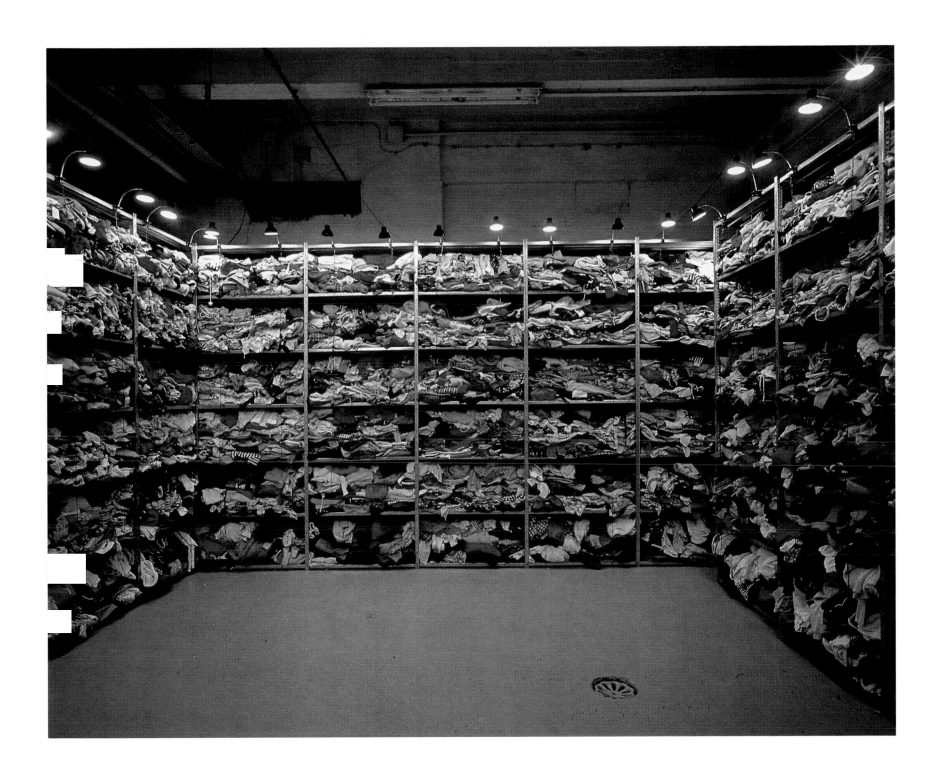

ing more normal than the Swiss. There is no reason for them to die, so they are more terrifying in a way. They are us."[55]

Boltanski showed *Les Suisses morts* in a number of different configurations. In one version, for the Whitechapel Art Gallery in London, the dead were stacked one atop another, from wall to ceiling, and lit by the omnipresent clamp-on lamps. At the Musée de Grenoble, they were placed at regular intervals— even, blank white spaces alternating with the deathly images—creating an uneasy pattern. For the 1991 Carnegie International in Pittsburgh, Boltanski increased their size. Blurrier than before, the images of the dead Swiss were jammed frame-to-frame from floor to ceiling along the two walls of an inclined corridor leading to the museum's staff offices. Characteristically, as he had at the 1987 Documenta, Boltanski chose a site not usually used for art installations. Lit, again, only by the desk lamps, the glass-covered photographs mirrored back the images of the dead on the facing walls. The result was disconcerting; the reflective gray walls had a slick, almost corporate feel about them that was definitely at odds with the photos that hung from them. While the *Lycée Chases* and *Fête de Pourim* series had shifted the focus away from individual viewers, who could solace themselves with the notion that the concentration camps were perhaps an aberration, an irrepeatable nightmare of history, *Les Suisses morts* was ineluctably current, everyday and banal—its impassive offering of quotidian mortality a chilling rebuke to hopes of indemnity.

Particularly moving, in its own morbid sort of way, was also *Réserve: Les Suisses morts* (Reserves: The dead Swiss), 1990, which was first shown at the Palais des Beaux-Arts in Brussels. There, Boltanski constructed a narrow, claustrophobic corridor from biscuit tins onto which he had glued faces clipped from Swiss obituaries. Like fallen soldiers in unmarked graves or the unidentified remains in a decrepit columbarium, these individuals, who will forever be conserved as part of this work, remain doomed nonetheless to perpetual obscurity.

The contrast between the tempered tenor of *Les Suisses morts* and the ghoulish content of the *El Caso* series mirrors Boltanski's earlier vacillation between the mediated approach of *Vitrines de référence* and the violent expressionism of his films. By simulating a museological and ethnological stance in his early work and later in his *Archives*, Boltanski was able to broach the subject of death from a distanced, less emotional vantage point than he exhibited in his choice of mutilated corpses lifted from the Spanish tabloid. With *Archives* and *Réserves*, which refer to locales where objects no longer perform their original functions, Boltanski again mocked the futility of attempts to preserve. Like the earlier *Vitrines*, they suggested loss—the cessation of life—that inevitably accompagnies storage and categorization.

144. Obituaries from the
Swiss daily *Le Nouvelliste
du Valais*, 1990.

Whereas, according to Boltanski, the biscuit boxes of *Réserves: Les Suisses morts* stored pillaged obituary notices, *Les Archives de C.B. 1965-1988* (The Archives of C.B. 1965-1988) contained his personal papers. Devoid of images and forming a wall of stacked tin boxes, they could easily be mistaken for a minimal sculpture from the seventies were it not for the ubiquitous clamp-on lamps. (As Boltanski himself has noted, he came of age artistically in the seventies when Minimalism and, in particular, the serial boxes of Donald Judd were at their most influential.[56])

With this personal monument, now in the collection of the Musée National d'Art Moderne in Paris, Boltanski succeeded in preserving and documenting, for the indeterminate future, details of his own existence. Here was proof that he lived at such-and-such address and that he received a letter from such-and-such person on such-and-such day. Another way to look at it, of course, is that by selling off his past, Boltanski was registering his own ironic views on the deification of artists in the twentieth century. Artists are like saints or stylites, he has said, in much the same way that:

> museums that want to have Mondrians today are very similar to the medieval cities that want to have relics of their saint. If they couldn't possess the bones of a great saint, they found a local saint, or invented one. I was very moved when the Japanese

133

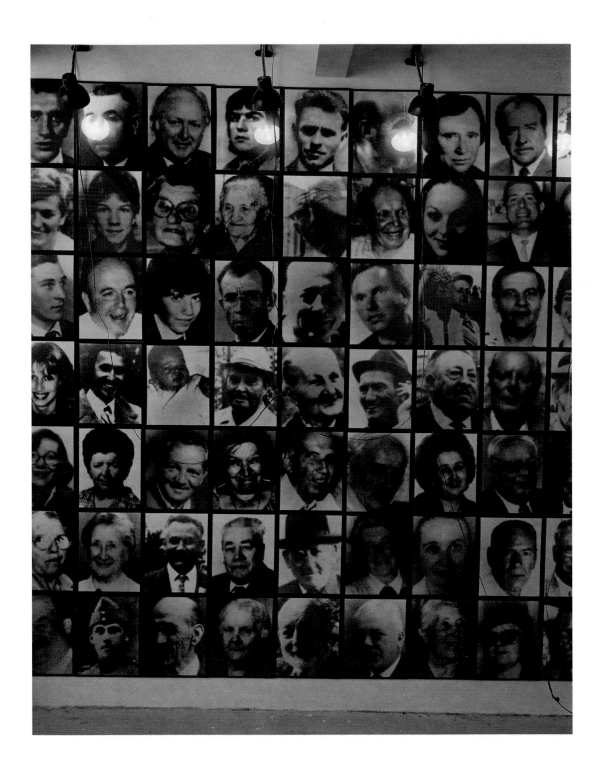

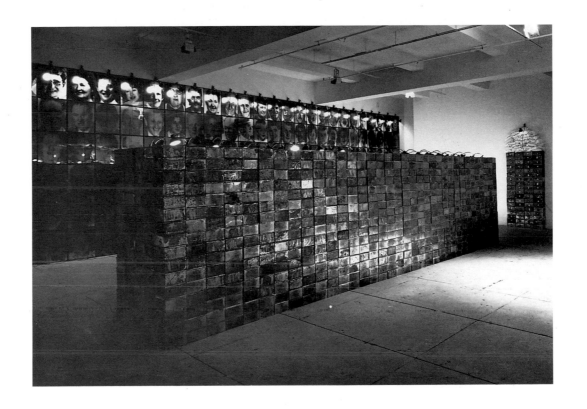

Above:
146. *Les Suisses morts* (The dead Swiss), 1990.
Installation view,
Marian Goodman Gallery,
New York, 1990.

p. 134:
145. Detail.

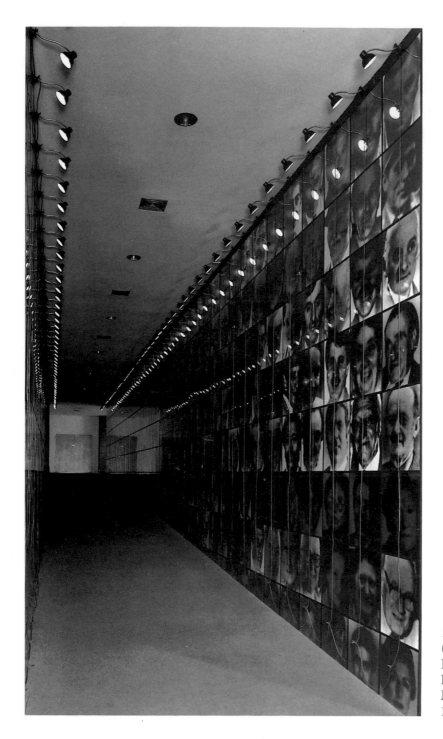

147. *Les Suisses morts*
(The dead Swiss), 1991.
Installation view, Carnegie
International, Carnegie
Museum of Art, Pittsburgh,
1991.

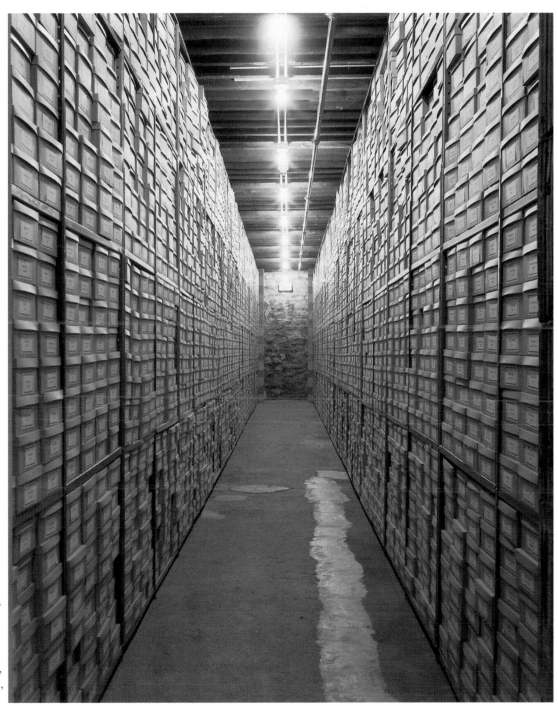

148. *La Réserve du Carnegie International* (The storage room of the Carnegie International). Installation view, Carnegie International, Mattress Factory, Pittsburgh, 1991.

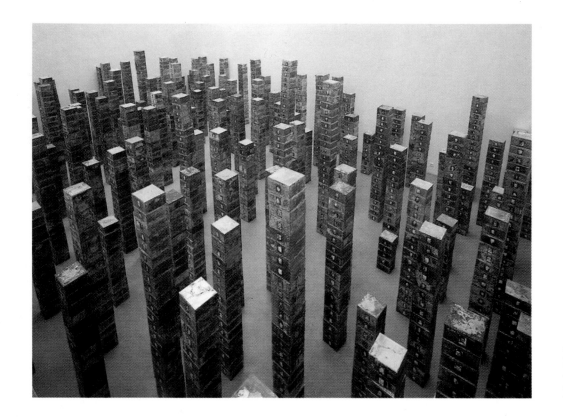

149. 150. *Réserve: Les Suisses morts* (Reserve: The dead Swiss), 1990. Installation views, Galerie Ghislaine Hussenot, Paris, 1991.

bought the Van Gogh [*Sunflowers* painting]: to think that these people who make computers needed this old piece of canvas, as if it were magical, because Van Gogh is one of the great western saints. The paintings of Van Gogh only exist because he is considered a great saint who led an exemplary life.[57]

This work recalled an early performance and mail-art piece of his, *Musée social: Dispersion à l'amiable du contenu des trois tiroirs du secrétaire de Christian Boltanski* (Social museum: sale of the contents of three drawers from Christian Boltanski's desk). In late May of 1972, Boltanski had mailed to his usual correspondents three typed pages listing forty-seven of his belongings and an invitation to their auction on 5 June of that year. The objects to be sold included the negative for the mail-art work *Photographie de ma petite soeur en*

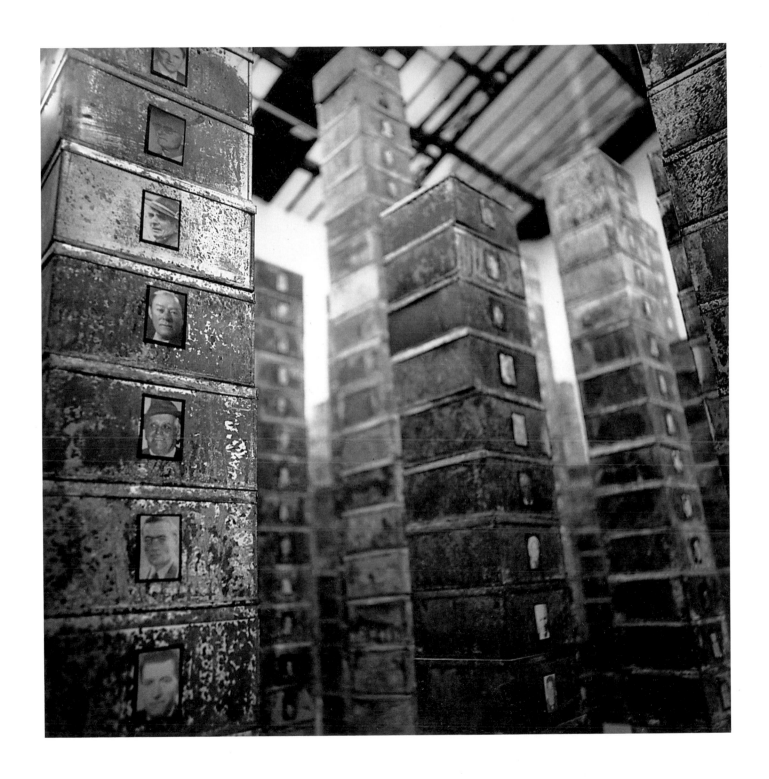

train de creuser sur la plage de Granville (Photograph of my little sister digging on the beach at Granville), correspondence, invitations to exhibitions, and unpublished essays by the artist. Like the *Vitrines*, this performance cannibalized some of his earlier work. The sale was intended to spoof auctions of the ephemera of "famous" artists or figures whose personal possessions have taken on the air of "relics." Boltanski, however, was not that well known at the time, so few of the items sold and those that did went at very low prices.[58] Nevertheless, with this performance, Boltanski was both conserving and erasing traces of his existence. By selling his papers, on the one hand, he was enhancing the possibility of their preservation since someone who buys something at auction is unlikely to turn around and throw it away. On the other hand, this very dissemination makes the work of the future historian or archivist extremely difficult.

Les Archives de C.B. 1965-1988 solved some of the problems posed by the 1972 work. As the piece was sold to the Musée National d'Art Moderne, its documents will be conserved, one assumes, for posterity in the work's hundreds of biscuit boxes. To make it, Boltanski had removed from his life and his studio years of accumulated clutter, shuffling his past into the boxes and out of sight, both from himself and from his audience. Once again, though, his irrepressibly ambivalent and contradictory spirit was in evidence. True, the papers and ephemera were saved in an archive, but lacking any index or order, it is, practically speaking, unusable.

Just as real documents putatively constituted the hidden contents of Boltanski's personal archives, real documents were an essential component of a two-part work commissioned for an exhibition in Berlin, "Die Endlichkeit der Freiheit" (The limitation of freedom), during the summer of 1990. The organizers of the exhibition, which was hastily assembled to take place in both halves of the newly reunified German city, invited artists to respond to Berlin's historic self-estrangement. Boltanski located an apartment complex in East Berlin whose middle section, destroyed during World War II, had never been rebuilt. To make the piece, titled appropriately *The Missing House*, he enlisted the aid of several German art students who, on his instructions, researched and identified some of the demolished building's previous occupants. Their names and occupations, as well as the dates of their deaths, were listed on plaques attached to the two adjoining walls of the surviving structures, close to their former apartments.

The students found more than just names. In city archives and libraries, they located numerous documents and photographs relating to the former residents, among whom, as it turned out, were approximately twenty Jews killed by the Nazis. These documents, both originals and photocopies, were displayed

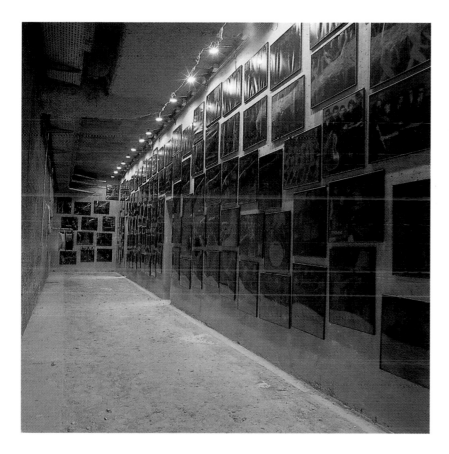 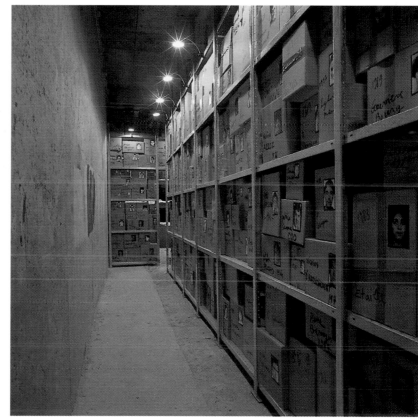

151. 152. *La Réserve du Conservatoire de Musique*
(The archive of the Conservatory of Music).
Permanent installation, Cité de la Musique, Paris, 1991.

MUSÉE SOCIAL

5, RUE LAS CASES, PARIS-VIIe - 4e ÉTAGE

DISPERSION A L'AMIABLE

DU CONTENU DES 3 TIROIRS DU SECRÉTAIRE DE

CHRISTIAN BOLTANSKI

ORIGINAUX - LETTRES - DOCUMENTS ET OBJETS DIVERS

LE LUNDI 5 JUIN A 20 HEURES

153. *Musée social: Dispersion à l'amiable du contenu des trois tiroirs du secrétaire de Christian Boltanski* (Social museum: Private sale of the contents of three drawers from Christian Boltanski's desk). Mail art and performance. 5 June 1972.

154. *Photographie de ma petite sœur en train de creuser sur la plage de Granville* (Photograph of my little sister digging on the beach at Granville). Mail art, November 1969.

in specially designed vitrines at the bombed-out Berliner Gewerber Ausstellung, the city's former museum of industry, located in what had been West Berlin, and they were also reproduced in *La Maison manquante* (The missing house), a book by Boltanski.[59] To enter Boltanski's open-air museum, viewers had to descend an eroded granite staircase, the only physical evidence left of the devastated museum. The vitrines, arranged in two rows of five, were placed in a clearing in the middle of the overgrown and wooded area where the museum had once stood. Here, the traces of former East Berliners relocated to the "free" West—the real stories of people who no longer exist, history reconstructed amid the ruins of histories destroyed—combined to create a compelling and moving installation. It provided Boltanski with another opportunity for reconstitution in which art and life were inextricably linked. As he has observed, "What interested me about this project was that you can take any house in Paris, New York, or Berlin, and with that one house, you can reconstruct an entire historical situation."[60]

142

155. Inventory of 47 items offered at the "Private Sale" of 5 June 1972.

While in Berlin, Boltanski came upon several German family photo albums at a flea market. Like the snapshots of the *Famille D.*, these albums documented the lives of ordinary people during extraordinary times. Among the ritualized shots of birthdays and anniversaries were uniformed Nazi soldiers—smiling and holding babies, happy, it seems, to have a respite from their duties. As Boltanski had noted in 1987, during the trial of the infamous Nazi war criminal Klaus Barbie in Lyons: "Barbie has the face of a Nobel Peace Prize winner. It would be easier if a terrible person had a terrible face."[61] The albums provided the inspiration and images for several works; one, titled *Conversation Piece*, used original snapshots from the albums, while another, *Sans-Souci*, reproduced them in a book. Not interested in ascribing blame, Boltanski was underscoring with these pieces the potential for evil that resides in us all.

Countering the high drama of some of the *Leçons de ténèbres* pieces are others that adopt a more distanced, pseudo-museological approach. For

example, in a second installation for the 1991 Carnegie International at the Mattress Factory, a neighboring alternative space, Boltanski created an archive documenting the exhibition's ninety-five-year history. In a narrow, vaulted corridor in the cellar, Boltanski installed small cardboard boxes onto which were glued typed labels with the names of all the artists who had participated in Internationals over the years. The boxes, which apparently contained information on the artists, were arranged in no logical order. Unlabeled, empty boxes were also added, awaiting those who will be included in future triennials. The installation and accompanying book, which simply listed the artists' names and the years they showed at the International, made one point unavoidably apparent: inclusion in this prestigious exhibition is no guarantee of immortality. Most of the approximately four thousand artists listed, particularly the most frequent participants, have been forgotten. This, implies Boltanski, whose name now figures on one of the boxes, may well be his own fate.

156. *La Maison manquante* (The missing house). First part: 15/16 Grosse Hamburger Strasse. 1990. Installation view, "Die Endlichkeit der Freiheit," Berlin, 1990.

157. *La Maison manquante* (The missing house). Second part: *Le Musée* (The museum), Berliner Gewerber Ausstellung. 1990. Installation view, "Die Endlichkeit der Freiheit," Berlin, September 1990.

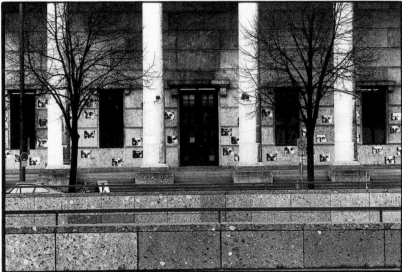

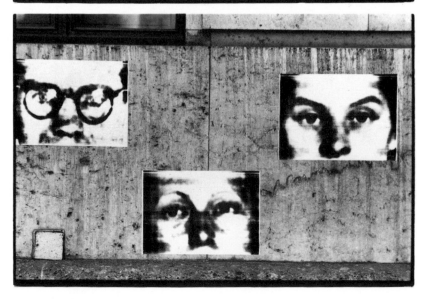

158. *Resistence.* 1993.
Installation views at Haus
der Kunst, Munich,
December 1993.

Here he has, once again, deviously subverted the original function of an archives. To use it—to add more information or find out what is already stored there—is a hit-or-miss operation. One can either casually peruse the boxes or search, for what could be a long time, to find a specific name. Willfully contradictory and ambivalent at the same time, Boltanski vacillates between transforming museum spaces into dysfunctional archives or, as in other installations of works from *Leçons de ténèbres*, into pseudo-religious settings.

With this body of work, Boltanski returned to the preoccupations with death and memory evident in his early work. The tiny, fetishistic figures he fashioned out of odds and ends for his *Compositions* reemerged as frightening phantasms in his *Ombres*. For the installations of *El Caso* and *Les Suisses morts*, he photographed photographs of those already dead, instigating yet another objectification and effectively assassinating their images one more time. But the physical apparatus of the camera and the chemical processes of development and enlargement have also functioned as cooling devices, inserting time and distance between himself and the difficult subjects he has broached. As he has upped the drama, he has also tempered it with his pseudo-archives. Consistently engaging his audience, first viscerally and then intellectually, he has imparted manifold lessons of light as well as those of darkness.

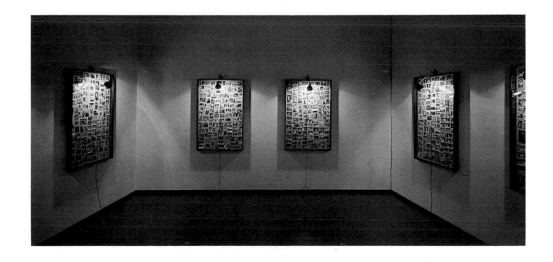

159. *Conversation Piece.* 1991. Installation view, "Inventar," Hamburger Kunsthalle, Hamburg, Germany, 1991.

pp. 148-149: 160. Double-page spread from the artist's book *Sans-Souci.* 1991.

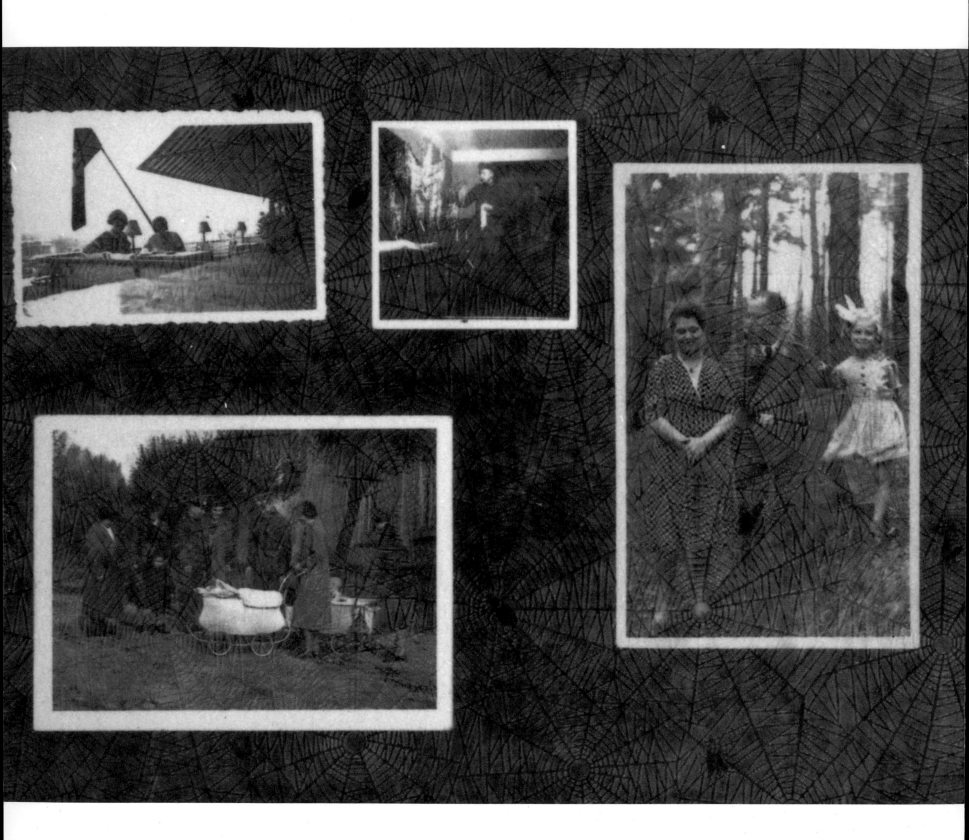

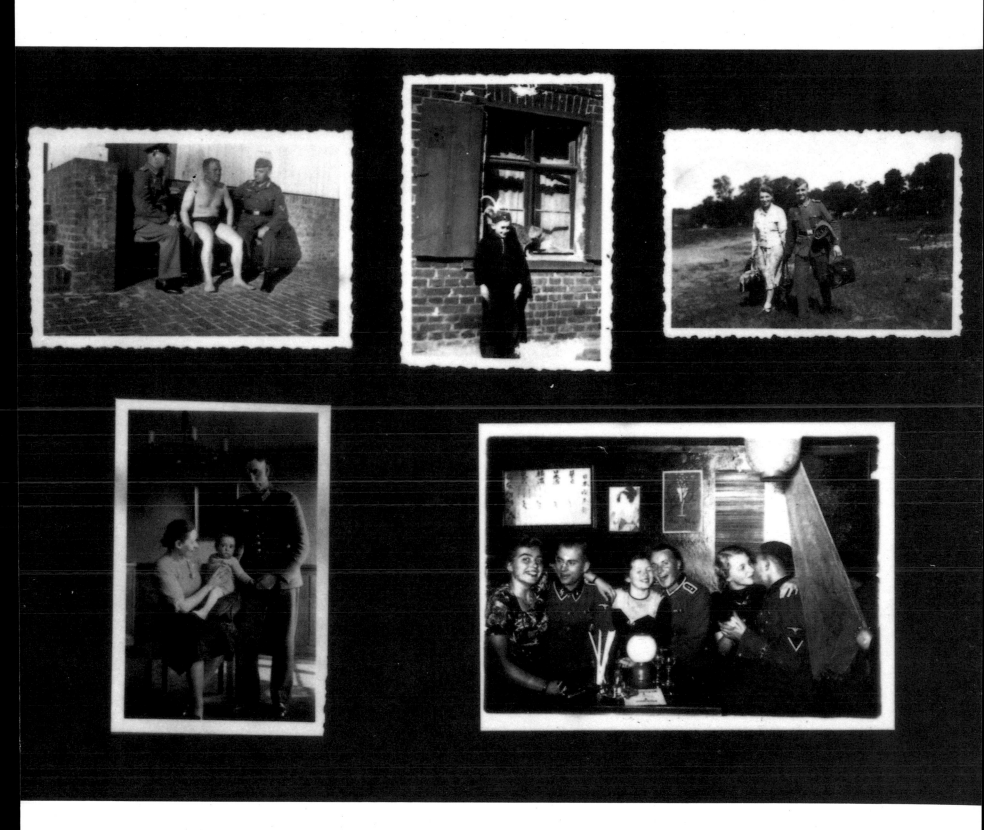

CHRISTIAN BOLTANSKI

a l'honneur de vous faire ses offres de service

il se propose de vous interpréter entouré de tous ses accessoires, de ses authentiques reliques, de sa fameuse poupée parlante et devant des décors représentant les lieux réels où se sont déroulées les scènes marquantes de son enfance, **ses célèbres souvenirs de jeunesse.**

THE DISAPPEARING
ACT OF C. B.

The more he has worked, Boltanski has remarked, the less he has lived. This observation, which he has repeated frequently over the years, underscores the interdependency, some might even say parasitic relationship, between his art and his life. Boltanski's life, in other words, feeds his art as much, if not more, than the contrary. Indeed, much of his oeuvre, but especially his early work, can be viewed as a continuing autobiography made up of self-portraits. But the cumulative picture that emerges is one that conceals Boltanski as much as it exposes him. Take his designation of himself as "C. B.," for example. By using his initials in the official version of his biography and in the titles of his works, Boltanski has been able to preserve a vestige—or a vestige of the idea—of anonymity. As one critic has astutely noted, "drawing on material of his own life, using his own experience for C. B.'s character, yet claiming a distance from C. B., he [has been] hiding in plain sight."[62] A shorthand device which lends an unexpected air of mystery to his work, the initials function as a distancing device, intimating that Boltanski's self-fetishizing is serving a larger purpose.

Indeed, the prospect of an ulterior motive reasserts itself when we consider the fact that, odd though it may seem, Boltanski's self-portraits have been composed not only of images of himself, but of French children, Austrian adolescents, Russian Jews, and Swiss bourgeoisie. Anonymous players in his drama of "self-revelation," they are the equivalent of extras in movie crowd scenes and constitute a cast of thousands. The overwhelming anonymity of their nameless faces contrasts sharply with Boltanski's own. Having seen it so often in his early work, we recognize *his* face among the countless others, but the recognition only delays our realization that we do not, in fact, know him. What most distinguishes Boltanski's self-depiction from simple vanity is that ultimately what we find in his work are reflections of ourselves.

A closer look at an early self-portrait in the form of a book, *10 Portraits photographiques de Christian Boltanski 1946-1964* (10 photographic portraits of Christian Boltanski 1946-1964) from 1972, reveals the sly wit with which he accomplishes the difficult task of mirroring us while ostensibly portraying himself. Like much of his art, the book is deceptively honest. Its straightforward title and captions forcefully exude an aura of fact and believability. However, the ten images it includes (each with a caption identifying it as Boltanski at various ages from two to twenty) do not, with one exception, portray him. Rather, they depict boys who happened to be in the Parc Montsouris in Paris on the same summer day and who, when asked to pose, assumed the same awkward stance with their arms loosely dangling at their sides. That the physiques of these boys—all brunettes except for one conspicuous blond—vary considerably from each other, however, hardly seems to disturb us. Boltanski, we rationalize, must have changed considerably as he grew. Evidence that he might be pulling our leg surfaces in his portrait at age five, in

p. 150:
161. *Christian Boltanski a l'honneur de vous faire ses offres de service* (Christian Boltanski is pleased to offer you his services). Mail art, May 1974.

162. 163. Cover and pages from the artist's book *10 Portraits photographiques de Christian Boltanski, 1946-1964* (10 photographic portraits of Christian Boltanski, 1946-1964). 1972.

10 PORTRAITS PHOTOGRAPHIQUES DE CHRISTIAN BOLTANSKI 1946-1964

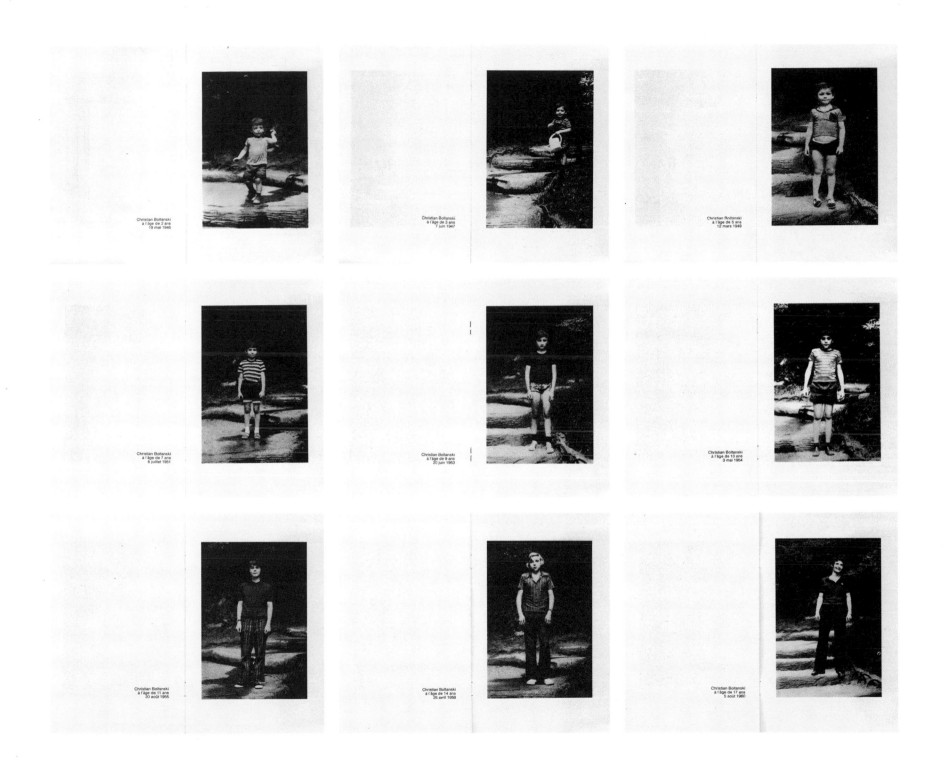

which he is seen in shorts and a shirt riding up his childish belly over a caption that states that the photo was taken in the still-blustery month of March. But even here, so strong is our tendency to take at face value the relationship of text to image that the summery garb, more often then not, does not undermine what we assume is the veracity of the photograph and caption. When we finally realize Boltanski's ruse, our own gullibility—how easily we are deceived—is disclosed.

The medium of photography has provided Boltanski with fertile terrain for effecting his artful hoaxes. It has also served as an effective means for capturing the transience and impermanence of life. As *10 Portraits photographiques* poignantly illustrates, the children it depicted no longer exist as they did in those particular pictures. Seizing on the theme of childhood early on, Boltanski made it the unlikely vehicle for his protracted meditations on mortality. Not surprisingly then, death is perhaps most movingly invoked in Boltanski's photographs of children, for example, those seen in the *Monuments*. Reshot and cropped, their faces seem to embody the pathos of arrested lives as they silently peer out at viewers, surrounded by soft, yellow haloes of incandescent lights.

Some of Boltanski's photographs, including those in *Monuments* and the black-and-white shots of the crumpled clothing of François C, also summon the specter of those who died in concentration camps. They, like the forlornly displaced belongings of the *Inventaires* and the second-hand garments of the suffocatingly crowded installations of clothing, conspicuously evoke the idea of absence. Similarly, the graduating students of the Lycée Chases, casually posing for the camera, as well as the costumed youths celebrating Purim and Boltanski's grammar-school classmates, all stand in for the millions of murdered Jews. That the Holo-

164. Last page of the artist's book *10 Portraits photographiques de Christian Boltanski, 1946-1964.* 1972.

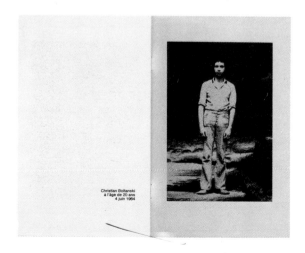

caust happened, he seems to suggest, ultimately points to the potential for evil that resides in us all.

But Boltanski doesn't remain mired in the morbid. Indeed, his self-portraiture, which he has characterized as a "false biography," numbers the triggering of collective memories—of recollections of happier pasts—among its motives. His early attempts to reconstitute his childhood were thus not only "snapshots" of his own past but of the era into which he was born. Even when he withdrew from his work in the mid seventies and seemed to turn his attention elsewhere, he was, it could be argued, using his absence to fill in the background of the larger picture of who he is and, by extension, who we are. As he has shown, family snapshots, like those he rephotographed for the *Famille D.*, successfully communicate, as do our own, the characteristics of the milieu from which they come, just as the banal, everyday *Images modèles* and the *Compositions classiques* reveal cultural biases of taste.

Boltanski's self-depiction has functioned as well to dramatize the role of the artist in society and, along the way, has revealed a nearly compulsive need to comment on art's relation to religion and life. Invariably, he has adopted one or another persona in his work as he holds forth on the raison d'être and function of art in interviews and artist's statements. After simulating the mannerisms of an itinerant preacher who incessantly sermonized on death, for example, he became a buffoon who revealed the futility and artifice of art. He has even gone so far as to compare artists to saints, asserting that both serve as role models since their life stories function as parables and their artworks take on the air of relics. But of all of Boltanski's personas, none is more uniquely his own than that of the vendor of corpses who sells images of dead and mutilated bodies.

Above all, Boltanski is a spellbinding magician who inevitably reveals the sleight-of-hand that creates the illusions; his bag of tricks are artworks that are made, for the most part, from shadows and silhouettes that take the form of rephotographed photographs and flickering penumbrae. Unafraid of acknowledging the sentimentality of his art, he has confirmed that he wants to make people cry and laugh. Feelings, after all, signal—indeed, affirm—that we are still alive. He intentionally provokes strong emotions with work that is at once transient, imposing, remarkably accessible, and in the end, deeply resonant.

A quintessential postmodern prankster, Boltanski continues to pose his existential conundrums. Both his self-portrayal in particular and his work in general can be seen as an unending disappearing act in which he unmasks both the artifice of art and the inevitability of our shared mortality. By insisting first and foremost that he is a painter, even though he stopped painting in 1967, Boltanski identifies art as an absurd activity through which the artist constantly and inevitably confronts failure. Nevertheless, like the journalist Roquentin in Jean-Paul Sartre's

semi-autobiographical novel *La Nausée*, Boltanski persists in finding hope and meaning in it. Answering questions with still more questions, he pulls back the curtain to reveal to us some of the perennial paradoxes that permeate both the future certainty of our deaths and the current uncertainty of our lives.

NOTES

THE IMPOSSIBLE LIFE OF CHRISTIAN BOLTANSKI

1. The version here was transcribed from the facsimile in *Christian Boltanski-Reconstitution*, exhibition catalogue (London, Eindhoven, and Grenoble: The Whitechapel Art Gallery, Stedelijk van Abbemuseum, and Musée de Grenoble, 1990). [Il faut que vous m'aidiez, vous avez sans doute entendu parler des difficultées [*sic*] que j'ai eu récemment et de la crise très grave que je traverse. Je veux d'abord que vous sachiez que tout ce que vous avez pu entendre contre moi est faux. J'ai toujours essayé de mener une vie droite, je pense, d'ailleur [*sic*] que vous connaissez mes traveaux [*sic*]; vous savez sans doute que je m'y consacre entièrrement [*sic*], mais la situation a maintenant atteint un degré intolérable et je ne pense pas pouvoir le supporter bien longtemps, c'est pour cela que je vous demande, que je vous prie, de me répondre *le plus vite possible*. Je m'excuse de vous déranger, mais, il faut absolument que je m'en sorte.]

2. "Monument à une personne inconnue : Six questions à Christian Boltanski," *Art Actuel Skira Annuel* (Geneva: Skira, 1975), pp. 147-148. Among those who responded were critics José Pierre [see p. 8], Pierre Restany, and Alain Jouffroy. See also *Christian Boltanski Catalogue: Books, Printed Matter, Ephemera 1966 - 1991*, Jennifer Flay, ed. (Cologne and Frankfurt am Main: Verlag der Buchhandlung Walther König and Portikus, 1992), pp. 24-27. Unless otherwise noted, translations are by the author. [J'ai eu cinq réponses, ce qui n'est pas tout de même pas mal, cinq personnes qui ont voulu m'aider. Mais si j'ai fait ce travail, c'est que j'étais réellement très déprimé. Si je n'avais pas été artiste, j'aurais sans doute écrit une lettre comme ça et je me serais peut-être jeté par la fenêtre : mais comme je suis un peintre, j'en ai écrit soixante, enfin la même soixante fois, et je me suis dit : "Quelle bonne pièce et quelle réflexion sur l'art et la vie !" . . . Quand on a envie de se tuer, on se fait son portrait en train de se tuer, mais on ne se tue pas.]

3. Silke Paull and Hervé Würz, in their "Bibliographie," in *Boltanski, Les Modèles : Cinq relations entre text & image* (Paris : Cheval d'attaque, 1979), p. 4, indicate that only thirty, and not sixty, letters were written. And in "Christian Boltanski: An Interview with Georgia Marsh," which is also titled "Christian, Carrion, Clown and Jew; Christian Boltanski Interviewed by Georgia Marsh revised by Christian Boltanski," in *Christian Boltanski-Reconstitution*, exhibition catalogue, p. 11, the artist states that he sent fifteen letters.

4. The letter was dated 16 June 1970; it is not known how many copies were sent. See Flay, *Catalogue*, pp. 32-33. The entire text of the letter reads: "Je désire vous informer de la nature des recherches que j'effectue actuellement. Elles peuvent paraître dans leur état présent sans ligne conductrice, mais, moi je sais qu'elles sont liées et ce n'est que lorsque ce lien aura été découvert que tout s'éclaircira. C. Boltanski P.S. je vous envoie 3 exemples qui vous donneront un aperçu des directions dans lesquelles je me suis engagé."

5. From an interview with Jacques Clayssen, "Boltanski," *Identité/Identifications*, exhibition catalogue, (Bordeaux : capc/Centre d'Arts Plastiques Contemporains, 1976), p. 24. [La photo m'intéresse parce qu'elle est ressentie comme vraie, comme preuve que l'histoire que l'on raconte est réelle, elle donne l'illusion de la réalité.]

6. Effie Stephano, "Existential Art," *Art and Artists* 9, no. 2 (May 1974), p. 25.

7. Alain Fleischer and Didier Semin, "Christian Boltanski: La Revanche de la maladresse," *Art Press*, no. 128 (September 1988), p. 6. [Une grande partie de mon activité est liée à l'idée de biographie : mais une biographie totalement fausse et donnée comme fausse avec toutes sortes de fausses preuves. On peut retrouver ceci dans toute ma vie : la non-existence du personnage; plus on parle de Christian Boltanski, moins il existe.]

8. See "Biographie commentée," in *Boltanski*, exhibition catalogue (Paris: Musée National d'Art Moderne, Centre Georges Pompidou, 1984), pp. 102-121. The texts were coauthored with then-curator Bernard Blistène while, in this case, Boltanski also contributed short boxed statements. The earliest version of an "official" annotated biography I have found cited appeared as the autobiographical section in an article, "Christian Boltanski," *Flash Art*, nos. 74-75 (May-June 1977), pp. 32-33. Another was in *Christian Boltanski: Compositions*, exhibition catalogue (Calais: Musée de Calais, 1980), p. 53.

THE EARLY WORK

9. See Didier Semin, *Christian Boltanski* (Paris: Art Press, 1988), p. 31.

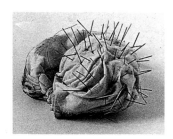

165. *Piège* (Trap). Detail. 1970.

10. Gilbert Lascault, "Boltanski au Musée municipal d'art moderne," *XXᵉ Siècle* 33, no. 7 (June 1971), p. 143. [On a l'impression qu'un homme tue une femme à coups de bâton, mais cela passe si rapidement qu'on le devine plutôt qu'on ne le voit.]

11. Démosthènes Davvetas, "Christian Boltanski," *Flash Art* [International Edition], no. 124 (October-November 1985), p. 82.

12. Germano Celant, "The Italian Complexity," in *The Knot: Arte povera at P.S. 1*, exhibition catalogue (Turin and Long Island City, New York: Umberto Allemandi & Co. and the Institute for Art and Urban Resources, Inc., 1985), p. 39. Although Celant refers specifically to *Arte Povera* artists, such profound changes were felt internationally.

13. Nancy Marmer, "Boltanski: The Uses of Contradiction," *Art in America* 77, no. 10 (October 1989), p. 172.

14. For a chronology of this period, see *Une scène parisienne 1968-1972* (Rennes: Centre d'histoire de l'art contemporain, 1991).

15. From a typed manuscript titled "Christian Boltanski: Extracts from a tape," 1971, first published in "Au départ mon problème était," *J & J all for art* (Paris), July 1973, then in Hebrew and French in *Les Inventaires*, the catalogue of the 1973 Israel Museum exhibit.

16. Davvetas, "Boltanski," p. 82. The book also included a text as *page de garde* (the flyleaf) titled "On ne remarquera jamais assez que la mort est une chose honteuse" (It is never mentioned enough that death is a shameful

thing). When it was reprinted in *Boltanski, Les Modèles*, it was reproduced from the original photographs and documents, and not from the book itself. Like the facsimile reprint in *Christian Boltanski-Reconstitution*, it thus looks different than the original book. See also Flay, *Catalogue*, pp. 8-11.

17. The cover of the book is blank except for the following annotation, which also serves as an alternate title: "Les documents photographiques qui suivent m'ont été remis par Luis Caballero." (The photographic documents that follow were given to me by Luis Caballero.) See Flay, *Catalogue*, pp. 30-31.

18. Delphine Renard, "Entretien avec Christian Boltanski," in *Boltanski*, Musée National d'Art Moderne, p. 71. The English translation of this important interview is by Cynthia Campoy, edited by the author. [C'était... l'époque de la découverte de l'ethnologie, du Musée de l'Homme et de la beauté, non plus d'une sculpture d'art nègre, mais de toute une série d'objets quotidiens : des hameçons eskimos, des flèches d'Indiens d'Amazonie... Le Musée de l'Homme a eu pour moi une très grande importance ; j'y voyais de grandes vitrines métalliques dans lesquelles se trouvaient de petits objets fragiles et sans signification. Dans un coin de la vitrine

166. *Album de photos de la famille D., 1939-1964* (Photo album of the family D., 1939-1964). 1971.

prenait souvent place une photographie jaunie représentant un "sauvage" en train de manier ces petits objets. Chaque vitrine présentait un monde disparu : le sauvage de la photographie était sans doute mort, les objets étaient devenus inutiles et, de toute façon, plus personne ne savait s'en servir. Le Musée de l'Homme m'apparaissait comme une grande morgue. De nombreux artistes ont découvert alors les sciences humaines (linguistique, sociologie et archéologie)...]

19. *Un art moyen* was published by Editions de Minuit in 1965. See Serge Lemoine, "Les Formes et les sources dans l'art de Christian Boltanski," in *Boltanski*, Musée National d'Art Moderne, p. 26, note 8. This informative essay was updated and reprinted as "Photographies, lampes de bureau, boîtes de biscuits : Propos sur l'art de Christian Boltanski," in the French edition of *Christian Boltanski-Reconstitution.*

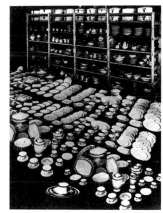

20. Willem Sandberg, ed., *'73-74': An Annual of New Art and Artists* (New York and Barcelona: Harry N. Abrams and Blume, et. al., 1974), unpaginated.

21. Suzanne Pagé, "Entretien Christian Boltanski/Suzanne Pagé, avril 1981," *Christian Boltanski: Compositions*, exhibition catalogue, (Paris: ARC, Musée d'Art Moderne de la Ville de Paris, 1981), p. 7. [Je me suis aperçu que ces images n'étaient que le témoin d'un rituel collectif. Elles ne nous apprenaient rien sur la famille D. ... mais nous renvoyaient à notre propre passé.]

22. Roland Barthes, *Camera Lucida: Reflections on Photography*, trans. Richard Howard (New York: Hill & Wagner, 1981), p. 14.

23. Ibid., p. 92.

24. *Monumente, eine fast zufäl-*

lige Ausstellung von Denkmäler in der zeitgenössischen Kunst (Düsseldorf: Städtische Kunsthalle, 1973) unpaginated. Although Boltanski specifies that there are sixty-two children in this piece, he usually only exhibits sixty. English translation by Eric DeBruyn. [Ich war 1955 elf Jahre alt, und ich glich diesen 62 Kindern, deren Foto in diesem Jahr in der Zeitschrift des Club Mickey abgebildet wurde. Sie hatten das Bild eingeschickt, das sie ihrer Meinung nach am besten wiedergab: lächelnd und gut frisiert oder mit ihrem Lieblingsspielzeug oder Lieblingstier. Sie hatten die glichen Wünsche und die gleichen Interessen wie ich. Heute müssen sie all ungefähr in meinem Alter sein, aber ich kann nicht erfahren, was aus ihnen geworden ist. Das Bild, das von ihnen geblieben ist, entspricht nicht mehr der Realität, und all diese Kindergesichter sind verschwunden.]

25. Lemoine, "Les Formes," p. 22. The work was funded as part of a 1-percent-for-art program required of new public buildings.

26. From an unpublished interview with the author, April 1991. Boltanski claims to have sent sixty-two letters; however the exact number is impossible to verify, nor is it that important. In addition to the *Inventaires* dating from June 1973 and December 1974, Boltanski had also made a work, *Le Musée de Christian Boltanski* (The museum of Christian Boltanski) in 1974, and which was comprised of various

paintings, objects, and photographs. Then, for the installation of "Christian Boltanski - Reconstitution" at the Stedelijk van Abbemuseum in Eindhoven, 25 August-7 October 1990, Boltanski created another version of the *Inventaires*, this time displaying the artifacts of one of the museum's interns. Later that year, for an exhibition at the capc/ Musée d'Art Contemporain in Bordeaux, Boltanski, working with the museum's staff, located a young woman whose belongings the museum then purchased for their permanent collection and titled *Inventaire des objets ayant apartenu à la jeune fille de Bordeaux* (Inventory of objects that belonged to a young woman from Bordeaux), 1972-1990. And for "Places from the Past: Site Specific Art in Charleston," 24 May-4 August 1991, in Charleston, South Carolina Boltanski added another version: *Inventory of Objects Belonging to a Young Woman of Charleston*, accompa-

167. Wartime storage of household dishes, 1942-1945. From the archives of the Central Jewish Museum.

nied by a small catalogue with a foreword by himself. For more about *Les Inventaires*, see Sylvie Couderec, "Christian Boltanski: Commentaires des oeuvres," in *Collection: Christian Boltanski, Daniel Buren . . .* , exhibition catalogue (Bordeaux : capc/Musée d'Art Contemporain, 1990), pp. 37-42, and Flay, *Catalogue*, pp. 80-91, 200-201. [Je voudrais que, dans une salle de votre musée, soient présentés les éléments qui ont entouré une personne durant sa vie et qui restent après sa morte témoignage de son existence; cela pourrait aller par example, des mouchoirs dont elle se servait jusqu'à l'armoir qui se trouvait dans sa chambre, tous ces éléments devront être présentés sous vitrine et soigneusement étiquetés.]

27. Boltanski worked on the film with Jean-Hubert Martin. See Couderac, "Commentaires," p. 38. [Les cahiers d'inventaire portaient la mention des objets utilitaires et des œuvres sur un même plan. Cet atelier muséographié rend compte d'un acte de préservation qui ne préserve rien... Dès que l'on essaie de protéger quelque chose on le tue.]

28. Lemoine, "Les formes," p. 23.

29. From unpublished interview with the author, April 1991. For more about artists' collections, see also Walter Grasskamp, "Artists and Other Collectors," in *Museums by Artists*, A. A. Bronson and Peggy Gale, eds., (Toronto: Art Metropole, 1983), pp. 129-148.

30. Renard, "Entretien," p. 85. In French, *interprétation* means both "explanation" and "performance." [Au moment des *Saynètes comiques...* je m'étais posé des questions sur la représentation et sur le double sens du mot "jouer"... Dans un petit livre de 1974, *Quelques interprétations par Christian Boltanski*, je m'interroge sur ce qui différencie quelqu'un qui boit un verre d'eau et un acteur qui interprète quelqu'un buvant un verre d'eau. Je me disais alors qui l'art consiste à faire quelque chose avec l'intention de montrer cette réalité.]

IMAGES MODÈLES TO COMPOSITIONS

31. Ibid., p. 81. [Je ne voulais me figer dans un personnage de menteur. J'ai eu le désir de détruire le mythe, et de le détruire par la dérision. Alors, un jour, de prêcheur je suis devenu clown, dans les *Saynètes comiques*. C'était un premier pas vers devenir artiste : je racontais les mêmes histoires qu'avant, mais sur un mode totalement dérisoire. Je disais aux gens : ce que je vous ai raconté était faux, même si en fait c'était vrai.]

32. The invitation card was to Boltanski's five-day exhibition of "Photographies couleurs" (Color photographs), which consisted of a continuous projection of slides, in the audiovisual room at the Musée National d'Art Moderne. The card is referred to as *Extrait d'une lettre envoyée de Berlin en août 1975 par Christian*

Boltanski à Guy Jungblut (Extract from a letter sent from Berlin by Christian Boltanski in August 1975 to Guy Jungblut). See Flay, *Catalogue*, p. 134. Jungblut was, according to Boltanski, the son of a Belgian Surrealist who had opened a gallery and also published books and multiples. [Je fais de la photographie; j'ai perfectioné ma technique et j'essaie de me conformer aux règles de cet art si difficile. J'aborde maintenant la photographie en couleurs qui se prête particulièrement bien aux sujets que j'affectionne : tout ce qui exprime la beauté des choses simples et la joie de vivre.]

33. *Art Actuel*, p. 148. [Je suis un peintre extrêmement traditionnel. Je travaille pour apporter des emotions aux spectateurs, comme tous les artistes. Je travaille pour faire rire ou pleurer le monde : je suis un prêcheur... Je pense que les peintres ont toujours eu à peu près les même choses à dire, le même désir de capter la réalité, mais ils l'expriment chaque fois d'une manière un peu différente et avec des moyens un peu différents... je me pose beaucoup de problèmes sur l'art et son utilité ou non-utilité, sur sa fonction, mais en même temps je crois en l'art d'une manière vague et inexpli-cable.]

34. Bernard Marcadé, *Ceci n'est pas une photographe*, exhibition catalogue (Bordeaux : Fonds Régional d'Art Contemporain Aquitaine, 1985), p. 6.

35. Renard, "Entretien," p. 79. Berck, Dinan, and Granville are well-known beach resorts in

France. [Je veux que les spectateurs ne découvrent pas, mais qu'ils reconnaissent. Pour moi, un tableau est en partie créé par celui qui le regarde, qui le "lit" à l'aide de ses propres expériences. J'ai intitulé l'une de mes séries *Images stimuli* pour indiquer que ce que l'on montre n'est qu'un excitant : il permet à chaque spectateur de ressentir une sensation différente. D'une manière plus générale, je pense que nous essayons constamment, dans la vie, de faire coïncider ce que nous voyons avec ce que nous savons. Et si je montre une photographie de la plage de Berck, l'un y reconnaîtra la plage de Dinan et l'autre celle de Granville.]

36. Clayssen, "Boltanski," p. 25. [Je crois que la valeur esthétique que l'on donne à une photographie s'est développée ces dernières années [au milieu des années soixante-dix] : la généralisation de la couleur, le développement des revues spécialisées qui ont créé des standards auxquels se réfèrent, consciemment ou inconsciemment, bon nombre de photographes amateurs, en sont les causes. De même que les sujets photographiques sont stéréotypés, la beauté photographique obéit à un cadre bien précis.]

37. Renard, "Entretien," p. 84. [Mes jardins japonais renvoyaient d'abord à une sorte d'ersatz culturel qui va des faux meubles chinois du XVIIIᵉ siècle aux petits jardins vendus chez les fleuristes, et qu'à ce succédané de culture orientale se mélangeaient, par exemple, sans raison comme dans notre savoir d'images, des ap-

pliques de café influencées indirectement par Kandinsky et les constructivistes ... Mes *Compositions* entretiennent avec le monde de l'art des relations ambiguës. Elles contiennent toujours des allusions à des images existantes, un curieux mélange culturel où se mêlent des souvenirs de peintures classiques, mais aussi d'autres sources visuelles : films, photographies, publicités, des images qui traînent...]

38. Pagé, "Entretien," p. 6. In another, related series, Boltanski used toy blocks for his *Compositions architecturales*, 1982. [Les jouets m'intéressent en tant qu'ils sont représentation culturelle du réel... Je désire que mes "Compositions" tiennent pour le spectateur un peu le même rôle que le jouet pour l'enfant : images codifiées et collectives de la réalité.]

LESSONS OF DARKNESS

39. Renard, "Entretien," p. 76.

40. See Denis Bordat and Francis Boucrot, *Les Théâtres d'ombres: Histoires et techniques* (Paris: L'Arche, 1956). As influences, Boltanski himself cites E. T. A. Hoffmann's *Shadow Thief*, as well as tales of Frankenstein and the Golem. See as well Barbara G. Walker, *The Woman's Encyclopedia of Myths and Secrets* (San Francisco: Harper and Row, 1983), pp. 927-928. The shadows also evoke the mythic origin of painting itself, according to which the first was made by the daughter

of the Corinthian Butades when she drew the silhouette of her lover from his projected shadow before he left for war. (*The Mirror and the Lamp*, exhibition catalogue, [Edinburgh: The Fruitmarket Gallery, 1986] and Gilbert Lascault, "Twelve Observations on Christian Boltanski's Shadows and Monuments," *Parkett*, no. 9 (June 1986), p. 13.] Boltanski's first attempts at shadow pieces did not fill up entire rooms, as in Rotterdam or at the Paris Biennale, but were smaller arrangements of his figurines—skulls, skeletons, winged creatures, as well as an occasional body part, such as hands—that were attached to looped wires ending in clumps of clay. Usually illuminated by only one lamp, they were projected on walls of galleries or in darkened corners.

41. Démosthènes Davvetas, "Christian Boltanski et Démosthènes Davvetas," *New Art*, no. 1, (October 1986), p. 20. Extracts from this interview also appeared in Davvetas, "Boltanski par lui-même," *Libération*, 14 March 1986. [De tous ces enfants, parmi lesquels je me trouvais et, très probablement, dont l'une des filles devait être celle que j'aimais, je ne me souvenais du nom d'aucun, je ne reconnaissais rien de plus que les visages sur la photographie. On aurait dit qu'ils avaient disparu de ma mémoire. On aurait dit que cette période était morte, puis qu'à présent, ces enfants devaient être des adultes dont je ne sais plus rien aujourd'hui. C'est pour cette raison que j'ai ressenti le besoin de rendre

hommage à ces "morts", qui, sur l'image, se ressemblent tous plus ou moins, comme des cadavres.]

42. Boltanski in an interview with Démosthènes Davvetas in *From the Europe of the Old*, exhibition catalogue (Amsterdam: Stedelijk Museum, 1987), unpaginated. In English and Dutch only.

43. Adam Gopnik, "The Art World: Lost and Found," *The New Yorker* (20 February 1989), p. 109.

44. See Suzanne Pagé, "Leçons de ténèbres," in *Christian Boltanski-Monuments*, exhibition catalogue, XLII Biennale de Venezia, Palazzo delle Prigione (Paris : Association française d'action artistique, Ministère des affaires étrangères, 1986), unpaginated. The best known of the musical "Leçons," by François Couperin, were commissioned in 1713 at the request of the Abbey of Longchamp. See also *The New Grove Dictionary of Music and Musicians*, ed. Stanley Fabdie. (London: Macmillan, 1980), entries on "Leçons de ténèbres" and "Lamentations." I would also like to thank Lucy Oakley for pointing out some of the Catholic inferences.

45. Renard, "Entretien," pp. 72-73. [Un rapport étrange avec le divin, le sentiment d'être à la fois l'élu et le dernier des hommes, me poussent à affirmer puis à me contredire, à pleurer et à me moquer, à dire que je fais de la peinture sans faire de la peinture... Dans la culture juive, je suis at-

tiré par le fait de dire à la fois la chose et son contraire, ou cette façon de répondre à une question par une autre question et constamment tourner en dérision la chose que l'on fait... J'imagine que mes rapports ambigus avec la peinture et mon utilisation de la photographie sont liés à cette conscience juive, si tant est que j'en aie une. Je fais de la photographie, considérée comme un art moins noble que la peinture, comme si je craignais de m'affronter à cet art trop sacré... De toute façon, cela demeure très flou chez moi; je n'ai aucune culture juive. Je suis comme les Indiens qui, dans les westerns, servent de guides aux soldats : ils ont tout oublié, mais quand ils ont bu, il leur revient des danses indiennes...]

46. In Stuart Morgan, "Little Christians," *Artscribe*, no. 72 (November-December 1988), p. 48.

47. Boltanski's revelations about

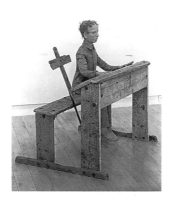

168. Stage prop for Tadeusz Kantor's play, *The Dead Class*, 1975.

the circumstances of his birth and of his family during the war were first, to the best of my knowledge, published in my essay, "The Life and Death of Christian Boltanski," in *Christian Boltanski: Lessons of Darkness*, exhibition catalogue (Chicago, Los Angeles, and New York: The Museum of Contemporary Art, Chicago, The Museum of Contemporary Art, Los Angeles, and The New Museum of Contemporary Art, 1988), pp. 53-55. There I disclosed that when Boltanski's father had received notification to report to the police during the occupation of Paris, his parents had publically pretended marital disagreement, separation, and then divorce. But rather then hiding in the cellar, as I stated there, the father apparently hid in a small compartment still in evidence that was constructed under the floorboards in the family home.

48. Boltanski now prematurely ages the biscuit tins he uses. The biscuit boxes also trigger memories of past youth: they, like cigar boxes, are used by children to store special toys and treasured odds and ends. Nor is the use of tin boxes to store memories limited to the West. Boltanski points to an unidentified photograph (probably of a scene in Shanghai) that he found and in which tin boxes, some with photographic portraits attached to the front of them and labeled in red, apparently contain references or objects of the deceased. Moreover, in his first variations of the *Lycée Chases* series, for example, at an exhibition at the Galerie Hubert

Winter in Vienna in 1986, Boltanski simply exhibited enlarged photos of the students on the wall, with the black desk lamps pushed against their faces.

49. Despite the fact that the title sometimes includes Odessa, the name of the Russian town where Boltanski's grandparents supposedly had lived, the photograph apparently was taken at a Jewish school in Paris in 1939. It was first published in the *Christian Boltanski, Réserves: La Fête de Pourim*, exhibition catalogue (Basel: Museum für Gegenwartskunst, 1989). See also *Catalogue*, pp. 180-181.

50. Georgia Marsh, "The White and the Black: An Interview with Christian Boltanski," *Parkett*, no. 22 (December 1989), p. 36. (In French, *souvenir* can also mean memory).

51. After the installation of *Lessons of Darkness* at The New Museum of Contemporary Art in New York in 1989, a visitor, Debora Preschel, who had apparently attended the school, wrote a letter to the museum stating that all the students pictured had, in fact, survived the Holocaust. Another former student, Leo Glueckselig, sent a letter to Boltanski, enclosing a photocopied illustration of the original source photograph from the book by Ruth Beckerman, *Die Mazzesinsel: Juden in der Wiener Leopoldstadt* (Vienna: Loecker Verlag, 1984), which Mr. Glueckselig had supplied. According to the caption, the class was from the Chajes-Realgymnasium, named after

Rabbi Chajes and located at Castelgasse 35 in Vienna. The misspelling of the name, then, is another instance of where fact and fiction, in Boltanski's work, become intertwined. Boltanski was also interested to learn that some of the Nazis' efforts to document Jewish lives eerily echoed his *Inventaires*. In occupied Czechoslovakia, the Nazis undertook a project to collect "possessions of both historic and artistic value" of departed Jews from the protectorates of Bohemia and Moravia. With these objects they intended to create a repository which, after the war, would function as a museum to a distinct race. To this end, the Jewish Museum in Prague was renamed, on the order of the Third Reich, the Central Jewish Museum. Its acquisitions paralleled the fate of the "donors": "first to captivity, then to extermination. No category of personal possessions was left untouched. Liturgical books and popular novels, portraits and genre paintings, religious/ceremonial and folk crafts, furniture, kitchen utensils, clothing, pianos, and synagogue implements were all amassed." These objects were catalogued by Jewish curators who, unlike the students of the 1931 graduating class of Chajes-Realgymnasium, died in the concentration camps. This bizarre plan by the Nazis to create a museum paradoxically resulted in one of the world's most important collections of Judaica. (Linda Altshuler and Anna R. Cohn, "The Precious Legacy," in David Altshuler, ed., *The Precious Legacy: Judaic*

Treasures from the Czechoslovak State Collections [New York: Summit Books, 1983], pp. 24, 29.)

52. Elisabeth Lebovici, "Entretien : Christian Boltanski," *Beaux Arts*, no. 37 (July-August, 1986), p. 29. [Ces enfants de Dijon photographiés ne sont ni des héros, ni des victimes, ce sont les "sales gosses" qu'on rencontre tous les jours.]

53. Part of Boltanski's inspiration to redo his earlier piece came from a photograph of an archive that appeared in the journal *Traverses* (Paris), no. 1 (September 1975), entitled "Lieux et objets de la mort" (Sites and objects of death). In it were what appeared to be wrapped boxes crudely labeled with what at first seemed to be birth dates but are in fact a series of six digits sepa-

rated into three pairs by hyphens. He has often also commented on the relationship of the *Détective* pieces both with the idea of innocence and with the notion of death. In art, he has pointed to the genre of still-life painting, which often serves as an illustration of Vanitas, the transitoriness of life visualized in the flower and fruits destined to decay.

54. Susan Stewart, *On Longing: Narratives of the Miniature, the Gigantic, the Souvenir, the Collection* (Baltimore and London: The Johns Hopkins University Press, 1984), pp. 150-151.

55. Marsh, "The White and the Black," p. 36.

56. Lemoine, "Les Formes," pp. 24-25. Boltanski has often cited the influence of Judd in

various interviews and conversations with the author. For example, in an unpublished interview from April 1990, Boltanski notes, "There has always been a very formal side to my work; the tin drawers with the Plasticine reconstructions were very much like Donald Judd's sculptures. Even the *Famille D.* is very minimal, and the biscuit boxes were always so. I think that this aspect of my work is very close to minimalism. I was born into this; it is the way I learned to see."

57. Fleischer and Semin, "La Revanche," p. 6. [Les musées qui, aujourd'hui, veulent avoir des Mondrian, c'est tout à fait semblable aux villes du Moyen-Age qui voulaient avoir leurs reliques de Saint. Quand elles ne parvenaient pas à posséder les os d'un grand Saint, elles trouvaient un Saint local, ou elles en inventaient

un. J'ai été très touché quand les Japonais ont acheté le Van Gogh : penser que ces gens qui fabriquent des ordinateurs avaient besoin de ce vieux bout de tissu comme d'un objet magique, parce que Van Gogh est un des grands Saints occidentaux ! Les tableaux de Van Gogh n'existent que parce que Van Gogh est considéré comme un grand Saint qui a eu une vie exemplaire.]

58. Most of the items were sold from between 20 and 180 French francs. Interestingly, one piece, a handwritten page cataloguing his works and stamped, as were all the objects auctioned, "DISPERSION - CHRISTIAN BOLTANSKI - Lundi 5 Juin 1972," sold for seven thousand francs at a recent auction.

59. Christian Boltanski, Christiane Büchner, and Andreas Fischer, *La Maison manquante (The missing house)* (Paris : Flammarion, 1992). See Flay, *Catalogue*, pp. 204-207.

60. From unpublished interview with the author, April 1991.

61. Boltanski quoted in René van Praag, "Century '87, een expositie van 'ideetjies." *Het Vrije Volk*, 28 August 1987. Translation by Eric DeBruyn.

THE DISAPPEARANCE
OF C. B.

62. Démosthènes Davvetas, "In the Twentieth Century C.B.," *Artforum* 25, no. 3 (November 1986), p. 109.

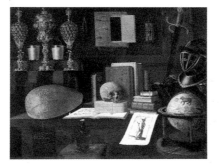

169. Sebastian Stosskopf,
Large Vanitas, 1641.

TEXTS
AND INTERVIEWS

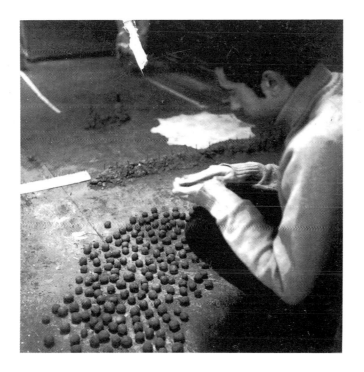

170. Christian Boltanski making small balls of dirt, 1969.

1. I still see him in my mind's eye, a small, slightly stooping man, he always looked worried somehow, always had a pipe in his mouth, I think I can honestly say that I never once saw him without his pipe.

2. He was very nice, very nice with everyone, you sometimes wondered whether perhaps he wasn't too nice to be honest.

3. He was pretty shrewd, he had that butter-wouldn't-melt-in-his-mouth look, the look of the poor little nervous Jew, but take it from me, he knew where he was heading.

4. When I knew him at the start, he really was a slob, but then that sorted itself out, and at least you can say that he wasn't a Don Juan.

5. He used to say that he'd have loved to be a real painter, wielding the brushes and putting paint to canvas, I don't know whether this was true or whether it was just one of his gimmicks for getting himself noticed.

6. He always called himself a painter even though he didn't paint, when people asked why he described himself that way, he said that everything he'd done had been painting, this wasn't an explanation, but as far as he was concerned people could call him a painter or a photographer or a sculptor, or whatever they wanted.

7. He told so many stories about his childhood, so many dubious anecdotes about his family that, as he often said, he no longer knew what was true and what wasn't, he no longer had any memories of his childhood.

8. He gave the impression of being very timid, he'd never look you right in the eye, I disliked the way he never seemed to be straight with you.

9. He quit school very young, and his spelling was terrible, he used to enjoy boasting about it.

10. I gave him a couple of Spanish lessons, he must have been about twelve or thirteen, it was hard going, he was extremely spoiled, always wriggled around in his seat, if I hadn't needed the money I would have quit for sure.

11. The only time I ever met him, he went into a whole spiel about saintliness, it was after an opening, I think he'd drunk too much.

12. As a child he was very quiet, capable of spending hours without moving or saying a word.

13. I had a conversation with him once, he explained how there were various kinds of time in his work, a period of waiting in which he did hardly anything—carving bits of wood, going for walks, and thinking—and times that he enjoyed less, where he had to create, this was very interesting.

14. He was really a sweetie, he did everything to give pleasure to the person he was with.

15. I know several stories about him, stories that don't show him in a very good light, but I'd rather not talk about them, what's the point of stirring all that up?

16. He played at war games up to the age of twenty-seven or twenty-eight, he played with his nephew, the battles would sometimes go on for a few days.

17. One time he came to give a lecture at the Beaux-Arts in Tourcoing, instead of showing slides of his work he talked in a somber voice about "memory" and "death," one thing that struck me was when he said that the artist holds up a mirror to the public and that each person who looks in it has to be able to recognize himself in it.

18. I often heard him say that the more he worked the less he existed and that he'd like to disappear, but he certainly enjoyed putting himself out front and having people talk about him.

19. The works I like are his early ones, like the balls of dirt and the carved sugar cubes, later on he tried to formalize and explain them, but the truth is that they were actually a product of a pathological phase he was going through, he probably cured himself by producing his early works and from then on had nothing more to say.

20. We must have been in the same sixth-grade class together, and I remember him as a slightly dirty little boy with frizzy black hair and an old navy-blue coat, none of us had any real contact with him, we used to call him the little rabbi.

21. His father was a wonderful man, but as for him, I don't remember much, he struck me as slightly retarded.

22. Each of his exhibitions was a surprise, he changed his style.

23. I think what I'm trying to say about him is that he was a very French artist, a bit too literary, in the Proustian tradition.

24. He used to complain all the time, I would never have imagined that it would end up as [that actor] Michel Simon more or less explains in his *Drôle de drame*: if you go around talking about horrible things, horrible things wind up happening to you.

25. He was a terrible driver, he drove very slowly, people often used to make fun of him for it.

26. He once told me, I think I can say this, it wasn't supposed to be a secret, that he always hated his previous works, or at least the ones that he'd made a year or two before, but that he sometimes got pleasure out of "rereading" his older works, which he "understood" better, and that this dislike of his more recent works was what enabled him to go further ahead.

27. You probably don't know this, but the piece entitled *L'Album de la famille D.* [The album of the family D.] consists of photographs that Michel Durand (you know, the art dealer) had lent him. C. B. and he had been friends in their youth (I think they were at school together, or something like that), Michel Durand had therefore come to install his own family album at [Documenta] in 1972 and it appears that Michel's mother was very surprised by the interest that he suddenly showed in these amateur photographs.

28. He was a friend of the artist Annette Messager, she was a beautiful and intelligent woman, they weren't a great match but he seemed to love her a lot, I believe they first met at the beach in Berck.

29. He was timid, I might even say cowardly, his pleasantness actually hid a fear of other people, I suspect that he had never had a physical fight in all his life.

30. You know the story of his fake letter asking for help, this was in 1970, he was doing mail art, it was rather fash-

ionable at the time, everyone was doing mail art, he sent a handwritten letter to about thirty people, some of whom knew him and some of whom didn't, a vaguely worded letter, it was a bit paranoid and suicidal and it ended with a plea for help, four or five people replied with little notes of encouragement, they didn't appreciate the joke when they found what it was all about, it's not for me to judge this way of going about things, it might be effective but it's kind of unpleasant and even C. B. was rather embarrassed by it and justified himself by saying that he'd written the letters in a moment of crisis and that if he hadn't been an "artist" he might have written to only one person, and since that was a terrible period he was going through, he could well have gone under.

31. Despite the fact that children frequently figure in his work, he didn't have any of his own, I think he didn't like children, he was too much of an egotist for that, he used all the kids he knew, had them posing for hours at a time, took their toys and their clothes to exhibit them in his vitrines.

32. He wasn't at all interested in money, for him the only thing that mattered was art, he used to boast that the pieces he made couldn't be sold and this was often true, but painters in those days didn't have the same relationship to money as nowadays.

33. He was an obsessive, everything he said or did really came from the heart.

34. He was extremely nervous, slept badly, but nobody ever managed to get him off his habit of drinking ten coffees a day.

35. My favorite is the piece he calls *Saynètes comiques* [Comic sketches], these are small sketches in the tradition of Eastern European cabaret shows, which are part funny and part sad, he also made a video called *Mourir de rire* [Die laughing], where his laughter turns into crying and vice versa, I never got to see it, it was produced in Milan or Florence.

36. He lived in a small house at the back end of a yard near Alésia, the house was like him.

37. He was a little man, you know, like Charlie Chaplin in his early films—the "little fellow."

38. He worked very little, or at least so he claimed, he used to say that he felt as if he'd retired, in summer he spent his time in public parks, and in museums in winter because they were heated.

39. Despite the fact that he worked all the time he was always complaining about having nothing to do, he regretted not having a routine job to occupy his hands and his mind.

40. One time, it was at an opening, I only knew him by sight at that time, I heard his friend A. M. tell him, "You're not funny, you really are not funny," it's true, he wasn't funny, but he did have a certain sense of humor.

41. He came from a very rich Jewish family, had a very sheltered childhood, you could even say luxurious, but he didn't talk about it, he tended to let people think that his parents had been poor immigrants.

42. As a child he hardly ever spoke and he seems to have been a bit disturbed.

43. I set up his first exhibition in Cologne, this was in 1971, there's an expressionist side to his art that appeals to a German audience.

44. He was forever talking about death but he wasn't the gloomy sort.

45. He looked bizarre, absolutely bizarre, and I sometimes wonder whether part of his behavior wasn't play-acting.

46. He had a strange kind of love-hate relationship with Madame Sonnabend, he would spend hours waiting for her in her gallery, she treated him with a kindness which could be rather condescending.

47. The story goes that he shut himself up in his room for two months and spent his time sitting on the floor shaping three thousand little dirt balls in the hopes of making one that was perfectly spherical.

48. I only worked with him a little, and this was later on, he was efficient, fairly professional (except where press photographs were involved), and straight in dealings with money, he had this rather ridiculous thing about always wanting to be liked.

49. He loved spaghetti, I remember once in a pizzeria near the Boulevard Saint-Germain he ate two platefuls in one sitting.

50. He had a fairly unpleasant way of using people, I'd printed a large number of photos for him, and the price was reasonable enough, during this period he sent me postcards and often came to see me, but when he switched over to color photos he changed labs and that was the last I saw of him.

51. He was always making spelling mistakes, his letters were full of them, I believe he dropped out of school very early plus there's the fact that his parents weren't French.

52. In fact his private life appears only rarely in his work, apart from a few images involving his nephew Christophe he's never used photographs of members of his own family.

53. He only admitted it much later on, but already back in 1970 I was telling him that the Holocaust and more generally his relationship with Judaism had a crucial influence on his work, a piece like *Les Habits de François C* [The clothes of François C] relates directly to those images of piles of clothing in the concentration camps.

54. He seemed to adore A. M., she must have been a good woman because it can't always have been easy living with him.

55. He bought himself a black leather coat that he would wear with black boots, a kind of Nazi getup, I don't know whether he was aware of the resemblance, anyway he wore it all through one winter.

56. He could be accused of a lack of unity in his work, although the themes have hardly changed, you find various influences, ranging from conceptual art to Arte Povera.

57. Something that people don't realize is that he would have liked to be a film director, when he was very young he had in fact made a number of films, very violent even slightly sadistic, probably deriving from adolescent fantasies, he had some success with his amateur films, I saw them in 1970 at the Toulon Festival, and later, I think it was in 1971, he made a longer semiprofessional film with a grant from the National Film Center, this was based on a news item about a woman who had decided to lock herself in her apartment with her children and starve herself to death, he chose his nephew and niece to play the part of the children.

58. He lived with Annette Messager, you always saw them together, there seemed to be a lot of love between them.

59. I went to see him, he was living in an attic packed with all kinds of objects that he'd either collected or made himself, you were literally walking on them, during the whole of our conversation he stayed perched on a radiator, he showed me a load of engagement calendars that he'd bought at the flea market and in personal property liquidations, he said he was using the calendars to imagine what the lives of these people might have been like, I found this rather morbid.

60. The first time I went to see him, this must have been in 1969, he was living in a kind of attic, it was cluttered with traps that he'd hung from the ceiling, he said he'd installed these "pieces" as he called them as much for himself as for others, if you weren't careful where you walked, you risked banging against one of the counterweights and getting a knife on the top of your head, there was something very disturbing about him, he seemed very young and very old at the same time.

61. At the start I was rather impressed by him, later when I got to know him better it was easier to separate the true from the false, the comedy from the tragedy.

62. He was fairly young when he had his first exhibition, twenty-four or twenty-five, and he was quite a hit, I would say that achieving success has never been of his problems, this was clearly due to his own talents, but also to his family, even though he wasn't rich as a young man he didn't have to work for a living and since childhood he had always been surrounded by intellectuals.

63. I think I can say that I'm one of those who knew him best, you may find this surprising but the memory that I have of him is as a *bon vivant*, he loved eating, sitting in the sun, enjoying himself, basically he was a happy man although he wasn't what you would call the life and soul of the party.

64. There was something rather sneaky about him, the first time I saw him I thought this man has a nasty side to him, the kind of guy who hangs in front of elementary schools waiting for little girls to come out.

65. I knew him ages ago, it must have been in '65 or '66, I was writing for a Madrid newspaper at the time, I was living near the Boulevard Saint-Germain, I was out for a stroll and happened to go into a small gallery on Rue de Verneuil, at the back of a rather dingy room I saw a young, dark-skinned man in the process of painting a big religious picture, kind of expressionist, it was him, since he was bored and hardly anyone ever went into the gallery he spent his time painting, I talked with him and he showed me a lot of canvases, they were all slightly morbid, full of torture and people being killed, I thought they were a bit too naive but interesting.

66. Death, death, that was all he ever talked about, death had become his stock in trade.

67. He once told me that he felt like a kind of preacher, a bad preacher, a bit like the one played by Robert Mitchum in the Charles Laughton film, *The Night of the Hunter*.

68. He used to rewrite entire passages in interviews and cross out anything that bothered him, which obviously didn't please the critics who'd interviewed him.

69. One time at the May Salon, this must have been in 1970, he exhibited an old scale model of the Museum of Modern Art, all falling apart, he explained to me that it had a symbolic value.

70. I have one of C. B.'s rarer pieces, a barely legible hand-written page where he's talking about the Mickey Mouse Club, I got it in a kind of auction he organized under the title "Liquidation of objects found in a drawer belonging to C. B.," where Michel Durand was offering C. B.'s personal letters at rock-bottom prices.

71. C. B. worked in my gallery, I took him on as a favor to his parents, charming people, at that time he was rather strange and extremely erratic, he used to come every afternoon, sit himself in a corner, and do absolutely nothing.

72. I first heard of him via P. A. Gette, who sent me a card announcing a walk through the Vincennes Zoo and featuring the names of J. Le G. and C. B.

73. He had been invited to the Beaux-Arts school in Bordeaux, that was where I met him, he told us a few stories, examples, as he put it, kind of like a preacher or a Zen master, some people thought he was ridiculous but I found him rather striking.

74. That day in Bordeaux, he wasn't very well dressed, you might have taken him for a bum or a madman, he said that painters were alchemists, that they could transform paper and wood into gold, he added that there were more works of modern art in the vaults of Zurich banks than in any museum in the world.

75. He was very attached to his family, I think he used to have lunch with his parents every day, it must have been hard for his companion to put up with this.

76. You'd always find him smoking a pipe, he was forever fiddling around to relight it, he had this habit of putting used matches back in the box.

77. He only liked cities, I think he'd never spent more than three days in the country at any one time, he said that the silence made him nervous.

78. He loved complaining, sometimes he'd get together with his brother and they'd see who could find the most things to complain about, I used to call this the Wailing Wall.

79. I never knew him as a close friend, he was kind of a loner.

80. You'd often find him at openings surrounded by the same group of friends, when he spoke to you, you sometimes had the impression that his eyes were looking around to see

if there was someone more important than you that he could be talking to.

81. At the table he seemed incapable of holding a knife and fork, he was a fast, messy eater, strange for someone who was brought up in a nice middle-class family.

82. His brother is a well-known sociologist, this certainly influenced him, and helped him, although he always denied it.

83. One of his pet jokes was to announce to the world that he was Corsican and to explain how this fact had played an important role in his art, I think he may have had some Corsican blood in him, but he'd made such a big deal about his Jewish origins that nobody could believe him.

84. I was the first person to take an interest in him, I got him exhibited and even got him a prize, this was in 1962 at the Salon of the Physician-Painters (as you may know his father was a well-respected doctor), he was exhibiting a large composition in oils, technically competent, the piece had character even if it was rather naive, it was called *L'Entrée des Turcs à Van* [The entry of the Turks into Van].

85. I went to photograph him at his place, he was living in a freezing attic, he was thin and very pale, he told me that every time anyone took a photo of him he wondered whether it might be the last picture ever taken of him.

86. This would need examining more closely, but I would say that Annette Messager had a crucial influence on C. B., he was always on the lookout for things, he soaked them up and transformed them so that they could be used in his work.

87. He used to wear a metal chain around his neck, but without a medallion, when I expressed surprise at this he said that he hadn't yet been able to decide, but that one day he hoped he would know what he should hang on it.

88. I never knew him well, he was kind of a ship in the night, a small man, a bit hunched over, now I regret that I never spoke with him, but I probably wouldn't have found anything to say to him anyway.

89. For a number of years he was very close with J. Le G., they would phone each other every day, and prepare their exhibitions together, I also heard that they were thinking of working together permanently, but then they had a falling-out, I don't know why.

90. He affected a certain literary culture and liked to quote from books, but if you ever embarked on a serious discussion with him you'd find that he'd hardly read anything.

91. There's no way I would have been able to live with him, he was the kind of man who's charming on the outside, sensitive to other people, but an egotist at home.

92. I'd wanted to make a film about him, I was going to film him in his everyday routines, as much when he was making his balls of earth as when he was buying a loaf of bread, but we decided against it, fortunately—that's the kind of project you have when you're very young and very naive.

93. He had everything a person needs for happiness, a measure of success, a brilliant girlfriend, but that didn't stop him from complaining all the time, he liked to show that he was depressed.

94. I once saw, more or less by accident, a little show that he staged in the municipal park in La Rochelle, he was wearing black clothes and was miming events from his childhood in front of a painted backcloth, the audience consisted of young children, they were laughing hilariously, I didn't find it funny at all, in fact I found it rather sad.

95. I had invited him to participate in an exhibition which brought together a number of "stars" with some painters from the southwest of France, he didn't even reply to my letter, and when I phoned him he said he was too busy to come, in fact I realized afterward that he thought this exhibition which was actually rather successful would have done nothing for him.

96. His works were not easy to sell to collectors, they were often large pieces that were fragile and rather makeshift.

97. I organized a one-man show for him in 1970, then a year later he signed up with Sonnabend, I think he made a

mistake in career terms, but he was attracted by the prestige that this American gallery was enjoying, we remained on good terms with each other and I still consider him an artist with something to say.

98. He didn't have a real social life, he didn't know many people, I don't know whether this was a deliberate choice on his part, he never said no whenever anybody invited him out.

99. I was with him at the Venice Biennale in 1972, he stuffed himself with spaghetti and talked nonstop about painting, not easy to do both at the same time.

100. He used to say that he never killed insects, that he couldn't bear the idea of ending a life, he used to be very proud of two or three big spiders that lived in his place, this didn't stop him from eating meat though.

Christian Boltanski.
Fig. 4. Paris: Fig. et Fourbis, 1990, pp. 77-93.

Q. Do you see yourself as a painter?

A. I don't think that much changes in painting, and I would say that the Impressionist painters already had my desire to capture an image, to preserve a fragment of reality. In general terms you could say that painters have always sought either the ability to draw the perfect line or the means of capturing a given reality. But they inevitably fail, because one can never capture reality, any more than one can produce a perfectly straight line. For me, the unifying factor among all artists is precisely this failure, which is inescapable and almost desired, or at least anticipated. When I work on memory, I always set out with the knowledge of this failure. In other words, while I try to retrieve a past time, obviously I'm not going to succeed, because it's past and gone.

Initially I tried to retrieve the remains of a particular phase of my childhood, from birth to the age of six. I did a kind of archaeology on myself, and I realized that I had practically nothing left of that period of my life; it was completely dead. Later I tried to use memory as a means of reconstituting certain parts of my childhood; I made copies of my favorite things in Plasticine, but I never succeeded in bringing them back.

Since you see yourself as a painter, why do you turn your back on painting?

For me, the way that I use vitrines is a means of bringing things closer, of making them more recognizable. I believe that the use of new forms is not a major issue, and that we are always making Impressionist paintings. But in order to be able to express what we feel, we need to invent ways that spectators do not recognize as art. They should say: "What's that?" If they have no reference point, you're more likely to provoke them and attract their interest.

I believe that the choice of new forms is simply a means for expressing oneself better at a given moment. New art forms lose their originality very quickly, which is why we have to be continually seeking new ones. Black-and-white photography was an interesting form a few years ago, but you can't use it any more because it has become too recognizable.

Some years ago I was working with mail art; at that time, mail art aroused a certain interest, people would say: "Who is this lunatic?" But now that people recognize it as an art form, it's no longer usable. Everything that we do is art, let's have no illusions about that; we are merely artists, and,

171

what's more, artists within a tradition. There is no change. For me the most interesting period is the one in which the spectators are not yet aware that what they are experiencing is art. During this moment—which is relatively short—you can engage spectators by presenting them with something that is art without saying that it is art. But very soon they realize that it's art, complacency sets in, and all they see is an outer form. That's also quite sad, because out of all you've created, the only thing left is the aesthetic form. Everything you're trying to say disappears.

Take the case of the inventories. I like the idea of one of the inventories being preserved—let's say the inventory of the woman of Bois-Colombes—and in a few years from now you'll probably find people saying "He had an excellent painter's eye. Look at that gray at the back of the vitrines!" (I never chose it.) "He has chosen to apply the golden rule in the arrangement of the objects," or, "Look at that wonderful corkscrew, what an extraordinary shape." In the end, once one loses the functioning of a work of art or a visual object, all that remains is the aesthetic aspect, and that's rather sad! Anyway, for my part I'm a great believer in the fear of being ridiculous, the fear of being caught off-balance.

How would you situate yourself in relation to tradition?

I'm an extremely traditional painter. Like all artists, I work to produce emotions in the viewer. I work to make the world laugh and cry; I'm a preacher.

I've made books, inventories, photos, and films, but they all amount to basically the same thing. I don't believe there are differences among the media. You have an idea and then you go looking for the best means to express it, the most feasible way at that given moment. I don't believe that there's such a thing as a priority form. I think that painters have always had more or less the same things to say, the same desire to capture reality, but they express it each time with ways and means that are slightly different. You're not going to change something just because you use video and other gadgets.

There can't be a real transformation of art unless there is a transformation of society. As long as we don't have this, it's my opinion that art doesn't progress in real terms. I think that we shouldn't give ourselves big ideas, and we shouldn't call ourselves "theoreticians" just because we're afraid to be painters. I also don't think we can go around saying "I'm going to change everything—do away with art dealers, art in museums," etc. Because it's not true—all present-day artwork is going to end up in a museum. If one day the people who are currently doing body art, or behavior art, won't have any more need to create little objects, or to make beautiful photos, because the market will have become a thing of the past, then art will change because society will have changed. But as long as it doesn't change, the activity of artists remains basically the same. I maintain, however, that we are moving increasingly toward the idea of the destruction of the work of art. This may be a sign of a transformation still to come, because at the moment everything is still totally co-opted. I think that we're a bit like those bishops in the period before the French Revolution who said: "You know, there are a lot of things about religion that need to be discussed," and who went to see philosophers, but who, in the end, still remained bishops. We're still painters, and we all use the present system, for all our reservations. Take me, for example. I ask a lot of questions about art and its purpose or non-purpose, but at the same time, in some vague and inexplicable way, I still believe in art. Maybe we'll find this stupid fifty years from now. Anyway, all that can be said is that a work is better when it gives a better account of a society with newer means—but that always remains inexplicable.

From *Art Actuel Skira Annuel*.
Geneva: Skira, 1975, pp. 146-148.

CHRISTIAN BOLTANSKI:
AWKWARDNESS STRIKES BACK

C. B. I believe that the important thing about artists is what one might call the exemplary quality of their lives, in the same sense that one has the exemplary lives of saints. Artists are exemplary not because they're paragons of virtue, but because the way in which their lives develop provides an example. I'm very interested in the lives of the desert saints, and in the ways they have been spoken about through history. The ways people speak of artists is rather similar: in both cases we have lives that transmit a message through example and image rather than through words. In this respect painters seem to me rather like Eastern philosophers who teach by example. This is where Didier has done a real scholar's job: writing an "exemplary life."

D. S. Exemplary and impossible, because you're always working at making your biography impossible.

C. B. Yes. A large part of my activity has to do with the idea of biography, but a biography that is totally false, and that is presented as false, with all kinds of false evidence. You find this throughout my life: the nonexistence of the person in question. The more people speak of Christian Boltanski, the less he exists. The more biographies and texts there are, the more the man becomes mythical. There is, for example, a little book from 1972, which shows C. B. at various ages, but it's never the same person—each time it's actually a different child. Photography is used to furnish a proof, and the proofs are always false.

A. F. You were saying also that the result of having told so many false stories is that you no longer have childhood memories.

C. B. That's true. The more you work, the less you exist. I believe (at least, I used to believe, because I no longer think this is entirely true) that the artist is like someone carrying a mirror in which everyone can look and recognize themselves, so that the person who carries the mirror ends up being nothing. That person has become only the others; the artist is the others. Another Christian kind of idea. I always think of artists as a kind of machine, working at being other people, and that their desire to make things is simultaneously a desire to suppress their own lives. When Proust started writing, he stopped living, and if we love him it's because we all have a ridiculous old aunt. We recognize ourselves; it's autobiographical and collective. I could venture some even more dubious thoughts: at this moment I believe that I'm a general-public artist, in the same way that people call [Claude] Lelouche a general-public film director, and this is what I have been working toward. I know that this is not necessarily good, and I'm aware of the dangers. When I say "general public," I mean artists who can communicate a direct emotion in relation to their own lives: this brings us back to the lives of the saints, which anybody would find moving. . . .

If today's art interests me much less than the art of the 1970s, this is in part a question of generation, but it's mainly because there are far fewer political struggles today—those

real-life struggles that we saw in the United States, even more than in France, which meant that artists were producing works that were more courageous, more interesting. There is a kind of climate for art: if American art is so uninteresting today, it's because you have these young people playing the stock market, this non-battle against the Establishment. And I'm of the opinion that there's a relationship between periods when art is at its most exciting and periods when there is a moral battle under way. What I'm saying is very romantic, but I do believe that artists must be in struggle against the Establishment, even if they're co-opted. They're inevitably going to be co-opted, but in order to create there has to be a climate of struggle, and not the kind of lax situation that we have in America today. It's difficult, because there are some bad painters who are very moral. I'm speaking in general, though, and I think that one of the factors explaining the very tough, minimalist artworks of the 1970s is that they were part of a climate of moral struggle.

D. S. And Christian's work is to make false shrouds.

C. B. At present, one of the subjects that interests me is the transformation of the subject into object. A whole section of my work centers on this idea—for example, my interest in corpses. In my use of photographs of children, there are people of whom I know absolutely nothing, who were subjects and who have become objects, in other words, corpses. They are nothing any more, I'm free to push them around, tear them, make holes in them. . . .

These ambiguous relationships are what I find most interesting. It's like the pleasure that you get out of watching a striptease artist, or young dancers at the Opera: they're subjects transformed into objects, because they're made to do things that are difficult, against nature. The emotion is that much greater when something still remains of their nature as subject.

From Alain Fleisher and Didier Semin
"Christian Boltanski: La Revanche de la maladresse."
Art Press (Paris), no. 128 (September 1988), pp. 4-9.

INTERVIEW WITH CHRISTIAN BOLTANSKI

D. R. Would you agree that the exhibition at the Musée National d'Art Moderne is virtually a work of art in its own right?

C. B. A long time ago I was struck by an exhibition that I saw at the Châtillon community center, dedicated to a painter who had just died. It included various biographical materials displayed in vitrines: his pen, a few of his letters, photographs of him on vacation, and then also his paintings. It struck me that despite the efforts of the organizers, both his life and his work still remained distant from me.

People can't be saved either by the conservation of their remains or by the preservation of their works. I hope that my exhibition expresses these strange links between life and art: life as art, and art as life. But in my case what we have, to a certain extent, is biographical elements that are false, and paintings that are not really paintings.

D. R. Have you always been so aware of the place in which you exhibit your work?

C. B. I've always found it surprising that in the Musée du Louvre you have everyday objects, like their collection of small Gallo-Roman oil bottles, exhibited on the same footing as, say, Rubens's paintings, which are objects of splendor conceived by an artist who was very well aware that he was making art.

I've developed an interest in the various different departments of museums. The *Reconstitutions* and the *Inventaires* [Inventories] would fit best in a department of archaeology or ethnology. The *Compositions*, if you extend the analogy, would fit best in the painting section of the Louvre's Grande Galerie.

In all these cases, what is involved is a game with the institution, a way of looking at the place and what it contains. I may change departments, but what I exhibit there only functions as a mirror of what is already there. I love museums—like public parks and swimming pools, they're special places where you can be alone in a crowd.

These are places without reality, places that are out of this world, protected, that work to make things pretty and lifeless.

D. R. It seems to me that at the start your work was characterized, among other things, by a rather derisive attitude toward art and museums. Do you still look at them with the same irony?

C. B. I would prefer the word "doubting" to "derisive." I believe that, no matter what you say and do, you can't escape from the artistic terrain of your own epoch. I'm an artist of the second half of the twentieth century. There is a kind of weight of history, which leads even the most varied and apparently opposed artists in a given era to produce rather similar painting; on the other hand, where certain artists may have the same story to tell, if they emerged at different times, they tell it, in formal terms, in very different ways. At the Documenta 5 in Kassel I was put next to Etienne Martin,

and I understood that here was an artist who was very different from me, but who had the same desire to speak of memory, and of memory as it related to his childhood.

What I mean is that things are more complicated, that to be a painter definitely means, at least for me, undergoing a kind of primitive therapy, but it also means belonging formally to the art of one's own times.

D. R. However some of your pieces, such as the *Boulettes de terre* [Balls of dirt], seem to have their closest affinity with the art of the "insane."

C. B. I suppose it was rather an obsessional thing to embark on—feeling a need to make things by hand, and trying to save yourself of it by making a thousand little balls of dirt by hand in the vain hopes of being able to produce a perfect sphere. But if I had been crazy I probably wouldn't have stopped after a given time, and I wouldn't have exhibited them, or at least not in the same way. It was a reflection on a crazy person, which is what I was at the time. But I think that the fact of calling yourself an artist, and of wanting to connect with the history of art, has to do mainly with a desire to situate yourself in reality, and to adapt your madness to a framework that is both acceptable and accepted. When I was making the dirt balls, I was telling myself that I was making art, and an art that had its place in the development of the history of art and of the world.

D. R. You say that there are formal links among all the artists of a given generation. How would you account for their differences?

C. B. For myself, it's a question of a choice that is practically religious, and I would say that the basic thing is the way one responds to that choice.

D. R. What do you mean by that?

C. B. Painting belongs to the domain of the religious, of the unknown, of the sacred, of that which is capable of giving a universal value to a patch of color. Some artists believe that they can go beyond their own consciousness to reveal a universe that escapes their rational understanding. I know that painting exists in the realm of what cannot be explained in words, of the felt, of the inexplicable, but at the same time

(and this may be a product of the period in which I grew up) I refuse to believe. Thus my way of envisaging painting embodies a certain contradiction. My work is located within a religious domain, but my hope is that within each piece there is something that contradicts it, that poses a question. Some paintings invite you only to communion and prayer; others ask you questions. I see myself as closer to the latter. Yet in a way I regret that I'm not religious. I would have liked to be a true painter, to be able to believe completely in the divine essence of painting; but I reject all that—there's my misfortune in a nutshell. . . .

I'm scared of an art that tries to impose itself on others. Some paintings embarrass me in the same way that I would be by a religious person trying to convert others. I imagine that my ambiguous relationship to painting and my use of photography have something to do with my mindset as a Jew, assuming that I have such a thing. I do photography, which is seen as less noble than the art of painting—as if I was scared to come to terms with the sacredness of painting.

D. R. You often talk about the true and the false. It's difficult to follow.

C. B. I think it's very hard to separate the true from the false. In one of my first interviews I was play-acting the role of a young man in a state of tormented depression. As I was speaking, I was thinking "I'm doing this well, they're believing me." But by the end, I became horribly depressed, because what I'd been saying was true—it was a truth that I'd been hiding from myself, and which I could only admit to myself via the cover of a game.

In most of my photographic pieces I have manipulated the quality of evidence that people assign to photography, in order to subvert it, or to show that photography lies—that what it conveys is not reality but a set of cultural codes. The *Album de la famille D.* [Album of the family D.] teaches us nothing about the life of that family, but addresses itself to the area of family mythology. In the *Saynètes comiques* [Comic sketches] the photographs lie, because there we have a person in makeup in front of a painted backdrop acting a scene that is confirmed by the accompanying text. The images of the *Saynètes* were doubly false, because they also suggested that a fictitious performer might have played the scenes.

D. R. You point to the element of "trickery" in photography. But do you think it is in fact possible to produce a photograph that's "transparent?" All photographers choose their framing, their viewpoint.

C. B. It was with the *Images modèles* [Model images] that I made the nonreality of photography most explicit. At that time I had become aware that in photography, and particularly in amateur photography, the photographer no longer attempts to capture reality; he attempts to reproduce a pre-existing and culturally imposed image, the models for which are to be found in the painting of the late nineteenth century. Amateur photographers produce only images of happiness—smiling children on nice green grass; they reconstitute an image with which they are already familiar. In 1975, together with Annette Messager, I did a piece entitled *Le voyage de noces à Venise* [The honeymoon in Venice], commissioned by the Biennale. In the process, I realized that in the eyes of its visitors, Venice has no reality of its own. Anyone visiting the place has already seen so many pictures of it that they can only attempt to view it via these clichés, and they take home photographs of Venice that are similar to the ones that they already know. Venice was becoming like one of those painted backdrops that photographers use in their studios. I did three *Images modèles*, in Venice, Berck-Plage, and Berlin: all of them, each one in its own way, were places with no reality, three painted backdrops. It was then a natural transition from these constructed images to others such as my *Compositions photographiques* [Photographic compositions] or the *Compositions japonaises* [Japanese compositions].

D. R. Are your *Images modèles* a reflection on middle-of-the-road taste?

C. B. First and foremost they're my photographs, and I think they're pretty good. When I look at them nowadays, they have a practical use value, in the sense that they remind me of the summer of 1975. But I was also engaged in a reflection on taste, and on "displacement." The *Images modèles* and the *Compositions photographiques* were received differently in an avant-garde art gallery from the way they were received in a photographers' gallery: what was seen as pretty at the photo club in Choisy-le-Roi was considered ugly at the Sonnabend Gallery, and vice versa. These images were posed as stereotypes, and as such they embodied a refusal of established fact and of photography as evidence of reality.

D. R. Returning to the term "model," do you think that, taken as a whole, your images are "model images," to use the title of one of your series?

C. B. I don't want viewers to discover; I want them to recognize. For me, a work is in part created by the people who look at it, who "read" it with the aid of their own experiences. I called one of my series "Stimulating Images" to suggest that what is being shown is only a stimulant: it permits each spectator to feel something different. In more general terms, I would say that in life we always try to match what we see with what we know. If I show a photograph of the beach at Berck, one person will recognize it as the beach at Dinan, and another as the beach at Granville.

D. R. Is recognition a way of seducing the spectator?

C. B. I try to find images that are sufficiently imprecise to be as widely shared as possible, vague images that spectators can embroider as they see fit.

In my little book *Les Histoires* [The stories/histories], I showed a series of images taken from a history book that we all remember from our childhood; under each picture I placed captions that read, for example, "That day the teacher came in with the principal." Each image has to have the power to call to mind an infinite number of phrases of that kind, and each person thinks up their own.

From Delphine Renard,
"Interview with Christian Boltanski,"
Boltanski, exhibition catalogue.
Paris: Musée National d'Art Moderne,
Centre Georges Pompidou, 1984, pp. 70-85.

171. Christian Boltanski
working on *Les Compositions*, 1983.

EXHIBITIONS,
BIBLIOGRAPHY,
FILMOGRAPHY

172. Excerpt of a letter sent by Christian Boltanski
to Paul Armand Gette, 6 February 1971. Facsimile.

SELECTED SOLO EXHIBITIONS

1968
Paris, Cinéma le Ranelagh. "La Vie impossible de Christian Boltanski" (film, mannequins, and paintings).

1970
Paris, ARC/Musée d'Art Moderne de la Ville de Paris (with Sarkis).

1971
Paris, Galerie Sonnabend. "Essai de reconstitution d'objets ayant appartenu à Christian Boltanski entre 1948-1954."

1972
Berlin, Galerie Folker Skulima. "Règles et techniques."
Fontainebleau, France, Musée Municipal du Costume Militaire (with Jean Le Gac). Traveled in France to Saint-Etienne, Musée d'Art et d'Industrie, 1972; Mâcon, Musée Municipal des Ursulines, 1973; Cognac, Musée de Cognac, 1973; Dijon, Musée Rude, Biennale des nuits de Bourgogne (also with Annette Messager), 1973.
Paris, Galerie Sonnabend. "Règles et techniques."

1973
Baden-Baden, West Germany, Staatliche Kunsthalle. "Les Inventaires."
Jerusalem, Israel Museum. "Les Inventaires."
New York, Sonnabend Gallery.

1974
Dijon, France, Musée Archéologique. "Le Musée de Christian Boltanski: 1966-1974."
Humlebaek, Denmark, Louisiana Museum. "Les Inventaires."
Münster, West Germany, Westfälischer Kunstverein. "Affiches – Accessoires – Décors, documents photographiques." Traveled in West Germany to Kiel, Kunsthalle, 1974, and Stuttgart, Württembergischer Kunstverein, 1975.
Paris, CNAC/Centre National d'Art Contemporain. "Les Inventaires."

1975
New York, Sonnabend Gallery. "Saynètes comiques."

1976
Bonn, West Germany, Rheinisches Landesmuseum. "Modellbilder" (with Annette Messager).
Paris, Galerie Sonnabend. "Photographies."
Paris, Musée National d'Art Moderne, Centre Georges Pompidou. "Photographies couleurs – Images modèles."

1977
Paris, Galerie Sonnabend. "Compositions photographiques."

1978
Karlsruhe, West Germany, Badischer Kunstverein. "Arbeiten 1968-1978."
Long Island City, New York, P.S. 1/Institute for Art and Urban Resources. "School Project P.S. 1."
Warsaw, Poland, Galerie Foksal/PSP. "Les Images stimuli" (with Annette Messager).

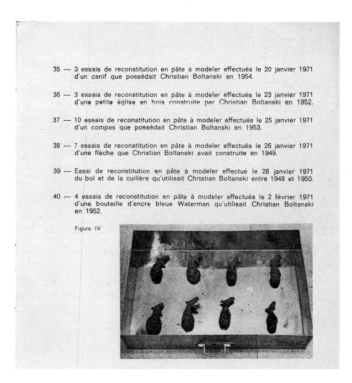

173. Detail of one page from the artist's book *Catalogue: Essais de reconstitution d'objets ayant appartenus à Christian Boltanski entre 1948 et 1954* (Catalogue: Attempts to reconstruct objects that belonged to Christian Boltanski between 1948 and 1954). March 1971.

MUSÉE MUNICIPAL DU COSTUME MILITAIRE

15, RUE ROYALE, 77 - FONTAINEBLEAU

vous êtes priés de bien vouloir assister au vernissage
de l'exposition

Christian Boltanski Jean le Gac

Fac-similés - Documents - Originaux - Écrits

le 19 mai 1972 à 18 heures

qui aura lieu sous la présidence de
Monsieur Paul Seramy, maire de Fontainebleau

Cette exposition est organisé en collaboration avec le C.N.A.C. du 15 mai au 12 juin,
ouvert tous les jours sauf le mercredi de 10 h. à 12 h. et de 14 h. à 17 h.

Notre travail est une tentative pour trouver dans notre aujourd'hui les moyens de transmettre et de conserver l'expérience que nous faisons d'une activité artistique : parcours mental, jalonné de vestiges (photos, objets, fragments de textes...) que nous nous efforçons de sauver de l'indifférence et de l'usure du quotidien. Il était naturel que nous songions à présenter ce type d'activité dans des musées qui ont précisément pour vocation de remonter le temps en classant et le document et son histoire.

Il nous a également semblé que les éléments de notre travail pourraient être examinés sur un mode égalitaire qui permettrait de les confronter avec les autres témoins de l'activité humaine, et donc, il était intéressant de chercher cette confrontation dans d'authentiques musées qui ont la charge de garder la mémoire des choses et des motivations retrouvées qui ont présidé à leur élaboration.

Enfin, en utilisant ce cadre pour notre travail, nous gagnons sans doute du temps sur notre mort : il était passionnant de placer dès à présent notre activité dans une perspective muséographique, puisque de toutes façons et en dernier ressort c'est ce plan là qui guette toute chose.

Christian Boltanski Jean Le Gac

174. 175. Invitation to the opening of the exhibit "Christian Boltanski – Jean Le Gac: Fac-similés – Documents – Originaux – Écrits" (Christian Boltanski – Jean Le Gac: Facsimiles, documents, originals, writings), Fontainebleau, Musée du Costume Militaire, 19 May 1972.

1979
Châlon-sur-Saône, France, Maison de la Culture. "Les Modèles."
New York, Sonnabend Gallery.

1980
Calais, France, Musée des Beaux-Arts. "Christian Boltanski – Compositions."

1981
Cambridge, Massachusetts, Carpenter Center, Harvard University.
Paris, ARC/Musée d'Art Moderne de la Ville de Paris. "Compositions."

1984
Paris, Galerie Crousel-Hussenot.
Paris, Musée National d'Art Moderne, Centre Georges Pompidou. Traveled to Zurich, Switzerland, Kunsthaus Zürich; Baden-Baden, West Germany, Staatliche Kunsthalle; Bonn, West Germany, Bonner Kunstverein.
Rotterdam, The Netherlands, Galerie 't Venster. "Shadows."

1985
Dijon, France, Le Consortium. "Monuments."
Organized by Le Coin du Miroir.

1986
Munich, West Germany, Kunstverein München. "Leçon de ténèbres."
Paris, Galerie Crousel-Hussenot. "Monuments."
Paris, Chapelle de la Salpêtrière, Festival d'automne. "Leçon de ténèbres."

1987
Düsseldorf, West Germany, Kunstverein für die Rheinlande und Westfalen. "Classe terminale du Lycée Chases en 1931: Castelgasse-Vienne."
Marseilles, France, Galerie Roger Pailhas. "Œuvres inédites."
Vienna, Austria, Galerie Hubert Winter. "Locus Solus 1."

1988
Chicago, Museum of Contemporary Art; Los Angeles, Museum of Contemporary Art; New York, The New Museum of Contemporary Art (1988-1989). "Christian Boltanski: Lessons of Darkness." Traveled to Vancouver, British Columbia, Vancouver Art Gallery, 1989; Berkeley, California, University Art Museum, 1989; Toronto, The Power Plant, 1989-1990.
Toronto, Ydessa Hendeles Art Foundation.
Madrid, Centro de Arte Reina Sofia. "El Caso."
New York, Marian Goodman Gallery.

1989
Paris, Galerie Ghislaine Hussenot. "Archives."
Basel, Switzerland, Museum für Gegenwartskunst. "La Fête de Pourim."
Athens, Greece, Galerie Jean Bernier. "Odessa."
Jerusalem, Israel Museum. "Lessons of Darkness."

1990
London, Whitechapel Gallery. "Christian Boltanski-Reconstitution." Traveled to Eindhoven, The Netherlands, Stedelijk van Abbemuseum; Mönchengladbach, Germany, Städtische Museum; Grenoble, France, Musée de Grenoble.
Nagoya, Japan, Institute of Contemporary Arts. Traveled to Mito, Japan, ATM Contemporary Art Gallery.

1991
Hamburg, Germany, Hamburger Kunsthalle. "Christian Boltanski: Inventar."
London, Lisson Gallery. "Conversation Pieces."
Frankfort, Portikus.
Paris, Galerie Ghislaine Hussenot. "La Réserve des Suisses morts."

1992
St. Gall, Switzerland, Stiftsbibliothek.
London, Lisson Gallery.
Mexico City, Centro Cultural Arte Contemporaneo.
New York, New York Public Library.

176. Cover of catalogue for the exhibition "Modellbilder" (Model images), with Annette Messager, Rheinisches Landesmuseum, Bonn, 1976.

SELECTED INTERVIEWS

"Monument à une personne inconnue. Six questions à Christian Boltanski." *Art Actuel Skira Annuel.* Geneva: Skira, 1975.

Jacques Clayssen. "Boltanski." In the exhibition catalogue *Identité/Identifications.* Bordeaux: capc/Centre d'Arts Plastiques Contemporains, 1976.

Irmeline Lebeer. "Entretien entre Irmeline Lebeer et Christian Boltanski." In the exhibition catalogue *Boltanski: Les Modèles.* Châlon-sur-Saône: Maison de la Culture de Châlon-sur-Saône, 1979.

Suzanne Pagé. In the exhibition catalogue *Compositions.* Paris: ARC/Musée d'Art Moderne de la Ville de Paris, 1981. Reprinted in part in the exhibition catalogues *Trigon 81* (Graz, Austria: Neue Galerie am Landesmuseum, 1981); *Vergangenheit Gegenwart Zukunft* (Stuttgart, West Germany: Württembergischer Kunstverein, 1982); *Statements New York '82: Leading Contemporary Artists from France* (New York, Sonnabend Gallery, 1982).

Michel Nuridsany. "Christian Boltanski: Le Montreur d'ombres." *Art Press* (Paris), no. 79 (March 1984), pp. 8-10.

Delphine Renard. In the exhibition catalogue *Boltanski.* Paris: Musée National d'Art Moderne, Centre Georges Pompidou, 1984. Reprinted in part in *Camera Austria* (Graz, Austria, 1984) and in the exhibition catalogue *Les Années 70: Les Années mémoire. Archéologie du savoir et de l'être* (Meymac, France: Abbaye Saint-André, Centre d'Art Contemporain, 1987).

Démosthènes Davvetas. "Christian Boltanski." *Flash Art* (Milan), no. 124 (October-November 1985), pp. 82-83. Reprinted in part in "Christian Boltanski par moi-même," *Libération* (Paris), 14 March 1986, and in the exhibition catalogues *18a Bienal Internacional de Saõ Paulo* (Saõ Paulo, Brazil, 1985) and *Christian Boltanski: Leçon de ténèbres* (Munich: Kunstverein München, 1986).

Elisabeth Lebovici. "Entretiens: Christian Boltanski." *Beaux-Arts* (Levallois, France), no. 37 (July-August 1986), pp. 26-31.

Démosthènes Davvetas. "Christian Boltanski." In the exhibition catalogue *From the Europe of Old.* Amsterdam: Stedelijk Museum, 1987.

Brigitte Paulino-Neto. "Le Peintre, ange noir du choréographe." *Libération* (Paris), 24 June 1987, pp. 38-40.

Alain Fleischer and Didier Semin. "Christian Boltanski, la revanche de la maladresse." *Art Press* (Paris), no. 128 (September 1988), pp. 4-9.

Stuart Morgan. "Little Christian." *Artscribe* (London), no. 72 (November-December 1988), pp. 46-49.

Bracha Ettinger. "Excerpts from an Interview with Christian Boltanski." In *Christian Boltanski: Lessons of Darkness.* Jerusalem: Israel Museum, 1989.

Jörg Zutter. "Musée de nous-mêmes, Christian Boltanski zu seiner Installation *Réserves – La Fête de Pourim.*" In the exhibition catalogue *La Fête de Pourim.* Basel, Switzerland: Museum für Gegenwartskunst, 1989.

Georgia Marsh. "The White and the Black." *Parkett* (Zurich), no. 22 (December 1989), pp. 36-40.

————. "Christian Boltanski – Christian, Carrion, Clown and Jew." In the exhibition catalogue *Christian Boltanski: Reconstitution.* London: Whitechapel Art Gallery, 1990.

Gumpert, Lynn. "Christian Boltanski in Conversation with Lynn Gumpert." *Art and Design* (London), no. 1-2, 1990.

SELECTED EXHIBITION CATALOGUES

Boltanski: Reconstitution. Karlsruhe, Germany, Badischer Kunstverein. Texts by Christian Boltanski, Andreas Franzke, and Michael Schwarz. Paris: Editions du Chêne, 1978.

Christian Boltanski: Les Modèles. Châlon-sur-Saône, France, Maison de la Culture. Texts by Christian Boltanski and Irmeline Lebeer. Paris: Cheval d'attaque, 1979.

Christian Boltanski: Compositions. Calais, France, Musée de Calais. Text by Dominique Viéville. Calais, 1980.

Boltanski. Paris, Musée National d'Art Moderne, Centre Georges Pompidou. Texts by Bernard Blistène, Dominique Bozo, Klaus Honnef, Tadeusz Kantor, Gilbert Lascault, Serge Lemoine, Günter Metken, Delphine Renard, and Dominique Viéville. Paris, 1984.

Christian Boltanski: Leçon de ténèbres. Munich, Kunstverein München. Texts by Christian Boltanski, Démosthènes Davvetas, and Zdenek Felix. Munich, 1986.

Christian Boltanski: Lessons of Darkness. Chicago, Museum of Contemporary Art; Los Angeles, The Museum of Contemporary Art; New York, The New Museum of Contemporary Art. Texts by Lynn Gumpert and Mary Jane Jacob. Chicago, Los Angeles, and New York, 1988.

Christian Boltanski: Lessons of Darkness. Jerusalem, Israel Museum. Texts by Suzanne Landau and Bracha Ettinger. Jerusalem, 1989.

Christian Boltanski-Reconstitution. Eindhoven, Stedelijk Van Abbemuseum; London, The Whitechapel Art Gallery; Grenoble, Musée de Grenoble. Texts by Lynn Gumpert, Serge Lemoine, and Georgia Marsh. Eindhoven, London, and Grenoble, 1990.

MONOGRAPHS AND SELECTED ARTICLES

Louis Aragon. "Reconstituer le crime." *Les Lettres Françaises* (Paris), 6-12 January 1971.

Gilbert Lascault. "Boltanski au Musée municipal d'art moderne." *XXᵉ siècle*, no. 36 (June 1971), pp. 143-145.

Effie Stephano. "Existential Art." *Art and Artists* (London) 9, no. 2 (May 1974), pp. 24-29.

Gilbert Lascaux. "Inventaires de Boltanski." *XXᵉ siècle* (Paris), no. 43 (December 1974), pp. 180-181.

——————. "Huit critiques grotesques pour un travail de Christian Boltanski." In Mikel Dufrenne, ed., *Vers une esthétique sans entrave*. Paris: 10/18, 1975.

Bernard Marcadé. "Les Scènes primitives de Christian Boltanski." *Arte Factum* (Antwerp), no. 2 (February 1984), pp. 43-45.

——————. "Noël est la Fête la plus triste du Monde." In *Eloge du mauvais esprit*. Paris: Editions de la Différence, 1986.

Gilbert Lascaux. "Twelve Observations on Christian Boltanski's Shadows and Monuments." *Parkett* (Zurich), no. 9 (June 1986), pp. 12-15.

Démosthènes Davvetas. "In the Twentieth Century C.B." *Artforum* 25, no. 3 (November 1986), pp. 108-109.

Klaus Honnef. "Un magicien moderne: Réflexions à propos de l'œuvre de Christian Boltanski." *Artstudio* (Paris), no. 5 (Summer 1987), pp. 107-116.

Didier Semin. *Boltanski*. Paris: Art Press, 1988.

Jiri Svestka. "Christian Boltanski." *Galeries Magazine* (Paris), no. 24 (April-May 1988), pp. 97-103.

Arthur C. Danto. "Christian Boltanski." *The Nation*, 13 February 1989, p. 210.

Adam Gopnik. "The Art World: Lost and Found." *The New Yorker*, 20 February 1989, p. 108.

Nancy Marmer. "Boltanski: The Uses of Contradiction." *Art in America* 77, no. 10 (October 1989), pp. 169-180.

Beatrice Parent. "Light and Shadow, Christian Boltanski and Jeff Wall." *Parkett* (Zurich), no. 22 (December 1989), pp. 60-62.

Didier Semin. "An Artist of Uncertainty." *Parkett* (Zurich), no. 22 (December 1989), p. 26.

Anne-Madeleine Durez, Dorothée Gravoueille, and Franck Lepin. "Christian Boltanski." In *Une scène parisienne 1968-1972*. Rennes: Centre d'histoire de l'art contemporain, 1991, pp. 75-85.

Jennifer Flay, ed. *Christian Boltanski Catalogue: Books, Printed Matter, Ephemera 1966-1991*. Cologne and Frankfurt am Main: Verlag der Buchhandlung Walther König and Portikus, 1991.

Introduction: When I arrived in Paris I called Christian and he asked me to meet him at the opening of a film by Chantal Ackerman at the Louvre. The film is about Jewish immigrants in America. Very artificial, dead-pan shots of actors telling old Yiddish sories and jokes. The projection was preceded by a concert of ~~sad~~ Yiddish music played by a cello, violin, and piano. He invited two people to join us for dinner. While we ate and drank Christian, without the tape, spoke freely and openly about his family background. "This," I thought," is a set-up."

The next day Chistian sat me down in his studio facing a neatly folded pile of children's clothing. Leaning against this wall was the highly contrasted, blurred photo of a smiling graduate of the Jewish high school in Vienna, class of '31. If I looked at Christian I couldn't quite focus the image which meant that as we spoke my eyes flipped constantly between his face and what appeared to be the black and white image of a grinning Death's Head.

. . .

GM: *Christian, why this delectation of the dead?*
CB: ~~~~ It is one of the strangest things, the fact that we are all going to die. We are all so complicated, and then we die. We are a subject one day, with our vanities, our loves, our worries, and then one day, abruptly, if you are not a

believer, we become nothing but an absolutely disgusting pile of shit. We pass very quickly from one stage to the next. ~~~~ Suddenly we become an object you can handle, like a stone. But a stone that was someone. ~~~~.

The photographs and clothing that I am working with now have this in common: the are both objects and souvenirs of subjects. Exactly as a cadaver is both an object and a souvenier of a subject. Clothing reminds you of the person who was in it. We have all had the experience when someone in the family dies. You see their shoes and you see the form of their feet as a hollow image of the person, a negative. ~~~~.

I did the piece about the children of Dijon for a Catholic festival, All Saint's Day, with the idea that every human being is holy. I had a couple of hundred photographs of children, adolescents, all fairly ugly, and yet each one is different from the others and each one is holy so I put little lights around them as if each one were a saint. There is something interesting about a herd of identical rotting objects that had each hoped, wanted, desired differently from the others. ~~~~. There is a

177. Pages from the "Interview with Georgia Marsh, reviewed and corrected by Christian Boltanski," 1990.

SELECTED ARTIST'S BOOKS BY CHRISTIAN BOLTANSKI

(See also *Christian Boltanski Catalogue: Books, Printed Matter, Ephemera 1966-1991*, cited above.)

Recherche et présentation de tout ce qui reste de mon enfance, 1944-1950. Paris: Edition Givaudon, 1969. 9 pp., 15 b/w illustrations. 150 copies.

Reconstitution d'un accident qui ne m'est pas encore arrivé et où j'ai trouvé la mort. Paris: Edition Givaudon, 1969. 6 pp., 12 b/w illustrations. 150 copies.

Tout ce que je sais d'une femme qui est morte et que je n'ai pas connue. Self-published, 1970. 8 pp., 5 b/w illustrations.

Reconstitution de gestes effectués par Christian Boltanski entre 1948 et 1954. Self-published, 1970. 12 pp., 7 b/w illustrations. 500 copies.

Catalogue: Essais de reconstitution d'objets ayant appartenus à Christian Boltanski entre 1948 et 1954. Paris: Galerie Sonnabend, 1971. 4 pp. with b/w illustrations.

Album de photos de la famille D., 1939-1964. Luzerne, Switzerland: Kunstmuseum Luzern, 1972. 46 pp., 150 illustrations.

L'Album photographique de Christian Boltanski, 1948-1956. Hamburg and Paris. Grossmann Verlag and Galerie Sonnabend. 1972. 32 pp., 32 b/w illustrations. 500 copies.

10 portraits photographiques de Christian Boltanski, 1946-1964. Paris: Editions Multiplicata, 1972. 20 pp., 10 b/w illustrations. 500 signed copies.

List of Exhibits Belonging to a Woman of Baden-Baden Followed by an Explanatory Note. Oxford, England: Museum of Modern Art, 1973. 4 pp., 52 b/w illustrations.

Inventaire des objets ayant appartenu à une femme de Bois-Colombes. Paris: CNAC, Centre National d'Art contemporain, 1974. 48 pp., 310 b/w illustrations.

Quelques interprétations par Christian Boltanski. Paris: CNAC, Centre National d'Art Contemporain, 1974. 16 pp., 8 b/w illustrations. 200 signed and numbered copies.

Les Morts pour rire de Christian Boltanski. Didweiler, West Germany: Editionen A. Q., 1974. 32 pp., 14 b/w illustrations. 150 copies.

4 saynètes comiques interprétés par Christian Boltanski. Zagreb, Yugoslavia: Galerie Suvremene Umjetnosti, 1975. 18 pp., 16 b/w illustrations. 500 copies.

Saynètes comiques. Brussels: Palais des Beaux-Arts, 1975. 32 pp., 22 b/w illustrations.

Les Images stimuli. Warsaw: Galeria Foksal PSP, 1978. 12 pp., 14 b/w illustrations.

Monuments. Leçons de ténèbres. Paris: Association Française d'Action Artistique, 1986. 256 pp., 110 b/w and 4 color illustrations.

Le Lycée Chases: Classe Terminale du Lycée Chases en 1931: Castelgasse – Vienne. Saint-Etienne, France: Maison de la Culture et de la Communication, 1987. 44 pp., 20 b/w illustrations.

Théâtres. La Rochelle, France: Maison de la Culture de La Rochelle et du Centre-Ouest, 1987. 40 pp., 19 b/w and 4 color illustrations.

El Caso. Madrid, Spain: Centro de Arte Reina Sofia, 1988. 64 pp., 22 b/w and 1 color illustration.

Reserves: La Fête du Pourim. Basel, Switzerland : Museum für Gegenwartskunst, 1989. 62 pp., 24 b/w and 1 color illustration.

El Caso. Zurich, Switzerland: Parkett Publishers, 1989. 17 b/w illustrations bound with two rings. 80 copies.

Archives. Arles: Le Méjan and Actes Sud, 1989. 48 pp., 100 b/w illustrations.

Le Club Mickey. Ghent: Imschoot, Uitgevers, 1990. 30 pp., 148 sepia illustrations.

Sans-Souci. Frankfort am Main and Cologne: Portikus and Verlag Walther König, 1991. 16 pp., 56 b/w illustrations, 2,000 copies.

La Maison manquante (The missing house). Paris: Flammarion, 1991. With Christiane Büchner and Andreas Fischer. Approximately 150 documents reproduced in facsimile. 120 signed and numbered copies.

FILMS AND VIDEOS BY CHRISTIAN BOLTANSKI

La Vie impossible de Christian Boltanski.
8mm, 12 min., color, 1968.

Comment pouvons-nous le supporter? 16mm, 24 sec.,
color, in collaboration with Alain Fleischer, 1969.

L'Homme qui lèche. 16mm, 2 min. 30 sec., color, 1969.

L'Homme qui tousse. 16mm, 3 min. 30 sec., color, 1969.

Tout ce dont je me souviens. 16mm, 18 sec., color, 1969.

Derrière la porte. 16mm, 2 min. 30 sec., b/w, 1970.

*Essai de reconstitution des 46 jours qui précèdèrent la mort
de Françoise Guiniou.* 16mm, 25 min., b/w, 1971.

L'Appartement de la rue de Vaugirard. 16mm, 8 min.,
b/w, 1973.

Quelques souvenirs de jeunesse. Video, 25 min.,
b/w, 1974.

La Vie c'est gai, la vie c'est triste. Video, 25 min.,
b/w, 1974.

LIST OF ILLUSTRATIONS

Some works by Christian Boltanski were made in multiple editions. Collections, especially museums or foundations, are noted where possible. Some works were site-specific and are no longer extant.

1. *Christian Boltanski à 5 ans et 3 mois de distance* (Christian Boltanski at five years and three months apart). Mail art, September 1970. 2 ID photos on index card. Sent to 60 people.

2. *La Vie impossible de Christian Boltanski* (The impossible life of Christian Boltanski). Invitation for the exhibition at Cinéma le Ranelagh, May 1968.

3. *Il faut que vous m'aidiez . . .* (You have to help me . . .). Handwritten letter requesting help. Mail art, 11 January 1970. Sent to 30 people.

4. Reply from critic José Pierre.

5. *Lettre manuscrite dans laquelle j'explique les directions contradictoires dans lesquelles mon travail s'engage* (Letter in which I explain the contradictory directions of my work). Mail art, 16 June 1970. Number of copies unknown.

6. Christian Boltanski's studio in 1974.

7. *Tout ce dont je me souviens* (All that I remember). Color film, 16mm, 24 sec., 1969.

8. Rejection letter concerning both the distribution permit and the exportation visa for the film *L'Homme qui tousse*.

9. *L'Homme qui tousse* (The man who coughs). Color film, 16mm, 3 min. 30 sec., 1969.

10. 11. Two views of Christian Boltanski's studio in 1967.

12. *L'Entrée des Turcs à Van* (The entry of the Turks into Van). 1961. Oil on board, approximately 100 x 200 cm (39³/₈ x 78³/₄ in.). Collection of the artist.

13. *La Concession à perpétuité* (Grant in perpetuity). Installation with Jean Le Gac and Gina Pane. Sixth Paris Biennale, 1969 at Musée d'Art Moderne de la Ville de Paris.

14. *La Concession à perpétuité* (Grant in perpetuity). On-site installation with Jean Le Gac and Gina Pane. Ecos, France, 10 September 1969.

15. Installation view, Sixth Paris Biennale, "Jeunes artistes à Paris" (Young artists in Paris) at Palais Galliéra, 1969.

16. *Les Sucres taillés* (Carved sugar cubes). 1971. Tin box, sugar cubes, wire screen.

17. *Christian Boltanski et ses frères, 5/9/59* (Christian Boltanski and his brothers, 5/9/59). Mail art, 9 October 1970. B/w photograph and text. Sent to 60 people.

18. *Fabrication et envoi de 60 petits sachets en drap blanc contenant des cheveux* (Fabrication and mailing of 60 small sachets of white sheet containing hair). Mail art, September-October 1969. Each sachet approximately 11 x 8 cm (4³/₈ x 3¹/₈ in.) or 7 x 7.5 cm (2³/₄ x 3 in.).

19. *Vitrine de référence* (Reference vitrine). 1970. Wooden vitrine containing various objects. Approximately 60 x 120 x 12 cm (23⁵/₈ x 47¹/₄ x 4³/₄ in.). Collection Musée Départemental des Vosges, Epinal.

20. Text by Christian Boltanski on the flyleaf of the original edition of the artist's book *Recherche et présentation de tout ce qui reste de mon enfance, 1944-1950* (Research and presentation of all that remains from my childhood, 1944-1950). May 1969. Paris: Edition Givaudon. 9 pp., 15 b/w illustrations. 150 copies.

21. 22. 23. Pages from the artist's book *Recherche et présentation . . .*

24. 25. 26. Cover detail and pages from the artist's book *Reconstitution d'un accident qui ne m'est pas encore arrivé et où j'ai trouvé la mort* (Reconstruction of an accident that hasn't happened to me yet and in which I met my death). November 1969. Paris: Edition Givaudon. 6 pp., 12 b/w illustrations. 150 copies.

27. 28. Double-page spreads from artist's book *Reconstitution de gestes effectuées par Christian Boltanski entre 1948 et 1954* (Reconstruction of gestures made by Christian Boltanski between 1948 and 1954). November 1970. Self-published. 12 pp., 7 b/w illustrations. 500 copies.

29. *Essais de reconstitution d'objets ayant appartenu à Christian Boltanski entre 1948 et 1954* (Attempts to reconstruct objects that belonged to Christian Boltanski between 1948 and 1954). 1970-1971. Plasticine objects, tin drawer, wire screen, typed label. 13 x 60 x 40 cm (5¹/₈ x 23⁵/₈ x 15³/₄ in.). Collection Fonds Régional d'Art Contemporain Limousin, Aixesur-Vienne.

30. Installation view, "Reconstitution," Galerie Sonnabend, Paris, 1971.

31. *Vitrine de référence* (Reference vitrine). 1970. Various objects in wooden vitrine with Plexiglas. 120 x 70 x 15 cm (47¹/₄ x 27¹/₂ x 6 in.).

32. View of gallery at the Musée du Trocadéro (now Musée de l'Homme), 1935.

33. Double-page spread from the artist's book *Tout ce que je sais d'une femme qui est morte et que je n'ai pas connue* (Everything I know about a woman who is dead and whom I didn't know). May 1970. Self-published. 8 pp., 5 b/w illustrations.

34. Installation view, "Inventar," Hamburger Kunsthalle, Hamburg, Germany, 1991, with *Album de photos de la famille D., 1939-1964* (Photo album of the family D., 1939-1964), 1971, and *Vitrines de référence* (Reference vitrines), 1970-1971. Musée d'Art Moderne, St.-Étienne.

35. 36. *Album de photos de la famille D., 1939-1964.* 1971. Details. 150 b/w photographs in tin frames with glass, each 20 x 30 cm (7⁷/₈ x 11³/₄ in.).

37. 38. Flyleaf and inside page from artist's book *Le Club Mickey* (The Mickey Mouse Club). 1990. Ghent: Editions Imschoot, Uitgevers. 30 pp., 148 sepia illustrations.

39. 40. *Les 62 membres du Club Mickey en 1955* (The 62 members of the Mickey Mouse Club in 1955). 1972. Overall view and detail. 62 b/w photographs in tin frames with glass. Each photo 30.5 x 22.5 cm (12 x 8⁷/₈ in.). Collection Ydessa Hendeles Art Foundation, Toronto.

41. *Portraits des élèves du CES des Lentillères* (Portraits of the students of the Lentillères College of Secondary Education). 1973. Permanent installation at the Lentillères College of Secondary Education, Dijon.

42. Cover of the weekly *Détective* magazine (Paris).

43. *Images d'une année de faits divers* (Images from a year of news items). 1973. Installation view, Sonnabend Gallery, New York, 1973. 408 b/w magazine illustrations of varying dimensions. Art Institute of Chicago.

44. *Je me permets de vous écrire pour vous soumettre un projet qui me tient à coeur . . .* (I'm writing to you to propose a project that is very close to my heart . . .). Mail art, 3 January 1973. Handwritten letter sent to museum curators.

45. 46. Two negative responses. January 1973.

47. Prague, Central Jewish Museum. View of one of the many storage rooms for books confiscated by the Nazis, 1942-1945.

48. Cover of artist's book *Inventaire des objets appartenant à un habitant d'Oxford précédé d'un avant-propos et suivi de quelques réponses à ma proposition* (Inventory of objects that belonged to a resident of Oxford preceded by a preface and followed by some answers to my proposal). 1973. Münster: Westfälischer Kunstverein. 80 pp., 344 b/w illustrations.

49. *Inventaire des objets ayant appartenu à un habitant d'Oxford* (Inventory of objects that belonged to a resident of Oxford). 1973. Detail. 200 b/w photographs, each 24 x 30 cm (9¹/₂ x 11¹³/₁₆ in.). Collection capc/Musée d'Art Contemporain, Bordeaux.

50. Daniel Spoerri, *Autoportrait, les tiroirs* (Self-portrait, the drawers). 1982. Various objects in wooden drawer, 33 x 35 x 7 cm (13 x 13³/₄ x 2³/₄ in.).

51. Annette Messager, *Les Albums-collections* (The album

collections). Installation view, "Ils collectionnent" (They collect), Musée des Arts Décoratifs, Paris, 1974.

52. *Inventaire des objets ayant appartenu à une femme de New York* (Inventory of objects that belonged to a woman of New York). 1973. Installation view, Sonnabend Gallery, New York, 1973.

53. Double-page spreads from the artist's book *List of exhibits belonging to a woman of Baden-Baden followed by an explanatory note*. Oxford, England: Museum of Modern Art, June 1973. 4 pp., 52 b/w illustrations.

54. *Inventaire des objets ayant appartenu à une femme de Baden-Baden* (Inventory of objects that belonged to a woman of Baden-Baden). Installation view, Staatliche Kunsthalle, Baden-Baden, Germany, 1973.

55. 56. *Inventaire des objets ayant appartenu à une femme de Bois-Colombes* (Inventory of objects that belonged to a woman of Bois-Colombes). 1974. Installation views, CNAC/Centre National d'Art Contemporain, Paris, 1974.

57. 58. The German comedian Kurt Valentin.

59. *Affiches - Accessoires - Décors, documents photographiques* (Posters - props - sets, photographic documents). Installation view, Westfälischer Kunstverein, Münster, 1974.

60. *Affiches: Le Repas refusé* (Posters: The refused meal). 1974. Watercolor and oil crayon on b/w photograph, 104 x 79.4 cm (41 x 31¼ in.).

61. *Saynètes comiques: La Mort du grand-père* (Comic sketches: Grandfather's death). 1974.

Watercolor and crayon on b/w photograph, 102 x 76 cm (39¾ x 30 in.).

62. *Saynètes comiques: L'Horrible découverte* (Comic sketches: The horrible discovery). 1974. Watercolor and crayon on b/w photograph, 102 x 76 cm (39¾ x 30 in.).

63. *Affiches: Le Blagueur* (Posters: The joker). 1974. Watercolor and oil crayon on b/w photograph, 104 x 79.4 cm (41 x 31¼ in.).

64. 65. 66. Cover and inside pages of the artist's book *Quelques interprétations par Christian Boltanski* (Some interpretations by Christian Boltanski). Paris: CNAC/Centre National d'Art Contemporain, 1974. 16 pp., 8 b/w illustrations. 200 signed and numbered copies.

67. 68. 69. Cover and inside pages from the artist's book *Les Morts pour rire de Christian Boltanski* (The pretend deaths/deaths for fun of Christian Boltanski). Dudweiler, Germany: Editions A. Q., 1974. 32 pp., 14 b/w illustrations. 150 copies.

70. *Composition photographique* (Photographic composition). 1974. Color photograph, 100 x 100 cm (39⅜ x 39⅜ in.). Collection of the artist.

71. Robert Mitchum in Charles Laughton's *Night of the Hunter*, 1955. B/w film still.

72. Invitation to "Images modèles" (Model images), Galerie Sonnabend, Paris, January 1976.

73. Excerpt from a letter sent by Christian Boltanski to Guy Jungblut in August 1975 and published on the back of the invitation to "Christian Boltanski - Photographies couleurs" (Christian Boltanski - Color photo-

graphs), exhibition held at the Musée National d'Art Moderne, Centre Georges Pompidou, Paris, 19-24 May 1976.

74. Installation view, "Reconstitution," Musée de Grenoble, France, 1991, with *Les Enfants de Berlin* (The children of Berlin), 1975, and *Lanterne magique* (Magic lantern), 1981.

75. *Les Enfants de Berlin* (The children of Berlin). 1975. 32 color photographs, each 40 x 30 cm (15¾ x 11¾ in.). Fonds Régional d'Art Contemporain Aquitaine, Bordeaux.

76. *Les Jolis enfants* (The pretty children). 1975. 10 color photographs, each 40 x 30 cm (15¾ x 11¾ in.). Collection Sonnabend.

77. *Voyage de noces à Venice* (Honeymoon in Venice). 1975. Collaborative work with Annette Messager. 96 color photographs and 21 drawings in colored pencil.

78. *Composition fleurie* (Flowery composition). 1975. Color photograph, 50 x 50 cm (19⅝ x 19⅝ in.).

79. *Compositions décoratives* (Decorative compositions). 1976. Color photographs. Musée d'Art Contemporain, Nîmes.

80. *Images modèles* (Model images). 1975. Color photographs mounted on boards, each 40 x 30 cm (15¾ x 11¾ in.).

81. Installation view, Sonnabend Gallery, New York, 1979, with *Compositions photographiques* (Photographic compositions), 1977 and *Compositions murales* (Mural compositions), 1976, color photographs.

82. *Projections*. Installation views, *Le Coin du Miroir* (The Mirror's Corner), Dijon, France,

1978. Le Consortium, Centre d'Art Contemporain, Dijon.

83. *Composition murale* (Mural composition). 1977. Color photograph, 3 panels, each 115 x 160 cm (45¼ x 63 in.).

84. *Composition grotesque* (Grotesque composition). 1981. Color photograph, 110 x 193 cm (34¼ x 76 in.). Musée National d'Art Moderne, Centre Georges Pompidou, Paris.

85. Installation view, Musée National d'Art Moderne, Centre Georges Pompidou, Paris, 1984, with *Composition grotesque* (Grotesque composition), 1981, *Composition classique* (Classic composition), 1982, and *Composition enchantée* (Enchanted composition), 1982, color photographs.

86. *Compositions japonaises*. 1978. Color photographs, each 30 x 150 cm (11¾ x 59 in.).

87. Installation view, ARC, Musée d'Art Moderne de la Ville de Paris, 1981, with *Compositions théâtrales* (Theatrical compositions). 1981. Color photographs, each 30 x 150 cm (11¾ x 59 in.).

88. *Composition théâtrale* (Theatrical composition). 1981. Color photograph, 243 x 127 cm (95⅝ x 50 in.). Musée National d'Art Moderne, Centre Georges Pompidou, Paris.

89. Installation view, ARC, Musée d'Art Moderne de la Ville de Paris, 1981, with *Compositions héroïques* (Heroic compositions). 1981.

90. *Composition héroïque* (Heroic composition). 1981. Color photograph, 158 x 112 cm (56¼ x 44 in.).

91. Installation view, Musée National d'Art Moderne, Centre

Georges Pompidou, Paris, 1984, with *Compositions hiératiques* (Hieratic compositions), 1983, color photographs, 260 x 100 cm (102⅜ x 39⅜ in.) and *Composition mythologique* (Mythological composition), 1982, color photographs, 231 x 200 cm (91 x 78¾ in.).

92. *Composition architecturale* (Architectural composition). 1982. Color photograph, 300 x 100 cm (118⅛ x 39⅜ in.).

93. *Les Bougies* (Candles). 1986. Copper figurines, tin shelves, candles. Figurines approximately 8 to 12 cm (3⅛ to 4 in.); shelves 3.5 x 31 x 10 cm (1½ x 12¼ x 4 in.). Installation view, Chapelle de la Salpêtrière, Festival d'automne, Paris, 1986.

94. "Lesson of Shadow Games," from *Introduction à la haute école de la peinture* (Introduction to the noble school of painting) by Samuel van Hoogstraten. 1652.

95. Henri Rivière, *La Tentation de saint Antoine* (The temptation of St. Anthony), 1887. Zinc cutout, 73 x 42 cm (28¾ x 16½ in.).

96. *Ombres* (Shadows). 1984. Wood, cardboard, tin, cork, wire, projector, fans, dimensions variable. Installation view, Institute of Contemporary Art, Nagoya, Japan, 1990. Collection Institute of Contemporary Art, Nagoya, Japan.

97. Photograph of Christian Boltanski's class at the Hulst Middle School. Paris, 1951.

98. *Monument*. 1986. "Monuments," Galerie Crousel-Hussenot, Paris, 1986. B/w and color photographs, tin frames, lights with wires. Overall dimensions: 200 x 80 cm (78¾ x 31½ in.).

99. Installation view, Institute of Contemporary Art, Nagoya, Japan, 1990, with *Monuments,* 1985, and *Bougies* (Candles), 1986.

100. *Monuments.* 1985. "Monuments," Galerie Crousel-Hussenot, Paris, 1986. B/w and color photographs, tin frames, lights with wires. Overall dimensions: 330 x 160 cm (130 x 63 in.). Collection Ydessa Hendeles Art Foundation, Toronto.

101. *Portraits des élèves du C.E.S. des Lentillères* (Portraits of students from the Lentillères College of Secondary Education). 1973. Permanent installation at the Lentillères College of Secondary Education, Dijon, France.

102. 103. *Monument: Les Enfants de Dijon* (Monument: The children of Dijon). Installation view and detail, Le Consortium, Centre d'Art Contemporain, Dijon, France, 1985. B/w and color photographs, lights with wires. Each photograph 28 x 24 cm (11 x 9½ in.) to 40 x 50 cm (15¾ in. x 19¾ in.).

104. 105. Installation views, Chapelle de la Salpêtrière, Festival d'automne, Paris, 1986.

106. 107. *Monuments: Les Enfants de Dijon* (Monuments: The children of Dijon) and *Monument.* Installation view, Palazzo delle Prigione, 42nd Venice Biennale, 1986 and detail.

108. Installation view, "Inventar," Hamburger Kunsthalle, Hamburg, Germany, April 1991, with *Monuments: Les Enfants de Dijon* (Monuments: Les Enfants de Dijon) and *Monuments.*

109. 110. *Les Bougies* (Candles). 1986. Copper figurines, tin shelves, candles, dimensions variable. Installation view and detail, Kunstmuseum, Bern, Switzerland, 1987.

111. Installation view, Chapelle de la Salpêtrière, Festival d'automne, Paris, 1986.

112. *L'Ange d'alliance* (The angel of accord). 1986. Copper, feathers, projector, metal base. Dimensions variable. Musée de l'Archéologie Méditerranéenne, Centre de la Vieille Charité, Marseille.

113. *Récit-Souvenir* (Story-recollection). April 1971. Published in *Opus International* (Paris), no. 24-25 (May 1971), pp. 82-83.

114. *Les Habits de François C* (The clothes of François C). 1972. B/w photographs, tin frames, glass. Each photograph 22.5 x 30.5 cm (8⅞ x 12 in.). Musée d'Art Contemporain, Nîmes, on loan from the Fonds National D'Art Contemporain.

115. 116. *Archives.* 1987. Photographs, glass, metal screens, electric lamps. Each photograph 18 x 20 cm (7 x 7⅞ in.) to 40 x 60 cm (15¾ x 23⅝ in.); screens 227 x 284 cm (89⅜ x 111¾ in.). Installation view and detail, Documenta 8, Kassel, Germany, 1987.

117. Photograph of graduating class, Chajes high school, Vienna, 1931.

118. *Boîtes à biscuits datées contenant des petits objets de la vie de Christian Boltanski* (Dated biscuit boxes containing small objects from the life of Christian Boltanski). Installation view of "Local I" exhibition, Galerie Daniel Templon, Paris, 1970.

119. Installation view of "Le Lycée Chases," Kunstverein für die Rheinlände und Westfalen, Düsseldorf, Germany, 1987.

120. Double-page spread from the artist's book *Le Lycée Chases: Classe terminale du Lycée Chases en 1931: Castelgasse, Vienne* (Chases high school: Senior class of the Chases high school in 1931: Castelgasse, Vienna). Kunstverein für die Rheinlände und Westfalen, Düsseldorf, Germany, 1987. 62 pp., 1 color illustration, 18 b/w illustrations. 1,018 copies.

121. *Le Lycée Chases* (Chases high school), detail. 1987. B/w photographs, tin frame, tin biscuit boxes, photomechanical prints, metal lamps. Installation approximately 120 x 60 x 23 cm (47¼ x 23⅝ x 9 in.).

122. *Le Lycée Chases* (Chases high school), detail. 1988. B/w photographs, tin drawers, wire screen, metal lamps. Overall dimensions approximately 220 x 422 cm (86½ x 166 in.). Installation view, "Lessons of Darkness," Museum of Contemporary Art, Chicago, 1988.

123. *Autel Chases* (Altar to the Chases high school). 1987. B/w photographs, tin frames, metal lamps. Museum of Contemporary Art, Los Angeles.

124. *Autel Chases* (Altar to the Chases high school). 1988. B/w photographs, tin boxes, photomechanical prints, metal lamps. Overall dimensions 110 x 215 cm (43¼ x 84⅝ in.). Collection Durand-Ruel, Paris.

125. Photograph of Purim celebration at a Jewish school in France, 1939.

126. *Réserves: la Fête de Pourim* (Reserves: The Purim holiday). 1989. B/w photographs, metal drawer, wire, second-hand clothing, metal lamp.

127. Installation view, "Reconstitution," Musée de Grenoble, France, 1991.

128. *Monument (Odessa).* Details. "Reconstitution," Musée de Grenoble, France, 1991.

129. *Monument: la Fête de Pourim* (Monument: The Purim holiday). Tin boxes, b/w photographs, metal lamps, wires. Installation view, Galerie Bebert, Rotterdam, The Netherlands, 1988.

130. *Reliquaire* (Reliquary). 1989-1990. Tin boxes, b/w photos, metal lamps. Badischer Kunstverein, Karlsruhe, Germany.

131. Installation view, "Inventar," Hamburger Kunsthalle, Hamburg, Germany, 1991, with *Réserve: Canada,* 1988, and *Reliquaire* (Reliquary), 1989-1990.

132. *Canada.* 1988. Second-hand clothing. Installation view, Collection Ydessa Hendeles Art Foundation, Toronto, 1988.

133. *Réserve: Lac des morts* (Reserve: Lake of the dead). 1990. Second-hand clothing, wood, metal lamps. Installation view, Institute of Contemporary Art, Nagoya, Japan, 1990.

134. Cover of the Spanish weekly *El Caso,* May 1990.

135. 136. *El Caso.* 1988. Installation views, Centro de Arte Reina Sofia, Madrid, 1988. Collection Hamburger Kunsthalle, Hamburg.

137. *Archives de l'année 1987 du journal El Caso* (Archives from 1987 from the newspaper *El Caso*). 1989. Approximately 300 b/w photographs, electric lamps, wires. Dimensions variable. Installation view, "Archives," Galerie Ghislaine Hussenot, Paris, 1989. Collection Fundación Caixa de Pensiones, Barcelona.

138. *Les Archives: Détective* (Archives: Détective). 1987. B/w photographs, tin boxes, magazine clippings, metal lamps. Installation view, "From the Europe of Old," Stedelijk Museum of Modern Art, Amsterdam, 1987. Collection Ydessa Hendeles Art Foundation, Toronto.

139. Photographs clipped from the weekly *Détective,* 1972, by Christian Boltanski.

140. Italian cemetery. Photograph by Gilles Ehrmann reproduced in *Traverses* (Paris), no. 1, "Lieux et objets de la mort" (Places and objects of death), September 1975.

141. *Réserve: Détective.* 1988. Installation view, "Inventar," Hamburger Kunsthalle, Hamburg, Germany, 1991. Wooden shelves, cardboard boxes, desk lamps, magazine clippings. Museum Wiesbaden, Germany.

142. 143. *Réserve du musée des enfants* (Storage area of the children's museum). 1989. B/w photographs, each 50 x 60 cm (19⅝ x 23⅝ in.), children's clothing, metal shelves, lamps. Installation view, "Histoires de musées," Musée d'Art Moderne de la Ville de Paris, 1989, and permanent installation in the same museum.

144. Obituaries from the Swiss daily *Le Nouvelliste du Valais,* 1990.

145. 146. *Les Suisses morts* (The dead Swiss), 1990. Detail and installation view, Marian Goodman Gallery, New York, 1990.

147. *Les Suisses morts* (The dead Swiss), 1991. B/w photographs, glass, metal lamps. Overall

dimensions 548.6 x 2,499.4 cm (216 x 984 in.). Installation view, Carnegie International, Carnegie Museum of Art, Pittsburgh, 1991.

148. *La Réserve du Carnegie International* (The storage room of the Carnegie International). Installation view, Carnegie International, Mattress Factory, Pittsburgh, 1991.

149. 150. *Réserve: Les Suisses morts* (Reserve: The dead Swiss), 1990. Tin boxes and newsprint. Installation views, Galerie Ghislaine Hussenot, Paris, 1991. Collection IVAM Centre Julio González, Valencia, Spain.

151. 152. *La Réserve du Conservatoire de Musique* (The archive of the Conservatory of Music). B/w photographs, metal shelves, cardboard boxes, metal lamps, newsprint. Permanent installation, Cité de la Musique, Paris, 1991.

153. *Musée social: Dispersion à l'amiable du contenu des trois tiroirs du secrétaire de Christian Boltanski* (Social museum: Private sale of the contents of three drawers from Christian Boltanski's desk). Mail art and performance. 5 June 1972.

154. *Photographie de ma petite soeur en train de creuser sur la plage de Granville* (Photograph of my little sister digging on the beach at Granville). Mail art, November 1969. b/w photograph. Sent to 50 people.

155. Inventory of 47 items offered at the "Private Sale" of 5 June 1972. 3 pp.

156. *La Maison manquante* (The missing house). First part: 15/16 Grosse Hamburger Strasse. "Die Endlichkeit der Freiheit," Berlin, 1990. Permanent installation.

157. *La Maison manquante* (The missing house). Second part: *Le Musée* (The museum), Berliner Gewerber Ausstellung. 1990. Installation view, "Die Endlichkeit der Freiheit," Berlin, September 1990.

158. *Résistance*. 1993. Installation views at Haus der Kunst, Munich, December 1993.

159. *Conversation Piece*. 1991. Found b/w photographs on six framed boards, each 120 x 80 x 6 cm (47¼ x 31½ x 2⅜ in.). Installation view, "Inventar," Hamburger Kunsthalle, Hamburg, Germany, 1991. Collection Caisse de Dépôts et Consignations, Paris.

160. Double-page spread from the artist's book *Sans-Souci*. Frankfurt am Main and Cologne: Portikus and Walther König, 1991. 16 pp., 56 b/w illustrations, 2,000 copies.

161. *Christian Boltanski a l'honneur de vous faire ses offres de service* (Christian Boltanski is pleased to offer you his services). Mail art, May 1974.

162. 163. Cover and pages from the artist's book *10 Portraits photographiques de Christian Boltanski, 1946-1964* (10 photographic portraits of Christian Boltanski, 1946-1964). Paris: Editions Multiplicata, 1972. 20 pp., 10 b/w illustrations.

164. Last page of artist's book *10 Portraits photographiques de Christian Boltanski, 1946-1964*. 1972.

165. *Piège* (Trap). Detail. 1970. Cloth and pins.

166. *Album de photos de la famille D., 1939-1964* (Photo album of the family D., 1939-1964), 1971.

167. Wartime storage of household dishes, 1942-1945. From the archives of the Central Jewish Museum, Prague.

168. Stage prop for Tadeusz Kantor's play *The Dead Class*, 1975.

169. Sebastian Stosskopf, *Large Vanitas*, 1641. Oil on canvas. Musée des Beaux-Arts, Strasbourg, France.

170. Christian Boltanski making small balls of dirt, 1969.

171. Christian Boltanski working on *Les Compositions*, 1983.

172. Excerpt of a letter sent by Christian Boltanski to Paul Armand Gette, 6 February 1971. Cologne: Galerie M. E. Thelen, June 1971. Facsimile.

173. Detail of one page from the artist's book *Catalogue: Essais de reconstitution d'objets ayant appartenus à Christian Boltanski entre 1948 et 1954* (Catalogue: Attempts to reconstruct objects that belonged to Christian Boltanski between 1948 and 1954). Paris: Galerie Sonnabend, March 1971. 4 pp. with b/w illustrations.

174. 175. Invitation to the opening of the exhibit "Christian Boltanski - Jean Le Gac: Facsimiles - Documents - Originaux - Ecrits" (Christian Boltanski - Jean Le Gac: Facsimiles, documents, originals, writings), Musée Municipal du Costume Militaire, Fontainebleau, France, 19 May 1972.

176. Cover of catalogue for the exhibition "Modellbilder" (Model images), with Annette Messager, Rheinisches Landesmuseum, Bonn, Germany, 1976.

177. Pages from the "Interview with Georgia Marsh, reviewed and corrected by Christian Boltanski," 1990, 17 pp., published in the exhibition catalogue *Christian Boltanski-Reconstitution*, 1990.

PHOTOGRAPHIC CREDITS